RUNE FACTORY: GUARDIANS OF AZUMA

Unlocking Every Secret, Harvesting Every Crop, Forging Your Destiny

RITA K. LOPEZ

Copyright © 2025 by Rita K. Lopez
All rights reserved. No part of this publication may be reproduced, distributed, or transmitted in any form or by any means, including photocopying, recording, or other electronic or mechanical methods, without the prior written permission of the author, except in the case of brief quotations embodied in critical reviews and certain other noncommercial uses permitted by copyright law.

Table of content

Chapter 1 — 6
WELCOME TO AZUMA – Your Journey Begins — 6
- Setting the Stage: Installation and Setup — 6
- Mastering the Basics: Controls and Interface Overview — 11
- Choose Your Path: Difficulty Modes and Playstyles — 16
- The Hero of Azuma: Character Creation & World Introduction — 20

Chapter 2 — 25
WALKTHROUGH PART I – The Awakening and Early Trials — 25
- Early Quests and Tutorials — 25
- Exploring the First Region: Verdant Hills — 29
- Meeting Key NPCs and Establishing Your Farm — 32
- First Boss Battle and Dungeon Exploration — 35

Chapter 3 — 40
WALKTHROUGH PART II – Guardians, Secrets, and Destiny — 40
- Mid-Game Story Arcs and Side Quests — 40
- Unlocking New Towns and Areas — 43
- The Guardians of Azuma: Major Bosses — 47
- Endgame Setup and Final Showdown Preparation — 50

Chapter 4 — 55
THE WORLD OF AZUMA – Maps and Locations — 55
- Town Maps and Key Buildings — 55
- Dungeon Layouts and Puzzle Paths — 59
- Regional Maps and Biome Descriptions — 62
- Fast Travel Routes and Hidden Areas — 66

Chapter 5 — 70
SECRETS OF SUCCESS – Tips, Tricks & Pro Strategies — 70
- Combat Mechanics and Elemental Matchups — 70

- Farming Efficiency and Seasonal Planning — 74
- Crafting Upgrades and Optimal Recipes — 76
- Building Relationships and Hidden Bonuses — 80
- Resource Gathering and Money-Making Tips — 83
- Easter Eggs and Developer Secrets — 86

Chapter 6 — 89
SOWING PROSPERITY – Mastering Farming and Seasons — 89
- Seasonal Crop Guides — 89
- Soil Management and Fertilizers — 92
- Tool Upgrades and Automation — 95
- Greenhouse Mechanics — 99

Chapter 7 — 102
FORGE AND FLAME – Crafting and Equipment — 103
- Weapon and Armor Crafting — 103
- Accessory Creation and Buffs — 107
- Material Farming and Rare Drops — 110
- Best Equipment for Each Playstyle — 114

Chapter 8 — 119
BONDS BEYOND BATTLE – Taming Monsters and Companions — 119
- How to Befriend and Tame Monsters — 119
- Companion Combat Roles and Skills — 122
- Monster Ranching and Productivity — 126
- Best Monsters for Combat and Farming — 129

Chapter 9 — 134
HEART OF THE COMMUNITY – Festivals, Quests & Events — 134
- Maximizing Skills and Character Builds — 134
- Calendar of Festivals and Activities — 139
- Romance Options and Marriage Guide — 143
- Side Quests and Reward Trees — 147

Chapter 1

WELCOME TO AZUMA – Your Journey Begins

Welcome to Azuma serves as your essential guide to starting your epic adventure. This chapter covers everything you need to **install and set up** your game, get comfortable with the **controls and interface**, and understand the various **difficulty modes and playstyles** available. Finally, embark on your journey by delving into **character creation** and getting introduced to the vibrant world of Azuma.

Setting the Stage: Installation and Setup

Before you can embark on your grand adventure in Azuma, cultivating your farm, befriending monsters, and delving into mysterious dungeons, you first need to get *Rune Factory: Guardians of Azuma* up and running on your preferred platform. This section will guide you through the entire installation process, from checking system requirements to optimizing your initial game settings for the best possible experience.

1. System Requirements Check (PC)

For PC players, verifying that your computer meets the game's specifications is the crucial first step. Running a game on hardware below the minimum requirements can lead to performance issues, crashes, or an unplayable experience.

- **Where to Find Requirements:** Always refer to the official game store page (Steam, Epic Games Store, GOG, etc.) for the most accurate and up-to-date specifications.
- **Key Components to Check:**
 - **Operating System (OS):** Typically Windows 10 (64-bit) or newer.
 - **Processor (CPU):** Look for Intel Core i5-series or AMD Ryzen 5-series (or equivalent) for minimum, and i7/Ryzen 7 for recommended.
 - **Memory (RAM):** 8 GB RAM is often a minimum, with 16 GB recommended for smoother performance.
 - **Graphics Card (GPU):** Nvidia GeForce GTX series or AMD Radeon RX series (or equivalent). Check specific models like GTX 1060/RX 580 for minimum, and RTX 2060/RX 5700 for recommended.
 - **DirectX Version:** Usually DirectX 11 or 12.
 - **Storage:** The game will require a certain amount of free hard drive space (e.g., 20-30 GB). **SSD (Solid State Drive) is highly recommended** for faster loading times and smoother gameplay.
- **How to Check Your PC Specs:**

- **Windows 10/11:** Right-click the "Start" button, then select "System" for CPU and RAM. For GPU, right-click on your desktop, select "Display settings," scroll down and click "Advanced display settings," then "Display adapter properties." Alternatively, type "dxdiag" into the Windows search bar and press Enter for a detailed system report.

2. Purchasing and Installation

The installation process varies slightly depending on your chosen platform.

For PC (Steam, Epic Games Store, GOG, etc.):

1. **Purchase the Game:** Navigate to the game's page on your preferred digital storefront and complete the purchase.
2. **Access Your Library:** Once purchased, the game will appear in your "Library" section of the respective client (e.g., Steam Library).
3. **Initiate Download:** Click on *Rune Factory: Guardians of Azuma* in your library. You will see an "Install" or "Download" button. Click it to begin the process.
4. **Choose Installation Location (Optional):** The client will usually suggest a default installation path. If you have multiple drives, you can choose a different one, preferably an SSD for optimal performance.
5. **Monitor Download Progress:** The client will display the download size and estimated time remaining. Ensure you have a stable internet connection. Large game files can take a while to download.
6. **Automatic Installation:** Once the download is complete, the client will automatically install the game files. This may include installing necessary runtime components like DirectX or Visual C++ Redistributables.
7. **First Launch Preparations:** Before the first launch, the game client might perform a final verification of game files.

For Nintendo Switch:

1. **Physical Cartridge:**
 - Gently insert the *Rune Factory: Guardians of Azuma* game cartridge into the game card slot on the top right of your Nintendo Switch console.
 - The game icon will automatically appear on your Home screen.
 - **Updates:** Even with a physical cartridge, the game may require an initial download for day-one patches, bug fixes, or additional content. Ensure your Switch is connected to the internet.
2. **Digital Download (Nintendo eShop):**
 - From the Nintendo Switch Home screen, select the "Nintendo eShop" icon (orange shopping bag).
 - Search for "Rune Factory: Guardians of Azuma" using the search bar or by Browse.
 - Select the game and proceed with the purchase.

- o Once purchased, the download will begin automatically. You can monitor its progress on your Home screen.
- o **Storage:** Be mindful of your console's internal storage. If you're low on space, you may need to archive or delete other games, or use a microSD card for expanded storage (recommended for digital titles).

For Nintendo Switch 2 (Anticipated):

As Rune Factory: Guardians of Azuma is slated for release on June 5, 2025, it is expected to be available for the next generation of Nintendo hardware, the Nintendo Switch 2. While specific details might evolve, the installation process is highly likely to be very similar to the original Nintendo Switch.

1. **Physical Cartridge:** Insert the game cartridge into the designated slot. The game icon should appear on your Home screen.
2. **Digital Download (Nintendo eShop on Switch 2):** Access the eShop (or equivalent digital storefront) on your Switch 2, search for the game, purchase, and initiate the download.
3. **Initial Updates:** Regardless of physical or digital, ensure your Switch 2 is connected to the internet to download any mandatory updates or patches immediately after installation.

3. Initial Setup and Graphics Settings

Once the game is installed, the first time you launch it, you might be prompted to set up some basic preferences.

Common First-Launch Prompts:

- **Language Selection:** Choose your preferred language for text and (if applicable) voiceovers.
- **Brightness/Gamma Calibration:** Adjust the slider until the game's test image is clearly visible, ensuring proper lighting throughout your adventure.
- **Terms of Service/Privacy Policy:** You will likely need to accept these to proceed.

Graphics Settings (PC - Detailed Customization):

Access these settings usually from the "Options" or "Settings" menu from the title screen or pause menu. Optimizing these is key to balancing visual fidelity and performance (frame rate).

1. **Display Mode:**
 - o **Fullscreen:** Recommended for dedicated gameplay. Provides the best performance by dedicating all system resources to the game.
 - o **Borderless Windowed:** Good for multi-tasking (e.g., checking guides). Can have a slight performance impact compared to fullscreen.
 - o **Windowed:** Runs the game in a movable window.
2. **Resolution:** Set this to your monitor's native resolution for the sharpest image (e.g., 1920x1080 for Full HD, 2560x1440 for QHD, 3840x2160 for 4K).
3. **Refresh Rate (Hz):** Match this to your monitor's refresh rate (e.g., 60Hz, 144Hz). Higher refresh rates offer smoother visuals,

but require more powerful hardware to consistently achieve matching frame rates.

4. **Graphics Quality Preset:** Most games offer presets like "Low," "Medium," "High," and "Ultra." If unsure, start with "Medium" or "High" and adjust individual settings from there.

5. **Individual Graphics Settings (Order of Impact on Performance):**
 - **Texture Quality:** Affects the sharpness and detail of surfaces. High quality requires more VRAM (Video RAM).
 - **Shadow Quality:** Determines the resolution and realism of shadows. Very demanding.
 - **Anti-Aliasing (AA):** Smoothes jagged edges on objects. Common types:
 - **FXAA/SMAA:** Lighter performance impact, can blur textures slightly.
 - **TAA (Temporal Anti-Aliasing):** Generally good quality with moderate impact, but can introduce ghosting.
 - **DLSS/FSR (Upscaling Technologies):** If your GPU supports it (NVIDIA for DLSS, AMD for FSR), enable these! They render the game at a lower resolution and intelligently upscale it, providing near-native visual quality with a significant performance boost. Highly recommended.
 - **View Distance / Draw Distance:** How far into the distance objects, foliage, and details are rendered.
 - **Volumetric Lighting / God Rays:** Realistic light shafts and atmospheric effects. Can be demanding.
 - **Post-Processing Effects:** Includes Bloom (light glow), Motion Blur (can be disabled if disliked), Depth of Field (blurring distant objects).
 - **V-Sync (Vertical Sync):** Synchronizes the game's frame rate with your monitor's refresh rate to prevent "screen tearing." Turn it on if you experience tearing; turn it off if you prefer uncapped frame rates (often in conjunction with G-Sync/FreeSync monitors).
 - **Frame Rate Limit:** You might be able to set a target FPS (e.g., 30, 60, 120).
- **Optimization Tip:** If you experience low frame rates (FPS), try reducing **Shadow Quality**, **Anti-Aliasing**, and **Volumetric Lighting** first. If issues persist, lower the overall **Graphics Quality Preset**.

Graphics Settings (Console - Limited Options):

Console versions of games are pre-optimized for their hardware, so customization options are usually limited.

- **Brightness/Gamma:** As mentioned, usually adjusted during first launch.

- **Performance vs. Quality Mode:** Some newer console games offer a choice:
 - **Performance Mode:** Prioritizes higher frame rates (e.g., 60 FPS) by potentially lowering resolution or graphical fidelity.
 - **Quality Mode:** Prioritizes higher resolution (e.g., 4K) or more detailed graphics, often at a lower frame rate (e.g., 30 FPS).
 - Choose based on your preference: smoother gameplay or sharper visuals.
- **Motion Blur Toggle:** Occasionally, you might find an option to disable motion blur if you find it distracting.

4. Updates and Patches

Modern games frequently receive updates.

- **Day-One Patch:** It's common for a significant patch to be released on or around the game's launch date. This often includes critical bug fixes and performance improvements.
- **Automatic Downloads:** Digital storefronts (Steam, Epic, eShop) and console operating systems are usually set to download updates automatically when your device is connected to the internet.
- **Manual Check:** If you encounter issues, always ensure your game is fully updated. You can usually manually check for updates through the game client (PC) or by selecting the game icon on your console's Home screen and pressing the "Options" or "Plus" button.

5. First Launch and Troubleshooting

Once everything is installed and set up, hit that "Play" button!

- **Initial Loading:** The first launch may take a bit longer as the game loads initial assets and shaders.
- **Troubleshooting Common Issues (PC):**
 - **Crashes on Launch:**
 - Verify game files through your client (Steam: Right-click game > Properties > Installed Files > Verify integrity of game files).
 - Update your graphics drivers (NVIDIA GeForce Experience, AMD Radeon Software).
 - Run the game as administrator.
 - Disable any overlay software (Discord, GeForce Experience, etc.) temporarily.
 - **Low FPS:** Refer to the graphics settings optimization tips above.
 - **Input Lag:** Ensure V-Sync is configured correctly, and check if your monitor's refresh rate is set properly in Windows.
 - **Controller Not Working:** Ensure the controller is properly connected and recognized by your system. Some games require specific controller drivers or may conflict with certain third-party software.
- **Troubleshooting Common Issues (Console):**

- **Game Not Starting:** Eject and reinsert the cartridge. Restart the console.
- **Freezes/Crashes:** Ensure the console's system software is up to date. Restart the console. If issues persist, consider reinstalling the game (digital) or checking the cartridge for damage (physical).

With these steps, you've successfully prepared your system and game for an unforgettable journey. Now, prepare to immerse yourself in the rich world of Azuma!

Mastering the Basics: Controls and Interface Overview

Now that *Rune Factory: Guardians of Azuma* is installed and ready, it's time to get your hands dirty – or rather, to understand the tools you'll be using. This chapter will demystify the core controls and introduce you to the Heads-Up Display (HUD) and various menu systems, ensuring you can seamlessly interact with Azuma's vibrant world and manage your burgeoning farm and adventuring life.

1. Understanding Your Controls

Whether you prefer the precision of a keyboard and mouse or the comfort of a gamepad, familiarity with your input method is paramount.

A. Keyboard & Mouse Controls (PC)

The default keyboard and mouse setup offers precise movement and quick access to a wide array of actions.

- **Movement:**
 - W, A, S, D: Move character (Forward, Left, Backward, Right).
 - Shift (Hold): Sprint/Run (consumes Stamina/RP slightly faster).
- **Camera Control:**
 - Mouse Movement: Rotate camera view.
 - Mouse Scroll Wheel: Zoom in/out (often for viewing your farm or specific areas).
- **Interaction & Action:**
 - Left Mouse Button (LMB): Primary action.
 - Combat: Normal Attack.
 - Farming: Use equipped tool (e.g., swing axe, water crops).
 - World: Interact with objects, pick up items, talk to NPCs.
 - Right Mouse Button (RMB): Secondary action.
 - Combat: Guard/Block, Charge Attack (hold).
 - Farming: Alternate tool use (e.g., charged hoe, throw seeds).
 - E (or F): Contextual Interact (e.g., open doors, activate switches, accept quests).
- **Inventory & Menus:**
 - Esc: Pause game, open Main Menu/System Menu.
 - Tab: Open Quick Menu/Inventory (often toggles between quick item selection and full inventory).
 - I: Open Inventory directly.

- o M: Open Map directly.
- o J: Open Journal/Quest Log.
- o P: Open Party/Monster Companion Menu.
- **Tool/Item Hotkeys:**
 - o 1 - 9 (Number Row): Select items/tools from your quick slot bar.
 - o Q / E (or Mouse Wheel): Cycle through equipped tools/items in quick slots.
- **Specific Actions:**
 - o Spacebar: Jump, Confirm/Accept in menus.
 - o C: Crouch (less common in *Rune Factory*, but might exist for specific interactions).
 - o R: Sheathe/Unsheathe Weapon.
 - o F1-F12 (Function Keys): Often for screenshots, quick save/load (if available).
- **Key Remapping:** Always check the "Controls" or "Key Bindings" section in the game's Options menu. If a default key feels uncomfortable, remap it to something that suits your playstyle. This is highly recommended for personalized comfort and efficiency.

B. Controller Controls (Nintendo Switch / PC Gamepad)

The gamepad provides a more tactile and intuitive feel, especially for action combat and relaxed farming.

- **Movement:**
 - o Left Analog Stick: Move character.
 - o L3 (Press Left Stick Down): Sprint/Run (consumes Stamina/RP).
- **Camera Control:**
 - o Right Analog Stick: Rotate camera view.
 - o R3 (Press Right Stick Down): Reset camera or toggle first-person view (if available).
- **Interaction & Action (Nintendo Switch Button Layout Examples):**
 - o A (Bottom Face Button): Primary action, Confirm/Accept in menus.
 - ■ Combat: Normal Attack.
 - ■ Farming: Use equipped tool.
 - ■ World: Interact, pick up items, talk.
 - o B (Right Face Button): Cancel/Back in menus, Dash/Dodge (if available in combat).
 - o Y (Left Face Button): Secondary action.
 - ■ Combat: Charge Attack (hold).
 - ■ Farming: Alternate tool use (e.g., charged hoe, throw seeds).
 - o X (Top Face Button): Jump, Contextual Interact (open doors, specific actions).
- **Inventory & Menus:**
 - o + (Plus Button / Start): Open Main Menu/System Menu (Pause).
 - o - (Minus Button / Select): Open Map/Quick Menu (contextual).

- **L / R (Left/Right Shoulder Buttons)**: Cycle through equipped tools/items in quick slots.
- **ZL / ZR (Left/Right Triggers)**: Specific combat/farming actions (e.g., lock-on, charged attack, fishing).
- **D-Pad (Directional Pad)**:
 - **Up/Down/Left/Right**: Navigate menus, select quick items or specific functions (e.g., chat shortcuts).
- **Controller Remapping:** Check the "Controls" section in the game's Options menu. While less customizable than PC, some games allow for remapping a few key actions.

2. Heads-Up Display (HUD) Overview

The HUD is your constant source of vital information, displayed on the screen without needing to open menus. Mastering its elements will allow you to make quick, informed decisions.

1. **Health Bar (HP):**
 - **Location:** Usually top-left corner of the screen.
 - **Purpose:** Represents your character's current health. If it reaches zero, you will be defeated and sent back to your home/clinic.
 - **Visual:** Typically a green or red bar.
 - **Recovery:** Recovers slowly over time, significantly by sleeping, or instantly by consuming food/potions.
2. **Rune Points (RP) / Stamina Bar:**
 - **Location:** Often below or next to your HP bar.
 - **Purpose:** The crucial resource for almost all non-combat actions: farming (tilling, watering, planting, harvesting), crafting, cooking, fishing, and some special combat abilities.
 - **Visual:** Usually a blue or yellow bar.
 - **Consequence of Depletion:** If your RP reaches zero, you will start consuming your HP instead to perform actions. This is dangerous, especially in dungeons!
 - **Recovery:** Recovers slowly over time, significantly by sleeping, or by consuming specific foods (especially cooked dishes) or drinks. Some areas (Runeys) also naturally restore RP.
3. **Mini-Map:**
 - **Location:** Top-right or top-left corner.
 - **Purpose:** Shows your immediate surroundings, your character's position, key landmarks (like your farm, the general store), exits to other areas, quest markers, and sometimes nearby NPCs or monsters.
 - **Interaction:** Often expandable to a full-screen map (M on PC, - on Switch).
4. **Quick Slot / Tool Bar:**
 - **Location:** Bottom center of the screen.
 - **Purpose:** Displays the tools and items you have quickly equipped

and can switch between. This is where your farming tools (hoe, watering can, axe), weapons, and often frequently used recovery items reside.
 - **Interaction:** Use number keys (PC) or L/R shoulder buttons (Controller) to cycle through or select items.
5. **Time and Date:**
 - **Location:** Often in the top corner (e.g., top-right).
 - **Purpose:** Displays the current time of day, day of the week, and season. This is critical in *Rune Factory* as:
 - NPC schedules change throughout the day.
 - Shops have opening/closing hours.
 - Festivals occur on specific dates.
 - Crops have seasonal growth cycles.
 - Certain monsters or resources only appear at specific times.
 - **Progression:** Time passes automatically as you play. Sleeping advances time to the next day.
6. **Money / Gold Counter:**
 - **Location:** Typically bottom-right or near the time display.
 - **Purpose:** Shows your current gold amount. Used for buying seeds, tools, upgrades, and gifts.
7. **Buff/Debuff Icons:**
 - **Location:** Usually small icons near your HP/RP bars.
 - **Purpose:** Indicate temporary status effects affecting your character.
 - **Buffs (Positive):** E.g., Increased Attack, Defense Boost, RP Recovery Up.
 - **Debuffs (Negative):** E.g., Poisoned, Paralyzed, Fatigue (reduces RP recovery).
8. **Quest Tracker:**
 - **Location:** Often on the side of the screen (e.g., left or right middle).
 - **Purpose:** Provides a quick summary of your active main story and key side quest objectives, helping you remember what to do next.

3. Interface Navigation and Menu Systems

The menu systems are where you'll manage your inventory, equipment, relationships, and game settings. Learning to navigate them efficiently saves you time and keeps you organized.

A. The Main Menu (Esc / + Button)

This is your central hub for detailed management. Each section provides crucial functionality:

- **Inventory:**
 - **Purpose:** View, equip, use, discard, and organize all the items you've collected.
 - **Key Features:** Different tabs for items (food, materials), weapons, armor, accessories. You can often

sort items. Pay attention to stack limits.

- **Equipment:**
 - **Purpose:** Change your currently equipped weapon, shield (if applicable), headgear, body armor, and accessories.
 - **Key Features:** See stat changes when comparing new gear. Essential for preparing for combat.
- **Skills:**
 - **Purpose:** Track your character's progression in various skills (e.g., Farming, Cooking, Forging, Fighting, Walking). Leveling skills often grants passive bonuses or unlocks new recipes/abilities.
- **Map:**
 - **Purpose:** A detailed map of the current area, town, dungeon floor, or the entire world.
 - **Key Features:** Shows your precise location, important NPCs, shops, fast-travel points, and quest markers. Essential for exploration.
- **Journal / Quests:**
 - **Purpose:** Review your active quests (main story and side quests), read lore entries, and sometimes view tutorials or character bios.
 - **Key Features:** Often provides hints or reminders for objectives.
- **Relationships:**
 - **Purpose:** Monitor your friendship and romance levels with all the townsfolk and potential companions.
 - **Key Features:** Shows individual character profiles, their likes/dislikes (often hinted at), and their current heart/friendship level. Higher levels unlock events and benefits.
- **Crafting / Forging / Cooking (if accessible from main menu):**
 - **Purpose:** Access crafting stations or recipes directly from the menu (sometimes these are dedicated in-world stations).
- **System / Options:**
 - **Purpose:** Adjust game settings (audio volume, music, camera sensitivity, graphics settings), save your game, load a previous save, or return to the title screen.
 - **Saving:** Always remember to save your game frequently, especially before challenging bosses or after significant progress!

B. Dialogue and Interaction Prompts

- **Speaking to NPCs:** When you approach an NPC, an interaction prompt (e.g., "Talk," "A") will appear. Pressing the corresponding button will initiate dialogue.
- **Dialogue Choices:** During conversations, you might sometimes be presented with multiple dialogue options. Your choices can affect NPC relationships, quest progression, or reveal additional lore. Choose carefully!
- **Shop Interfaces:** When interacting with merchants, a shop interface will appear,

allowing you to buy and sell items. Pay attention to pricing and your current gold.
- **Item Use:** When you pick up an item, a prompt might appear to explain what it is. You can use consumable items directly from your inventory or quick slot bar.

4. Essential First Steps for Mastery

1. **Practice Movement:** Simply walk around your starting town. Get a feel for how your character moves and how the camera responds to your input.
2. **Experiment with Interaction:** Talk to every NPC you see! Try interacting with doors, signposts, and sparkling objects to see what happens.
3. **Familiarize with Tools:** Once you receive your initial farming tools, equip each one and try using it on your farm plot to understand its function and RP cost.
4. **Open Menus Repeatedly:** Spend a few minutes just opening and closing the Main Menu and cycling through its tabs. The more you do it, the more natural it will feel.
5. **Check the Map:** Regularly open your map to orient yourself and see where key locations and NPCs are.
6. **Manage RP:** Keep a close eye on your RP bar, especially when farming. Learn which actions cost how much, and practice recovering RP with food or by returning home to sleep.

By taking the time to understand these fundamental controls and interface elements, you'll lay a strong foundation for your success in *Rune Factory: Guardians of Azuma*. The world is vast, but with a solid grasp of the basics, you'll navigate it with confidence!

Choose Your Path: Difficulty Modes and Playstyles

Rune Factory: Guardians of Azuma offers a flexible experience, allowing you to tailor your journey to match your preferences and skill level. Before you fully dive into the rich world, understanding the available difficulty modes and considering your preferred playstyle will significantly enhance your enjoyment. This section will guide you through making these crucial choices.

1. Difficulty Modes: Tailoring the Challenge

The game typically offers a range of difficulty settings that affect various aspects of gameplay, primarily combat and resource management. Choosing the right one ensures you're neither overwhelmed nor unchallenged.

A. Story Mode / Casual

- **Recommended For:**
 - Players new to the *Rune Factory* series or action RPGs in general.
 - Those who prioritize the narrative, farming, social interactions, and crafting over combat challenge.
 - Players seeking a relaxed, low-stress gaming experience.
- **Key Characteristics:**
 - **Combat:** Enemies have significantly reduced HP (Health Points) and deal less damage. Boss battles are more forgiving.
 - **Resource Management:** RP (Rune Point) consumption for farming and crafting might be reduced, or RP/HP recovery rates could be boosted. This allows for

more actions before needing to rest or consume recovery items.
- **Item Drop Rates:** May be more generous, making it easier to acquire necessary materials.
- **Consequences of Defeat:** Penalties for being knocked out in dungeons might be minimal (e.g., losing less money or fewer items).

- **Experience:** This mode is designed to be highly accessible, allowing you to immerse yourself in the world of Azuma without constantly worrying about challenging combat encounters. It's perfect for exploring, experimenting with farm layouts, and building deep relationships with townsfolk at your own pace.

B. Normal Mode / Standard

- **Recommended For:**
 - Players familiar with *Rune Factory* games or action RPGs.
 - Those who enjoy a balanced blend of combat, farming, and social simulation.
 - Players seeking the intended, authentic *Rune Factory* experience.
- **Key Characteristics:**
 - **Combat:** Standard enemy HP and damage. Combat requires thoughtful engagement, proper equipment, and occasional use of recovery items. Bosses present a moderate challenge.
 - **Resource Management:** RP consumption is standard. Efficient RP management through cooked dishes, RP-recovering items, and strategic resting becomes more important.
 - **Item Drop Rates:** Standard drop rates, requiring some grinding for rarer materials.
 - **Consequences of Defeat:** Standard penalties apply, such as losing a portion of your money or some items collected during the dungeon run.
- **Experience:** This mode offers a satisfying progression curve where you feel the impact of your character's growth, gear upgrades, and strategic decisions. It balances the different gameplay pillars, providing both a relaxing farm life and engaging dungeon crawling.

C. Hard Mode / Veteran

- **Recommended For:**
 - Experienced *Rune Factory* veterans or seasoned action RPG players.
 - Players who crave a significant combat challenge and enjoy optimizing every aspect of their character.
 - Those who appreciate a more punishing and strategic gameplay loop.
- **Key Characteristics:**
 - **Combat:** Enemies have vastly increased HP and deal substantially more damage. Bosses become formidable tests of skill, requiring precise dodging, careful ability usage, and optimal gear.

- **Resource Management:** RP consumption may be increased, or recovery rates reduced, making efficient farming and strategic use of every RP point crucial. Recovery items become more valuable.
- **Item Drop Rates:** Might be slightly lower, increasing the grind for high-end materials.
- **Consequences of Defeat:** Penalties for being knocked out can be more severe, potentially leading to greater losses of money or valuable items.

- **Experience:** This mode demands mastery of combat mechanics, in-depth knowledge of crafting and monster taming, and meticulous planning. Every dungeon dive is a calculated risk, and every boss defeat is a hard-earned victory. It's for players who want to push their limits.

D. Post-Game Difficulties (Potential)

- Many *Rune Factory* titles introduce even harder difficulties (e.g., "Hell Mode," "Chaos Mode") that unlock after completing the main story. These are designed for ultimate endgame challenges, New Game+, and maximizing character builds. Don't worry about these for your initial playthrough, but be aware they offer continued replayability.

Recommendation: For your first playthrough, if you're new to the series, **Story Mode** is a safe and enjoyable starting point. If you like a balanced challenge, **Normal Mode** is ideal. You can often change the difficulty in the Options menu later if you find your initial choice isn't quite right.

2. Choosing Your Playstyle: Your Azuman Identity

Rune Factory: Guardians of Azuma integrates multiple gameplay elements, allowing you to focus on what you enjoy most. While the game encourages a balanced approach, understanding these archetypes can help you define your journey.

A. The Master Farmer

- **Focus:** Dedicating most of your time and resources to cultivating your farm.
- **Activities:**
 - Clearing vast plots of land.
 - Researching seasonal crop guides and optimal planting patterns.
 - Upgrading farming tools (hoe, watering can, sickle, axe, hammer) for efficiency.
 - Mastering soil quality, fertilizer usage, and rune/shine point generation.
 - Building and managing monster barns for monster helpers.
- **Motivation:** To achieve maximum crop yields, grow rare produce, make significant profits, and enjoy the calming rhythm of farm life. Combat is primarily for clearing land, collecting monster products, or advancing the plot just enough to unlock new farm mechanics.
- **Tips:** Prioritize crafting farming tools, invest in seeds, and cook dishes that restore RP to sustain longer farming sessions. Befriend monsters that can help with farm chores.

B. The Dauntless Adventurer

- **Focus:** Exploring every dungeon, battling powerful monsters, and uncovering the world's secrets.
- **Activities:**
 - Spending extended periods in dungeons, pushing deeper into dangerous territories.
 - Honing combat skills, learning enemy attack patterns, and mastering weapon types.
 - Searching for rare materials, boss drops, and hidden passages.
 - Taming a diverse roster of monster companions for combat prowess.
 - Challenging formidable bosses.
- **Motivation:** To become the strongest warrior, discover ancient artifacts, and unravel the mysteries of Azuma. Farming is a secondary activity, used mainly for generating income for better gear or cultivating specific ingredients needed for combat buffs.
- **Tips:** Focus on crafting and upgrading weapons/armor, learn monster weaknesses, and cook dishes that restore HP and grant combat buffs. Prioritize skills like weapon proficiencies and combat magic.

C. The Master Crafter / Artisan

- **Focus:** Specializing in forging weapons, armor, accessories, and brewing potent medicines.
- **Activities:**
 - Extensive material gathering from both farming and dungeons.
 - Grinding crafting skills (Forging, Chemistry, Cooking) to unlock new recipes.
 - Experimenting with different ingredients and recipes to create powerful gear with unique properties.
 - Selling high-quality crafted items for substantial profit.
- **Motivation:** To create the best possible equipment for yourself and others, becoming a pillar of the community's economy and strength.
- **Tips:** Dedicate significant time to mining and monster hunting for raw materials. Keep an eye on ingredient lists for valuable recipes. Invest in crafting stations and upgrade your workshop.

D. The Social Butterfly / Town Charmer

- **Focus:** Building deep relationships with every villager, participating in festivals, and experiencing all social events.
- **Activities:**
 - Talking to all NPCs daily.
 - Giving gifts tailored to individual preferences.
 - Completing villagers' requests and side quests.
 - Actively participating in every festival and town event.
 - Pursuing romantic relationships and eventually marriage.
- **Motivation:** To unlock all character events, witness charming storylines, and experience the vibrant community life of Azuma. The strength of your relationships

often unlocks unique rewards, shops, or even combat assistance.

- **Tips:** Carry a variety of gifts. Pay attention to dialogue for clues about likes and dislikes. Check the request board daily. Remember birthdays! Farming and adventuring are means to gather gifts and fulfill requests.

E. The Balanced Guardian (Recommended)

- **Focus:** Engaging with all aspects of the game in harmony.
- **Activities:**
 - Dividing your time efficiently between farming chores, dungeon exploration, crafting sessions, and social interactions.
 - Using farm profits to fund adventure gear, and dungeon spoils to create better tools for farming.
 - Befriending townsfolk to gain access to new items or information, while also taming monsters for both farm work and combat.
- **Motivation:** To experience everything *Rune Factory: Guardians of Azuma* has to offer, maximizing progression across all systems.
- **Tips:** This is the most rewarding playstyle for most players. Learn time management, create daily routines that incorporate different activities, and adapt your focus based on current quest objectives or seasonal events.

Rune Factory: Guardians of Azuma truly shines when you engage with its diverse systems. While you might naturally gravitate towards one playstyle, don't be afraid to dabble in others. The game is designed so that each activity complements the others, enriching your overall experience in the beautiful land of Azuma. Choose your path, and let your unique adventure begin!

The Hero of Azuma: Character Creation & World Introduction

Your journey in *Rune Factory: Guardians of Azuma* officially begins when you step into the shoes of your own custom-made hero. This pivotal first chapter concludes by empowering you to design your protagonist and then immerses you into the vibrant, magical world of Azuma. This section will guide you through the character creation process and prepare you for the narrative that unfolds.

1. Character Creation: Forging Your Legend

Before you can save Azuma, you must first define yourself. The character creation suite allows you to personalize your protagonist, making your adventure truly your own.

A. Gender Selection

- **Your First Choice:** The very first decision you'll likely make is to choose your character's gender: **Male** or **Female**.
- **Impact on Gameplay:**
 - **Romance Options:** This is typically the most significant impact. Your chosen gender will determine which bachelor(s) or bachelorette(s) you can pursue for marriage. *Rune Factory* games traditionally feature gender-locked romance options, though some

modern titles are exploring more inclusive approaches.
- **Dialogue/Pronouns:** NPCs will refer to you using appropriate pronouns.
- **No Major Mechanical Differences:** Generally, character gender does not affect combat stats, farming abilities, or skill progression. Both male and female protagonists are equally capable of being the "Hero of Azuma."
- **Choosing Wisely:** Consider who you might want to romance if that's a key part of your experience. Otherwise, simply pick the gender that appeals to you most for your protagonist.

B. Appearance Customization

Once your gender is chosen, you'll delve into customizing your hero's aesthetic. While *Rune Factory* games aren't known for hyper-realistic character creators, they offer enough options to make your character feel unique.

- **Hair:**
 - **Hairstyles:** A selection of pre-set hairstyles, ranging from short and practical to long and flowing, perhaps with some traditional Azuman flair.
 - **Hair Colors:** A palette of natural and perhaps some vibrant fantasy colors. Experiment to find a hue that matches your hero's personality.
- **Eyes:**
 - **Eye Shapes:** Different styles to convey various expressions (e.g., sharp, gentle, inquisitive).
 - **Eye Colors:** A range of colors, from common browns and blues to more exotic purples or reds, hinting at a touch of magic.
- **Skin Tone:** A slider or selection of tones to choose your character's complexion.
- **Voice (Limited):** You may have a few voice samples to choose from for your character's grunts, shouts in combat, or brief affirmations. While the protagonist usually doesn't have extensive voiced dialogue, this adds a subtle layer of personality.
- **Starting Outfit:** You might have a choice between a few initial outfits. These are usually simple, default clothes, but serve to give your character a basic look. More elaborate outfits will be acquired or crafted later in the game.
- **Pro-Tip: Don't Stress Too Much!** While initial character creation is fun, *Rune Factory* games often provide ways to change your hairstyle, hair color, and outfits later in the game. You might unlock a salon, dyes, or new clothing patterns as you progress, allowing you to refresh your look whenever you desire.

C. Naming Your Hero

- **Your Identity:** This is arguably the most personal part of character creation. Choose a name that you'll be happy to see

associated with your protagonist throughout your entire adventure.
- **Length Limits:** Be aware of any character limits for your name.
- **Consider Lore (Optional):** If you're invested in the setting, you might consider a name that feels appropriate for the eastern-inspired land of Azuma, though any name you like is perfectly acceptable.

D. Naming Your Farm (If Applicable)

- Many *Rune Factory* games allow you to name your farm, making your home base even more personal. If prompted, pick a name that reflects your ambition, your style, or simply something you find pleasant (e.g., "Sunrise Farm," "Dragon's Roost Ranch," "Serenity Acre").

2. World Introduction: Stepping into Azuma

Once your hero is forged and named, the game will seamlessly transition into its opening sequence. This is your initial glimpse into the rich narrative and unique setting of *Rune Factory: Guardians of Azuma*.

A. Setting the Scene: The Eastern Land of Azuma

- **A Unique Backdrop:** Unlike previous *Rune Factory* titles that often featured more traditional fantasy settings, *Guardians of Azuma* places you in an **eastern-inspired nation**. Expect:
 - **Aesthetics:** Traditional Azuman architecture, vibrant natural landscapes reminiscent of East Asian aesthetics, and distinct cultural practices.
 - **Flora & Fauna:** Unique crops, native plants, and a variety of monsters that fit the eastern theme (e.g., mythical creatures inspired by folklore).
 - **Music & Atmosphere:** A distinct soundtrack that evokes the serene yet adventurous spirit of Azuma.
- **Cultural Blend:** The *Rune Factory* series is known for blending farming and fantasy. Azuma will likely continue this tradition, incorporating mystical elements and magic within its distinct cultural context.

B. The Protagonist's Mysterious Beginning (A Common *Rune Factory* Trope)

- **Amnesia:** A recurring theme in *Rune Factory* games is the protagonist waking up with **amnesia**. This serves as a brilliant narrative device for several reasons:
 - **Shared Discovery:** You, the player, learn about the world, its lore, and its inhabitants alongside your character, creating a strong sense of immersion.
 - **Clean Slate:** It allows the character to be anyone and embark on any path, free from a predetermined past.
- **Arrival in a New Place:** Your character will likely awaken or arrive, seemingly by chance, in a welcoming but initially small town or village. This location will become your home base for the majority of the game.

- **Immediate Needs:** Despite the amnesia, your character often retains basic skills and a strong desire to help others, setting the stage for early quests.

C. The Premise: Guardians, Mysteries, and Destiny

The title, *Rune Factory: Guardians of Azuma*, provides a strong hint at the core premise of your adventure.

- **Guardianship:** You are likely to become, or are destined to be, one of the "Guardians" responsible for protecting Azuma. This could involve:
 - **Balancing Nature:** Maintaining the delicate balance of the land's "Runes" (the magical energy that sustains life and crops).
 - **Fending Off Threats:** Protecting Azuma from encroaching monsters, ancient evils, or environmental imbalances.
 - **Upholding Tradition:** Potentially being chosen or growing into a role that upholds ancient traditions or defends sacred sites.
- **Unraveling Mysteries:** As a *Rune Factory* protagonist, you'll be drawn into a larger overarching narrative that involves:
 - **The Land Itself:** Discovering why monsters are appearing, what threatens Azuma, or why the Runes might be faltering.
 - **Your Own Past:** Piecing together fragments of your memory to understand who you are and why you ended up in Azuma.
 - **Ancient Lore:** Uncovering secrets about Azuma's history, its legendary figures, and powerful artifacts.

D. Your Initial Role and the Core Loop

- **The Farm as Your Foundation:** Almost immediately, you will be granted or find an abandoned farm plot. This is not just a side activity; it's central to your survival and progression.
 - **Self-Sufficiency:** Growing crops provides food to restore HP/RP and sell for income.
 - **Community Integration:** Your farming efforts will quickly tie you into the local economy and community life.
- **The Call to Adventure:** While farming provides stability, the narrative will soon propel you into dungeons and combat.
 - **Resource Gathering:** You'll need materials from dungeons for crafting better tools and equipment.
 - **Monster Taming:** Dungeons are where you'll encounter monsters to tame and bring back to your farm or accompany you in battle.
 - **Story Progression:** Advancing the main plot often requires exploring dangerous areas and defeating powerful foes.
- **Building Bonds:** The townsfolk are integral to your experience.
 - **Quest Givers:** Many side quests and opportunities come from villagers.

- **Shopkeepers:** They provide essential goods and services.
- **Friends & Lovers:** Building relationships unlocks unique events, dialogue, and eventually, the option to marry and start a family.

Embrace your new identity as the hero of Azuma. The stage is set for a truly unforgettable adventure, blending the calming rhythm of farm life with the thrill of discovery and the destiny of a guardian!

Chapter 2

WALKTHROUGH PART I – The Awakening and Early Trials

This chapter kicks off your adventure in Azuma, guiding you through your initial steps. You'll complete **early quests and tutorials** to learn the ropes of farming and combat. Get ready to **explore the Verdant Hills**, **meet important characters**, and **set up your very own farm**. The journey truly begins as you face your **first boss battle** and venture into your **first dungeon**.

Early Quests and Tutorials

Congratulations, Guardian! Having created your hero and glimpsed the world of Azuma, your adventure truly begins with a series of foundational quests and tutorials. These initial steps are designed to gently introduce you to the core mechanics of *Rune Factory: Guardians of Azuma*, ensuring you build a solid understanding of farming, combat, and social interactions. Pay close attention, as mastering these basics will pave the way for all your future successes.

1. The Awakening: Your First Moments and First Friend

Your journey typically begins with your character awakening, often with a touch of amnesia, in or near the starting town. Your very first objective will almost always be to meet a key NPC who serves as your initial guide.

- **Quest Trigger:** Usually automatic upon gaining control of your character.
- **Objective:** Find and speak to the designated introductory NPC. This character (often the local mayor, a friendly villager, or a helpful spirit) will likely discover you and offer assistance.
- **Tutorials Introduced:**
 - **Movement:** The game will prompt you on how to move your character (WASD / Left Analog Stick) and potentially how to sprint (Shift / L3).
 - **Camera Control:** Learn to adjust your camera view (Mouse Movement / Right Analog Stick).
 - **Interaction:** How to talk to NPCs (LMB / A button) and interact with basic objects (e.g., doors, signs).
- **Key NPC:** Expect to meet someone pivotal, like **Elder Hana** (the wise village elder), **Farmer Ren** (a seasoned local farmer), or **Shopkeeper Kiko** (the friendly general store owner). This individual will explain your current situation and offer you a place to stay.
- **Reward/Unlock:** Access to your first residence (likely a small house with an attached farm plot) and the promise of a fresh start.

2. Establishing Your Homestead: The Farming Basics

Soon after finding your new home, you'll be guided through the fundamental aspects of farming – the heart of any *Rune Factory* game. This is usually presented as your second main quest line.

- **Quest Trigger:** Speak to the initial guiding NPC after settling into your house. They will likely point you towards your overgrown farm.
- **Objectives:**
 1. **Clear the Land:** You'll be given basic tools (Axe, Hammer). The quest will require you to clear debris like weeds, rocks, and stumps from a small section of your farm plot.
 - **Tutorials Introduced:** How to equip and use tools (LMB / A button). Understanding **RP (Rune Point)** consumption for each tool swing.
 - **Tip:** Focus on clearing a 3x3 or 5x5 patch initially. Don't try to clear the entire farm at once, as it consumes a lot of RP and time.
 2. **Till the Soil:** Obtain a **Hoe**. Use it to till the cleared land, turning it into plantable squares.
 - **Tutorials Introduced:** The function of the hoe, and again, RP management.
 3. **Plant Seeds:** You'll be given a small handful of basic seeds (e.g., Turnip Seeds, Cabbage Seeds). Plant them in your tilled soil.
 - **Tutorials Introduced:** How to select seeds from your inventory/quick slot, and how to plant them.
 4. **Water Crops:** Obtain a **Watering Can**. Water your newly planted seeds daily.
 - **Tutorials Introduced:** How to use the watering can. The importance of daily watering for crop growth.
 - **Tip:** Water each square once per day.
- **Key NPC:** The same guiding NPC, or perhaps a dedicated farming mentor, will oversee these tasks.
- **Reward/Unlock:** A basic understanding of farming, a few valuable starting crops in progress, and possibly some small gold or extra seeds.

3. Community Connections: The First Errands

As your crops begin to grow, your guide will encourage you to explore the town and meet its residents. These quests typically serve as introductions to other key NPCs and services.

- **Quest Trigger:** Complete the initial farming tutorial.
- **Objectives:**
 1. **Meet X number of Villagers:** Simply talk to several named NPCs around town.
 - **Tutorials Introduced:** The importance of talking to NPCs daily (builds friendship), and contextual dialogue options.

2. **Visit Key Shops:** You'll be directed to the General Store, Clinic, and possibly the Forge/Blacksmith.
 - **Tutorials Introduced:** How to buy and sell items. Understanding shop hours (most shops are closed at night).
 - **Key NPC: Kiko** (General Store), **Doctor Leo** (Clinic), **Blacksmith Goro** (Forge). These NPCs are crucial for purchasing seeds, healing, and upgrading tools/weapons.
3. **Complete a Simple Request:** Often, one of the townsfolk will have a very easy request on the Request Board (located somewhere central, like outside the General Store or Town Hall). This might involve delivering an item or fetching something nearby.
 - **Tutorials Introduced:** How to accept and complete requests from the Request Board. Understanding the benefits (rewards, friendship points).

- **Reward/Unlock:** Initial friendship points with townsfolk, access to vital shops and services, and a sense of belonging in the community. You'll also earn your first few gold coins from request rewards.

4. Basic Combat Training: Facing Your First Foes

While farming is crucial, *Rune Factory* is also an action RPG. Your first foray into combat will likely involve clearing a nearby area of weak monsters.

- **Quest Trigger:** Often given by your guiding NPC or an adventuring guild representative after you've made some progress with farming and town interaction.
- **Objectives:**
 1. **Obtain a Weapon:** You'll likely be given a basic sword or staff, or directed to craft one.
 - **Tutorials Introduced:** How to equip weapons.
 2. **Enter a Safe Zone/Mini-Dungeon:** You'll be directed to a small, low-threat area just outside town, often a forest path or a cave entrance.
 - **Tutorials Introduced:** How to attack (LMB / A button), use charged attacks (RMB / Y button), and potentially guard/dodge. Understanding HP (Health Points) and its depletion.
 3. **Defeat X number of Weak Monsters:** Simple slimes, woolies, or small insects will be your first targets.
 - **Tutorials Introduced:** Basic combat strategy, targeting.

4. **Gather Materials:** Monsters often drop items. The quest might require you to collect a specific number of items.
 - **Tutorials Introduced:** How to pick up dropped items.
- **Key NPC:** Often an adventurer-type NPC like **Grizz** (a burly warrior) or a town guard.
- **Reward/Unlock:** Basic combat proficiency, a small amount of combat experience, and early monster drops which can be sold or used for basic crafting.

5. Managing Your Resources: Rest and Recovery

Throughout these early tutorials, the game will subtly (or explicitly) teach you about managing your two vital bars: HP and RP.

- **Tutorials Introduced:**
 - **Sleeping:** The most effective way to restore all HP and RP and advance time to the next day. The game will likely suggest you go to bed when your RP is low.
 - **Eating:** Consuming food from your inventory restores HP and/or RP. Early on, this will primarily be wild grasses or simple cooked dishes.
 - **Baths:** The public bathhouse (if available early) offers a temporary RP/HP restoration for a small fee.
- **Tip:** Don't let your RP drop to zero unless absolutely necessary, as subsequent actions will drain your precious HP. Always prioritize sleeping if your RP is low and you're done for the day.

Early Game Success Tips:

- **Talk to Everyone, Every Day:** This is paramount in *Rune Factory*. It builds friendship, unlocks new dialogue, and often triggers character-specific events or requests.
- **Check the Request Board Regularly:** Early requests are easy gold, items, and friendship points. They are a great way to learn about the town and its needs.
- **Prioritize Farm Expansion (Slowly):** Clear a small, manageable section of your farm first. As you gain more RP and better tools, gradually expand.
- **Sell What You Don't Need (Initially):** Early crops and common monster drops are your primary source of income. Sell them at the General Store.
- **Save Frequently:** Utilize the save points (often your bed) or the menu save option. Losing progress due to an unexpected defeat is frustrating.
- **Don't Rush Dungeons:** Your primary focus should be the town and farm in the very early game. Dungeon delving will become more important as you gain strength and better gear.
- **Read the Tutorial Prompts:** Don't skip the on-screen tutorial messages! They contain vital information on how to play.

By diligently following these early quests and familiarizing yourself with the tutorial prompts, you'll build a strong foundation for your epic journey in *Rune Factory: Guardians of Azuma*. Get ready to plant, fight, and connect!

Exploring the First Region: Verdant Hills

With your initial tasks complete and a basic understanding of your tools, the gates to the outside world beckon. The "Verdant Hills" will likely be your first major outdoor region beyond the immediate confines of your starting town. This area serves as a vital resource hub, an introductory combat zone, and a stepping stone to the wider world of Azuma. Learning to navigate and utilize it effectively is crucial for your early-game progression.

1. Layout and Geography of Verdant Hills

The Verdant Hills are typically designed as a relatively safe, interconnected series of outdoor zones, leading from your town to your first proper dungeon.

- **Gentle Paths and Trails:** Expect winding dirt paths, grassy clearings, and perhaps gentle slopes. These paths are designed to guide you.
- **Branching Routes:** While linear initially, the Verdant Hills will feature several branching paths. Some might lead to dead ends with unique resources, others to small, isolated clearings, and one will eventually lead to the next major story area or dungeon.
- **Transition Zones:** You'll notice distinct changes in scenery as you move from the immediate town outskirts further into the hills, indicating new sub-zones. These transition zones often have loading screens or seamless transitions.
- **Natural Obstacles:** Minor obstacles like shallow rivers (often with bridges), clusters of trees, or small rocky outcrops will shape the landscape, but won't impede progress significantly.
- **Mapping:** Regularly open your full map (M on PC, - on Switch) as you explore. New areas you discover will populate the map, helping you keep track of where you've been and identify unexplored paths. Pay attention to the icons for resources, monsters, and exits.

2. Resources for the Budding Guardian

The Verdant Hills are a treasure trove of early-game resources, essential for farming, crafting, and earning gold.

A. Foraging (Wild Items)

- **Location:** Found scattered randomly on the ground, often near trees, water bodies, or simply in open grassy patches. They respawn daily.
- **Common Items:**
 - **Weeds:** Often seem useless, but can be sold for a tiny amount of gold, used as basic fertilizer, or given as a universally disliked gift (though don't do this often!).
 - **Wild Grasses:** Often colored (e.g., Green Grass, Yellow Grass). These are your earliest and most common source of RP/HP recovery when eaten raw. They are also essential ingredients for basic medicines at the Clinic.
 - **Mushrooms:** Various types may appear. Some can be eaten raw, others are ingredients for cooking.

- **Berries/Wild Fruits:** Often found on bushes or small plants. Good for raw consumption or cooking.
- **Flowers:** Sometimes appear. Can be sold, used as simple gifts, or occasionally crafted into accessories.

- **Tip:** Always pick up every forageable item you see. Even seemingly useless items have a purpose later, and they are free money or basic sustenance.

B. Woodcutting (Logs)

- **Tool:** Axe
- **Location:** Trees of various sizes.
- **Resource: Wood** (or Lumber). This is a critical material for upgrading your house, building monster barns, crafting furniture, and expanding your farm facilities.
- **Process:** Equip your Axe, target a tree, and swing (LMB / A button). Larger trees may require multiple swings or a more powerful (charged) axe, consuming more RP.
- **Tip:** Prioritize upgrading your Axe early. A better axe consumes less RP per swing and can chop down larger trees, giving you more wood per day.

C. Mining (Stones & Ores)

- **Tool:** Hammer
- **Location:** Rock formations, small boulders, or sparkling ore veins embedded in cliffsides or cave entrances.
- **Resources:**
 - **Small Rocks/Stones:** Found by smashing small boulders. Useful for basic crafting.
 - **Material Stone:** A more common material found by smashing larger rocks. Used for building structures.
 - **Scrap Iron / Iron:** Your first basic ore. Essential for crafting basic tools and weapons at the Forge.
 - **Copper / Silver:** May appear rarely in the later sections of the Verdant Hills, or from stronger mining nodes.
- **Process:** Equip your Hammer, target a rock/ore, and swing (LMB / A button). Some nodes might require multiple hits or a charged hammer.
- **Tip:** Mining nodes often appear in the same locations daily, or after a few days. Learn where they are to maximize your daily haul. Like the axe, upgrading your Hammer will save you RP and allow you to break tougher rocks.

3. Early Game Monsters and Basic Combat

The Verdant Hills are home to Azuma's weakest monsters. They serve as your first combat training ground and a source of monster drops.

- **Common Monsters (Examples):**
 - **Woolies:** Often resemble walking sheep or goats. They typically drop **Wooly Furball** or **Small Fleece**, used for crafting fabric or simple gifts. They are docile until attacked.
 - **Slimes:** Simple blobs of various colors. They might drop **Slime Liquid** or **Spores**, used in basic chemistry or crafting. Often slow-moving.

- - **Ants/Bees:** Small, fast-moving insects. May drop **Insect Jaw** or **Honey**.
 - **Goblin/Orc Variants:** Bipedal, often with simple weapons. They might drop **Claws**, **Fangs**, or very basic **Scrap Metal**.
- **Combat Strategy:**
 - **Basic Attacks:** Use your equipped weapon (LMB / A button) to chain basic attacks.
 - **Charged Attacks:** Hold RMB / Y button for a stronger, often area-of-effect, attack. Use sparingly due to higher RP cost.
 - **Dodging/Guarding:** Learn to dodge (B button / designated key) or guard (RMB / designated key) against incoming attacks to minimize damage.
 - **HP & RP Management:** Keep an eye on your HP bar. If it gets low, use a Wild Grass or potion. If your RP gets low, your attacks will start consuming HP instead, so consider retreating or using an RP-restoring item.
 - **Monster Farming:** Defeat monsters repeatedly to collect their drops. These are crucial for crafting and fulfilling requests.
- **Tip:** Engage enemies one at a time when possible. If you find yourself overwhelmed, retreat to a safe zone or back to town to heal and rest. Don't be afraid to run away if your HP is low!

4. Points of Interest and Hidden Areas

As you explore, keep an eye out for specific landmarks and potential secrets.

- **Fishing Spots:** Look for sparkling areas in rivers, ponds, or lakes. These indicate fishing spots. You'll need a **Fishing Rod** (often obtained from a quest or purchase) to use them.
- **Harvestable Forage Nodes:** Sometimes, specific plants or bushes will yield more consistent or rarer forageables. Learn to recognize them.
- **Hidden Paths:** Occasionally, a dense thicket or a seemingly solid wall might hide a narrow path or a small cave leading to a secluded area with rare resources or stronger monsters.
- **Exit to First Dungeon:** The most important point of interest in the Verdant Hills is the exit to your first proper dungeon. This will usually be a more imposing cave entrance, an ancient ruin, or a distinct gate. The main story quest will guide you here eventually.
- **Runey/Glittering Spots:** Keep an eye out for glowing spots on the ground. These are "Runes" or "Glittering Spots" that, when picked up, instantly restore a small amount of your RP. They are invaluable for extending your exploration time.

5. Efficient Exploration Tips

- **Go Out Daily (Early Morning):** Maximize your day by heading out in the early morning. Resources respawn daily, and you have the most time to collect them before shops close or your RP runs low.

- **Carry Essential Tools:** Always have your Axe, Hammer, and a Weapon equipped or easily accessible in your quick slots.
- **Bring Recovery Items:** Stock up on Wild Grasses or simple cooked dishes (once you unlock cooking) to manage your HP and RP while exploring.
- **Don't Overextend:** Especially early on, your RP pool is small. Plan your trips. If your RP is low, head back to your farm to sleep, or use recovery items. Don't push yourself to the point of HP draining.
- **Know Your Limits:** If monsters are too strong, retreat and upgrade your gear or level up before trying again.
- **Empty Your Inventory Regularly:** Your backpack space is limited. Return to your farm to store materials in your storage box or sell excess items in town. Don't leave valuable drops behind because your inventory is full.
- **Listen to Environmental Cues:** Pay attention to sound cues. Sometimes a specific monster or a glittering spot will have a distinct sound.

By understanding the layout, resources, and dangers of the Verdant Hills, you'll transform this starting region into your personal supply chain and combat training ground, setting the stage for all the greater adventures that lie ahead in Azuma.

Meeting Key NPCs and Establishing Your Farm

With your initial tasks completed, it's time to delve deeper into the heart of *Rune Factory: Guardians of Azuma*: building relationships with the townsfolk and truly making your farm your own. These two aspects are intertwined, as the bonds you forge will directly impact your farming endeavors, and your farm will, in turn, influence your interactions with the community.

1. Key NPCs: Your First Friends and Mentors

The starting town is populated with a cast of characters who will become essential to your success. Building strong relationships with them unlocks new opportunities, quests, and even romantic possibilities.

A. Initial Guiding NPC (Elder Hana, Farmer Ren, etc.)

- **Role:** This character is your first contact in Azuma. They likely found you after your arrival (and amnesia) and offered you a place to stay.
- **Services:** Provides initial guidance on farming, town life, and basic quests.
- **Relationship Benefits:** Early friendship unlocks additional tutorials, items, or access to new areas.
- **Tip:** Talk to them daily and complete their early requests. They are your gateway to understanding the world.

B. The General Store Owner (Shopkeeper Kiko)

- **Role:** Runs the town's general store, your primary source for seeds, basic tools, food, and other essential supplies.
- **Services:** Buying and selling items. The store's inventory expands as you progress.
- **Relationship Benefits:** Higher friendship unlocks new items for sale, discounts, or even special quests.

- **Tip:** Visit the store daily to check for new stock. Buy seeds in bulk to save money.

C. The Clinic Doctor (Doctor Leo)

- **Role:** Runs the town's clinic, where you can heal from injuries or purchase medicine.
- **Services:** Healing (for a fee), selling healing potions and RP recovery items.
- **Relationship Benefits:** Higher friendship might unlock discounts on healing or new medicine recipes.
- **Tip:** Keep some healing potions on hand for dungeon exploration.

D. The Blacksmith (Blacksmith Goro)

- **Role:** The town's blacksmith, responsible for crafting and upgrading weapons, armor, and tools.
- **Services:** Crafting new equipment, upgrading existing equipment (for a fee and materials).
- **Relationship Benefits:** Higher friendship unlocks access to better crafting recipes and potentially discounts.
- **Tip:** Prioritize upgrading your farming tools first for more efficient farming.

E. The Innkeeper (Innkeeper Aki)

- **Role:** Runs the town's inn, providing a place to rest and recover HP/RP.
- **Services:** Sleeping (fully restores HP/RP), potentially selling basic meals.
- **Relationship Benefits:** Higher friendship might unlock special meals or discounts.
- **Tip:** Sleeping at the inn is a good alternative to going home if you're far from your farm.

F. Other Villagers

- **Role:** Each villager has their own personality, schedule, and story. Building relationships with them unlocks events, quests, and even romantic possibilities.
- **Tip:** Talk to everyone daily, give gifts they like, and complete their requests.

2. Establishing Your Farm: From Overgrown Patch to Thriving Homestead

Your farm is the heart of your *Rune Factory* experience. Nurturing it is essential for your survival, your income, and your connection to the community.

A. Clearing and Tilling Your Land

- **Initial State:** Your farm will likely start as an overgrown patch of land, littered with weeds, rocks, and tree stumps.
- **Tools:**
 1. **Axe:** Used to chop down trees and stumps.
 2. **Hammer:** Used to break rocks and boulders.
 3. **Hoe:** Used to till the cleared land into plantable squares.
- **Process:**
 1. Equip the appropriate tool.
 2. Target the obstacle.
 3. Swing/smash (LMB / A button). Larger obstacles may require multiple hits or a charged attack (RMB / Y button).
 4. Till the cleared land with the hoe.
- **Tip:** Start by clearing a small, manageable section (e.g., a 5x5 or 7x7 plot). Don't try to

clear the entire farm at once, as it consumes a lot of RP.

B. Planting and Watering Crops

- **Seeds:** Purchased from the General Store. Different seeds grow into different crops.
- **Process:**
 1. Select seeds from your inventory/quick slot.
 2. Target a tilled square.
 3. Plant (LMB / A button).
 4. Equip the Watering Can.
 5. Water each planted square daily.
- **Tip:** Different crops have different growth times. Check the seed descriptions for details.

C. Harvesting and Shipping

- **Harvesting:** Once a crop is fully grown, it will be visibly mature. Simply interact with it to harvest.
- **Shipping:** Place harvested crops in the **Shipping Box** (usually located near your house). The contents of the box are automatically sold at the end of each day, giving you income.
- **Tip:** Ship your crops daily to earn money.

D. Expanding and Upgrading Your Farm

- **Expanding:** Clear more land as you gain more RP and better tools.
- **Upgrading:** You'll eventually be able to upgrade your house, build monster barns, and construct other farm facilities.
- **Materials:** Wood and Stone (obtained by chopping trees and breaking rocks) are essential for upgrades.
- **Tip:** Prioritize upgrading your house to unlock more storage space and crafting options.

E. Monster Barns

- **Purpose:** Allows you to keep tamed monsters on your farm. They can assist with farm chores or provide valuable resources.
- **Construction:** Requires materials and often a specific quest.
- **Tip:** Befriend monsters that can help with planting, watering, or harvesting.

3. Building Relationships: Gifts, Requests, and Festivals

Your interactions with the townsfolk are crucial for unlocking new content and deepening your connection to Azuma.

A. Talking Daily

- **Importance:** Simply talking to NPCs daily increases their friendship level.
- **Tip:** Make it a part of your daily routine to greet everyone.

B. Giving Gifts

- **Likes and Dislikes:** Each NPC has preferences. Giving them a liked item greatly increases friendship. Giving them a disliked item decreases it.
- **Tip:** Pay attention to dialogue hints about their preferences. Experiment with different items.

C. Completing Requests

- **Request Board:** A central board in town where villagers post requests for items, deliveries, or monster slaying.
- **Rewards:** Gold, items, and a significant boost to friendship with the request giver.
- **Tip:** Complete requests as often as possible.

D. Festivals

- **Purpose:** Special events that occur on specific days of the year. They offer unique activities, rewards, and opportunities to interact with the community.
- **Tip:** Participate in every festival!

By actively engaging with the townsfolk and diligently tending to your farm, you'll not only thrive in Azuma but also create a vibrant and fulfilling life for your hero.

First Boss Battle and Dungeon Exploration

Having settled into your farm and connected with the townsfolk, the time has come to embrace the "Rune Factory" side of your adventure: delving into dungeons and facing formidable foes. Your first true dungeon experience will likely be presented as a pivotal story quest, leading you to your first major combat challenge – a boss battle. This section will prepare you for the dangers and rewards that lie ahead.

1. Locating and Entering Your First Dungeon

Your initial guiding NPC, or a quest giver related to Azuma's mysteries, will direct you towards the first significant dungeon.

- **Location:** This dungeon is typically found at the furthest accessible point of the "Verdant Hills" region you've been exploring. Look for a prominent landmark like a large cave entrance, an ancient ruin's gateway, or a mystical forest clearing.
- **Story Trigger:** You'll likely need to progress the main story quest to a certain point before the path to this dungeon is fully open or the boss becomes available.
- **Preparation Check:** Before stepping inside, ensure you've completed the earlier tutorials and have a basic understanding of your controls, combat, and resource management.

2. General Dungeon Mechanics: What to Expect Inside

Your first dungeon serves as a comprehensive introduction to exploration, resource management under pressure, and combat in a hostile environment.

- **Layout:**
 - **Linear Progression:** Early dungeons are usually quite linear, with clear paths guiding you forward. However, expect a few branching dead-ends that might hide extra resources or tougher enemies.
 - **Multiple Floors/Sections:** Dungeons are often divided into several floors or distinct sections, usually separated by a loading screen or a distinct transition (e.g., a staircase, a deep chasm).
 - **Mini-Boss/Gatekeeper:** Some sections might have a slightly

tougher "mini-boss" that acts as a gatekeeper before a new area.
- **Enemies:** You'll encounter more numerous and slightly stronger versions of the monsters you've met in the Verdant Hills, along with some new, more aggressive types.
- **Resources:**
 - **Mining Nodes:** Look for rock formations or glowing ore veins, often along walls or in small alcoves. These provide **Material Stone**, **Scrap Iron**, and potentially rarer ores like **Iron** or **Copper**. Always bring your **Hammer**!
 - **Foraging Spots:** Certain plants or crystals might drop unique dungeon-specific forageables.
 - **Monster Drops:** Defeated monsters will drop various materials unique to the dungeon, essential for crafting and requests.
- **Traps & Environmental Hazards:** Be mindful of simple traps like pressure plates that trigger spikes, falling rocks, or poisoned puddles. Observe patterns and timing to avoid them.
- **Save Points:** Look for specific glowing pedestals or crystals. Interacting with these allows you to save your game mid-dungeon. *Crucial for extended delves!*
- **Teleport Runes (Return Spell):** You will likely learn a "Return" spell or acquire an item that allows you to instantly warp back to the dungeon entrance or your home. This is invaluable for when your HP/RP runs low.

3. Early Dungeon Enemies and Combat Strategies

The monsters in your first dungeon will test your basic combat skills. Learn their patterns and weaknesses.

- **Expanded Monster Roster:** Beyond your typical Woolies and Slimes, expect to encounter:
 - **Horned Goblins:** More aggressive melee attackers.
 - **Fairy/Ghost variants:** May have ranged attacks or unique movement patterns.
 - **Giant Insects:** Faster and more agile.
- **Effective Combat:**
 - **Target One Enemy:** Avoid getting surrounded. Focus your attacks on one enemy at a time.
 - **Observe Patterns:** Most enemies have predictable attack patterns. Learn when to dodge or guard.
 - **Use Charged Attacks Wisely:** Charged attacks consume more RP but deal higher damage and can stun. Use them on tougher foes or groups, but don't deplete your RP.
 - **Weapon Types:** Experiment with different weapon types (if you have them) to see what feels best. Swords are balanced, Axes are slow but powerful, Spears have range, etc.
 - **Heal Proactively:** Don't wait until your HP is critical. Use healing items (Wild Grass, basic

cooked dishes, Potions) when your HP drops to around half.

4. Preparing for Your First Boss Battle

The boss at the end of your first dungeon is designed to be a significant challenge. Proper preparation is key to victory.

- **Equipment Check:**
 - **Weapon:** Ensure your weapon is the best you can currently craft or buy. Upgrade it at the blacksmith if possible.
 - **Armor:** Equip any armor you have (basic shield, chest piece). Even small defense boosts help.
 - **Accessories:** Rings or amulets that boost stats (Attack, Defense, HP) are very useful.
- **Stock Up on Supplies:**
 - **Healing Items:** Carry a good stack of cooked dishes that restore both HP and RP (e.g., Onigiri, simple stir-fries). If you can't cook yet, stack up on Wild Grasses and maybe a few basic Potions from the Clinic.
 - **RP Recovery Items:** Foods that restore RP specifically (e.g., bread, some cooked items) will let you use more charged attacks or active skills.
- **Save Your Game:** Find the nearest save point before entering the boss arena. You do not want to lose progress if you're defeated.
- **Clear the Dungeon:** Ideally, clear all regular enemies and gather resources up to the boss door. This ensures you're at full HP/RP and won't be bothered by lesser foes during a retreat.
- **Understand the Arena:** Some boss arenas might have environmental hazards or elements you can use. Observe it briefly before engaging.

5. Your First Boss Battle: Strategy and Survival

The first boss is typically a "gatekeeper" designed to teach you about boss mechanics: attack patterns, openings, and managing a longer fight.

- **Common First Boss Archetypes:**
 1. **Giant Slime/Golem:** Slow-moving, but hits hard. Often has a "slam" or "roll" attack.
 2. **Large Beast:** A wolf, bear, or similar creature. Fast charges, claw swipes.
 3. **Plant Monster:** Stationary or slow, but fires projectiles or creates AoE (Area of Effect) zones.
- **General Boss Strategy:**
 1. **Observe First:** Don't just rush in. Watch the boss's attacks for a few moments. What are its tells? Does it glow before a strong attack?
 2. **Learn Patterns:** Bosses have predictable attack sequences. Identify the safe windows to attack.
 3. **Dodge/Guard Everything:** Your primary goal is to avoid taking damage. Dodging is usually more effective than guarding against powerful boss attacks.
 4. **Attack During Openings:** After a boss completes an attack animation, there's usually a brief

window where it's vulnerable. Get a few hits in, then prepare to dodge its next attack.

5. **Target Weak Points (If Any):** Some bosses might have glowy or distinctly colored weak points. Attacking these can deal extra damage or stun them.
6. **Manage HP/RP:** Don't let your HP drop too low. Use a healing item if you're below 50% HP. If you run out of RP, revert to basic attacks, or use an RP recovery item if you need to execute charged attacks.
7. **Use Runes/Magic:** If you've unlocked any basic magic spells, they can be useful for ranged damage or status effects.
8. **Don't Get Greedy:** It's better to land one safe hit and dodge than to risk getting hit twice for one extra strike. Patience is key.
9. **Monster Companions:** If you've tamed an early monster and brought it with you, let it draw some aggro, but don't rely solely on it. Heal your companion if it gets low, but prioritize your own survival.

6. Post-Boss Actions

Victory! After defeating the boss:

- **Rewards:** The boss will drop valuable items (often unique crafting materials or a rare weapon/accessory) and a significant amount of experience.
- **Story Progression:** A cinematic or dialogue scene will play, advancing the main narrative. The immediate threat related to the dungeon is typically resolved.
- **New Areas:** Defeating the boss often unlocks the path to a new region of Azuma, signaling the next chapter of your adventure.
- **Farm Expansion/New Crafting:** The materials gained from the boss and new dungeon enemies might unlock powerful new crafting recipes at the blacksmith or enable further farm expansions.
- **Teleport Out:** Use your Return spell/item, or simply walk back to the dungeon entrance. Go back to town to rest, sell loot, and prepare for your next steps.

Important Reminders for Dungeon Crawling:

- **Pace Yourself:** Don't feel pressured to clear a dungeon in one go. You can always leave, rest, and return.
- **Over-leveling is Fine:** If a dungeon or boss feels too hard, spend a few days farming, fulfilling requests, and fighting monsters in the Verdant Hills to gain levels and better gear.
- **Explore Thoroughly:** Don't just rush to the boss. Explore every corner for hidden resources, treasures, and additional monsters to gain experience.
- **Inventory Management:** Regularly return to town to store your excess items in your storage box. You don't want to leave valuable loot behind because your bag is full.

Conquering your first dungeon and defeating your first boss is a significant milestone in *Rune Factory:*

Guardians of Azuma. It signifies your readiness to truly become a guardian of Azuma, blending your life as a thriving farmer with the courage of a seasoned adventurer.

Chapter 3

WALKTHROUGH PART II – Guardians, Secrets, and Destiny

This chapter delves deeper into your adventure as the world of Azuma truly expands. Follow intricate **mid-game story arcs and compelling side quests** that unravel the land's hidden lore. Discover and **unlock new towns and expansive areas**, meet new allies and challenges, and prepare for epic confrontations with **the Guardians of Azuma's major bosses**. This guide sets the stage for your character's growth and crucial **endgame setup, leading into the final showdown preparation**.

Mid-Game Story Arcs and Side Quests

As you progress beyond the initial trials of the Verdant Hills and conquer your first dungeon, *Rune Factory: Guardians of Azuma* truly begins to unfurl its deeper narrative and expand its world. The mid-game is a crucial period where the stakes rise, new mysteries emerge, and your role as a Guardian becomes increasingly vital. This guide will help you navigate the branching **mid-game story arcs** and discover the wealth of **side quests** that enrich your journey.

1. Understanding Mid-Game Story Progression

The transition from early to mid-game is typically marked by the opening of new geographical regions and the introduction of more complex plot points. The main story will now weave together larger threats, historical mysteries, and your developing connection to the 'Guardians of Azuma' lore.

A. Expanding the Main Storyline

- **Emerging Threats:** The initial "first boss" typically resolves a local issue. Mid-game arcs often introduce a broader, more pervasive threat to Azuma. This could involve:
 - **Runey Imbalance:** The magical energy of the land (Runes) is becoming unstable, leading to environmental decay or monstrous surges in new regions.
 - **Ancient Evils:** A long-dormant evil force is stirring, requiring you to investigate ancient ruins or forgotten temples.
 - **Political Intrigue:** Conflicts between different factions, towns, or even neighboring nations emerge, pulling you into their disputes.
- **Investigative Journey:** You'll likely be sent to several new dungeons and regions, each holding a piece of the puzzle. These are often less linear than early dungeons and require more strategic planning.
- **Key Story NPCs:** New characters crucial to the main plot will be introduced. They might be researchers, leaders of other towns, or even seemingly unassuming individuals with hidden knowledge. Build relationships with them as their trust can unlock vital information or paths.

- **The Guardians' Lore:** The game's title, "Guardians of Azuma," suggests a core theme. Mid-game is where you'll start learning about these legendary figures, their past, their purpose, and perhaps your own connection to them. This might involve collecting ancient texts, visiting sacred sites, or undertaking trials.
- **Pacing:** The main story will have natural breakpoints. Don't feel rushed to complete it. *Rune Factory* encourages a balanced approach, so take time for farming, crafting, and socializing between major story beats.

B. Progression Triggers

- **Quest-Driven:** Most main story progression is directly tied to completing specific quests given by key NPCs. Pay attention to dialogue and your quest log (J on PC, - on Switch) for objectives.
- **Boss Defeat:** Defeating a major boss at the end of a mid-game dungeon typically unlocks the next segment of the story or a new region.
- **Friendship Levels:** Occasionally, a story event or a critical piece of information might be gated behind a certain friendship level with a particular NPC. Make sure you're engaging with the townsfolk!

2. Side Quests: Deepening Your Connection to Azuma

The mid-game is when side quests truly flourish, offering a rich tapestry of localized stories, character development, and valuable rewards. Neglecting them means missing out on much of what Azuma has to offer.

A. Types of Mid-Game Side Quests

1. **Villager Requests (Request Board & Direct):**
 - **Complexity:** These become more involved. Instead of "fetch me 3 turnips," you might be asked to:
 - **Gather Rare Materials:** Venture into mid-game dungeons for specific monster drops or ores.
 - **Craft Specific Items:** Require you to level up your crafting skills and find new recipes.
 - **Deliver to Distant Locations:** Travel to newly unlocked towns or remote areas.
 - **Hunt Specific Monsters:** Target a particular type of monster, sometimes in a slightly tougher area.
 - **Rewards:** Significant gold, rare items, new crafting recipes, permanent stat boosts, and substantial friendship increases. These are invaluable for your progression.
 - **Tip:** Always check the Request Board daily. Prioritize requests that offer recipes or valuable materials. Some NPCs might also have direct, unlisted requests if you talk to them repeatedly.
2. **Character-Specific Events:**

- **Trigger:** These often trigger automatically when you reach a certain friendship level with an NPC, visit a specific location at a certain time, or after completing a particular story segment.
- **Content:** They provide deeper insights into an NPC's background, personality, and struggles. They can be humorous, dramatic, or heartwarming.
- **Relationship Building:** Essential for advancing romantic relationships.
- **Rewards:** Usually sentimental, but some might lead to unlocking new services, shops, or even joint attacks in combat.
- **Tip:** Pay attention to your friendship levels (P on PC, + on Switch for character menu) and try to talk to your favorite NPCs daily to ensure you don't miss these.

3. **Exploration & Discovery Quests:**

 - **Trigger:** Often no explicit quest giver. You simply find them by exploring.
 - **Content:** Discovering a hidden area, unlocking a new fishing spot, finding a secret passage, or stumbling upon a unique monster.
 - **Rewards:** New areas to farm/mine, rare resources, unique monsters to tame, or simply the satisfaction of discovery.
 - **Tip:** Always check behind waterfalls, break suspicious walls, and investigate glowing spots.

4. **Crafting/Farming Milestone Quests:**

 - **Trigger:** Reaching a certain level in a crafting skill (e.g., Forging Lvl 25), harvesting a certain amount of a crop, or taming a specific number of monsters.
 - **Content:** Often just a recognition of your achievement, sometimes with a small reward.
 - **Rewards:** New crafting recipes, improved tool efficiency, or bonus friendship points.
 - **Tip:** These are passive. Just keep engaging with the game's systems, and they'll come naturally.

3. **Tips for Managing Mid-Game Arcs and Quests**

The mid-game can feel overwhelming with the sheer amount of content. Here's how to manage it effectively:

- **Prioritize the Main Story (But Don't Rush):** While important, *Rune Factory* is not a race. Progress the main story enough to unlock new areas, resources, and NPCs, but then take breaks to consolidate your gains.
- **Check the Request Board Daily:** Make it a habit. Easy rewards, friendship, and material gathering.
- **Balance Your Activities:** Don't neglect farming for adventuring, or vice-versa.
 - **Farm for Gold & Food:** Sell high-value crops to finance equipment

upgrades. Cook food for RP and HP recovery for dungeon dives.
- **Dungeon for Materials & EXP:** Collect rare monster drops and ores for crafting better tools and weapons. Gain combat experience to take on tougher challenges.
- **Master New Mechanics:** The mid-game often introduces more complex mechanics:
 - **Advanced Cooking:** Utilizing better cooking stations and rarer ingredients.
 - **Monster Riding/Mounts:** Some tamed monsters can be ridden, improving travel or providing unique combat abilities.
 - **Relationship Management:** Deeper mechanics for romance, including rival events or specific gift-giving strategies.
- **Upgrade Your Gear Consistently:** The difficulty spike in mid-game dungeons means your starting gear won't cut it. Always craft or buy the best weapon, armor, and accessories you can afford.
- **Bring Companions:** Whether human party members (once unlocked) or tamed monsters, having a companion can significantly ease the burden of mid-game combat. Heal them and equip them if possible!
- **Explore Thoroughly:** New areas and dungeons introduced in the mid-game often hide valuable secrets, stronger mining nodes, and unique monsters. Don't leave any stone unturned.
- **Utilize Fast Travel:** As the map expands, master any fast-travel options (teleport runes, specific map points) to save time between locations.
- **Keep an Eye on the Calendar:** Festivals and NPC birthdays are important for maximizing relationship gains and unlocking unique events.

The mid-game of *Rune Factory: Guardians of Azuma* is where your character truly comes into their own. By balancing your efforts between the overarching narrative, the needs of your farm, and the desires of the townsfolk, you'll uncover Azuma's deepest secrets and solidify your place as its destined Guardian.

Unlocking New Towns and Areas

As your journey as a Guardian deepens in *Rune Factory: Guardians of Azuma*, the world will gradually unfold beyond the familiar Verdant Hills. Unlocking new towns and expansive areas is a cornerstone of the mid-game experience, vital for progressing the main story, discovering new resources, meeting new allies, and truly immersing yourself in the rich tapestry of Azuma. This guide will detail how these new locations become accessible and what benefits they offer.

1. Methods of Unlocking New Locations

New areas in *Rune Factory* games are typically unlocked through a combination of your efforts and the overarching narrative.

A. Main Story Progression

- **Primary Driver:** This is the most common and often mandatory method. As you complete major story quests and defeat key bosses in existing dungeons, the

narrative will naturally guide you to new regions.

- **Narrative Gates:** A path that was previously blocked (e.g., by rubble, a sleeping dragon, an unactivated portal, or a town gate) will become accessible after a specific story event.
- **Examples:** Defeating the first major boss in the Starter Dungeon might clear the way to the "Whispering Woods," which then leads to the "Mountain Pass," and eventually to the next town.

B. Specific Side Quests or Requests

- **Community Expansion:** Sometimes, a particular villager's request or a series of interconnected side quests will lead to the discovery or opening of a new area. This often involves helping a character with a problem that requires venturing into uncharted territory.
- **Farming/Crafting Milestones:** Less common for entirely *new* towns, but reaching a high level in a specific skill (e.g., farming, foraging, mining) might unlock access to a resource-rich hidden area or a specialized workshop within an existing town.

C. Reputation or Friendship Milestones

- **Gaining Trust:** Certain towns or factions might be initially wary of outsiders. Building a high enough reputation with the main town or achieving a specific friendship level with a key NPC (like a town leader or a seasoned adventurer) could grant you permission or guidance to access previously restricted areas.
- **Examples:** A character who guards a specific path might only move aside once their friendship with you reaches a certain point.

D. Environmental Interactions / Discovery

- **Hidden Paths:** Occasionally, a new area might be unlocked simply by interacting with a specific environmental element. This could be:
 - Breaking a seemingly solid wall with an upgraded hammer.
 - Activating a hidden switch.
 - Finding a secret passage behind a waterfall.
 - Cultivating a specific crop that opens up a unique "harvest" area.
- **Tips:** Always investigate suspicious-looking terrain, use your upgraded tools on anything that looks breakable, and pay attention to subtle visual cues like sparkling spots or unusual plant growth.

2. Types of New Areas to Expect

As Azuma expands, you'll encounter a diverse range of environments, each with its own challenges and opportunities.

A. New Dungeons

- **Increased Difficulty:** Dungeons encountered in the mid-game are significantly more challenging than your first one. Expect stronger, more numerous enemies, more complex layouts, tougher traps, and more demanding puzzles.
- **Unique Themes:** Each dungeon often has a distinct theme (e.g., a fiery volcanic cave,

an icy cavern, an ancient ruin, a lush jungle temple).

- **Specialized Resources:** These dungeons will contain new types of ores, monster drops, and forageable items essential for mid-to-late game crafting and upgrades.
- **New Bosses:** Each major dungeon culminates in a formidable boss battle, which often drives the main story forward.

B. New Resource Zones

- **Specialized Biomes:** Beyond dungeons, you'll find expansive outdoor areas that serve as dedicated resource zones. These could be:
 - **Forests:** Dense areas rich in higher-quality wood and unique forageables.
 - **Mountains/Plateaus:** Abundant in rare ores and tougher mining nodes.
 - **Rivers/Lakes/Coastal Areas:** Prime fishing spots for higher-tier fish and aquatic monster drops.
 - **Swamplands:** Home to unique poisonous plants and resistant monsters.
- **Higher-Tier Materials:** These zones are where you'll find the materials needed for mid-game tool upgrades, advanced cooking, and better equipment.

C. New Towns / Villages

- **Expanded Communities:** Beyond your starting town, you'll likely discover new settlements.
- **New NPCs:** Each new town will have its own unique cast of characters, including new bachelors/bachelorettes, shopkeepers, and quest givers.
- **New Services:** These towns might offer specialized services not available in your starting town (e.g., an advanced alchemy shop, a unique restaurant, a specific type of monster farm, or a specialized artisan).
- **Local Lore:** Each town will have its own history, traditions, and local problems that lead to new side quests and mini-storylines.

D. Optional or Secret Areas

- **Hidden Bosses/Enemies:** Some areas might contain super-tough optional bosses that yield extremely rare drops.
- **Rare Resource Nodes:** Tiny, out-of-the-way spots that regenerate highly valuable ores or monster products.
- **Ancient Shrines/Lore Spots:** Locations that reveal deeper lore about Azuma, the Guardians, or the world's magic.

3. Benefits of Exploring New Areas

Venture beyond your comfort zone! The rewards of exploring new locations are substantial:

- **Access to New Resources:** Essential for crafting powerful weapons, armor, and tools; building advanced farm facilities; and cooking high-tier dishes.
- **Stronger Monsters & More EXP:** Fighting tougher enemies grants more experience, helping you level up faster and become stronger.
- **New NPCs & Relationships:** Expanding your social circle unlocks new character events, side quests, and potential romantic partners.

- **New Shops & Services:** Access to better equipment, seeds, recipes, and specialized services.
- **Deeper Lore & Story Progression:** Unlocking new areas is often intrinsically linked to advancing the main plot and uncovering the world's mysteries.
- **Completionism:** For players who want to collect all items, tame all monsters, and see all events, exploring every nook and cranny is essential.

4. Preparation for Venturing into New Areas

Don't just rush into an unexplored region! Proper preparation can mean the difference between success and a swift defeat.

- **Upgrade Your Gear:** Before entering a new dungeon or a significantly tougher outdoor zone, ensure your weapon, shield, and armor are the best you can currently craft or buy.
- **Stock Up on Supplies:** Carry a generous supply of high-quality HP and RP recovery items (cooked dishes are best). Bring a few status-curing items (antidotes, paralysis cures) if the area's monsters inflict them.
- **Upgrade Your Tools:** A better Axe and Hammer will be crucial for harvesting higher-tier wood and ores in new zones.
- **Bring Companions:** If you have tamed monsters or unlocked human party members, bring them along. They can draw aggro, deal damage, and provide support. Ensure they are also well-equipped if possible.
- **Empty Your Inventory:** Clear your backpack before heading into a new resource-rich area so you can collect as much as possible without having to make frequent trips back.
- **Check the Weather/Day:** Some areas or resources might be influenced by specific weather patterns or time of day.
- **Save Your Game:** Always save your game before entering a challenging new area or dungeon.

5. Tips for Efficient Exploration

- **Pace Yourself:** Don't try to clear an entire new dungeon in one go. Explore a section, gather resources, then return to town to rest, sell, and consolidate.
- **Map Thoroughly:** Uncover every part of the map. Look for dead ends, hidden paths, and secret rooms.
- **Prioritize New Resources:** When in a new area, actively seek out new types of mining nodes, forageables, and monster types to acquire their unique drops.
- **Observe New Enemies:** Before engaging a new monster type, observe its attack patterns from a distance to identify openings and weaknesses.
- **Utilize Fast Travel:** Once unlocked, use any fast travel points (teleport runes, portal areas) to quickly move between newly discovered locations and your farm/town, saving precious in-game time.

By actively unlocking and exploring these new towns and areas, you'll continuously refresh your gameplay experience, overcome new challenges, and truly become the seasoned Guardian Azuma needs.

The Guardians of Azuma: Major Bosses

As you delve deeper into Azuma's unfolding mysteries, you'll inevitably confront its major bosses. These aren't just overgrown monsters; they are formidable challenges, often tied directly to the game's central narrative about the "Guardians of Azuma" and the threats facing the land. Major boss battles serve as critical milestones, testing your combat prowess, strategic planning, and overall mastery of the game's systems.

P1. The Significance of Mid-Game Bosses

Beyond being mere obstacles, mid-game bosses in *Rune Factory: Guardians of Azuma* fulfill several crucial roles:

- **Story Progression:** Defeating a major boss almost always advances the main storyline, unlocking new plot points, cinematics, and revelations about Azuma's history and the Guardians.
- **Gateway to New Areas:** These bosses typically guard the path to new regions, dungeons, or even entire towns, expanding the playable world.
- **Skill Check:** They test your understanding of combat mechanics, resource management (HP/RP), and the effectiveness of your current gear and farming efforts.
- **Resource Unlock:** Bosses drop unique and powerful materials essential for crafting high-tier weapons, armor, and accessories, enabling further progression.
- **Character Development:** Overcoming these challenges reflects your hero's growth and increasing strength as a true Guardian of Azuma.

2. Characteristics of Mid-Game Bosses

Expect these encounters to be significantly more complex and demanding than your first introductory boss.

- **Higher HP & Damage Output:** They can withstand more punishment and deal devastating blows, making careful HP management crucial.
- **Complex Attack Patterns:** Bosses will have multiple distinct attacks, often with various ranges (melee, ranged, AoE) and predictable "tells" (visual or auditory cues) before executing them. Learning these patterns is key.
- **Phases or Transformations:** Some bosses might transition into different phases during the fight (e.g., at 50% HP), changing their attack patterns or gaining new abilities.
- **Unique Mechanics:** They might employ specific mechanics that require more than just dodging and attacking, such as:
 - Summoning adds (smaller enemies).
 - Creating environmental hazards (poison pools, fire zones).
 - Requiring you to break specific body parts to stun them.
 - Having elemental resistances or weaknesses.
- **Status Effects:** Bosses are more likely to inflict debilitating status effects (Poison, Paralysis, Seal, Sleep, Fatigue) that drain your HP, RP, or disable your abilities.

3. General Boss Preparation: Before the Fight

Never rush into a major boss fight unprepared. A few minutes of preparation can save you hours of frustration.

1. **Gear Up:**
 - **Weapon:** Craft or buy the best weapon available at your current stage. Ensure it's fully upgraded with materials if possible. Consider elemental properties if the boss has a known weakness.
 - **Armor:** Equip the highest defense armor pieces for head, body, and shield (if applicable).
 - **Accessories:** Rings, amulets, or boots that boost your Attack, Defense, HP, or provide resistance to status effects are invaluable.
2. **Stock Your Inventory:**
 - **High-Tier Healing:** Bring plenty of cooked dishes that restore significant HP and RP (e.g., Sashimi, Gratins, high-level juices). These are far superior to raw ingredients or basic potions.
 - **Status Cures:** If you know the boss inflicts a specific status (e.g., Poison), bring Antidotes. Universal status cures are also useful.
 - **Buff Foods/Potions:** Cooked dishes or crafted potions that temporarily boost your Attack, Defense, or elemental resistances can turn the tide.
3. **Level Up (If Struggling):** If you've been avoiding combat, a major boss is a wake-up call. Spend some time grinding levels in the current dungeon or previous zones to increase your base stats.
4. **Companion Readiness:**
 - **Human Party Members:** If you've unlocked companions (through friendship quests), bring them! Ensure they are also well-equipped with the best available weapons and armor.
 - **Tamed Monsters:** Bring your strongest tamed monster companions. They can draw aggro, deal damage, and provide support. Check their HP and equip them with food if possible.
5. **Save Your Game:** Always, *always* save at the nearest save point before entering the boss arena. This is non-negotiable.
6. **Scout the Arena (If Possible):** Sometimes you can glimpse the boss arena before engaging. Look for environmental elements, escape routes, or places to take cover.

4. Major Boss Archetypes and Strategies (Mid-Game)

While specific boss names and moves vary, mid-game bosses often fall into these archetypes, each requiring a slightly different approach:

A. The Elemental Beast / Corrupted Spirit

- **Description:** A large creature or spirit embodying an element (e.g., Fire Dragon, Ice Golem, Wind Chimera). Often a Guardian that has been corrupted.

- **Attacks:** Large AoE attacks, elemental projectiles, charges, elemental status effects (Burn, Freeze, Paralysis).
- **Strategy:**
 - **Elemental Resistance:** Equip accessories or consume food that boosts resistance to their primary element.
 - **Elemental Weakness:** Exploit their elemental weakness (e.g., Water attacks on Fire Boss).
 - **Dodge Large Attacks:** Many elemental attacks have obvious wind-ups. Prioritize dodging over guarding.
 - **Hit-and-Run:** Get in a few hits after their big attacks, then back off.
 - **Target Vulnerable Spots:** Some might glow or expose a weak point during certain attacks.

B. The Sentient Construct / Ancient Machine

- **Description:** A large, often metallic or stone, automaton. Could be an ancient Guardian's forgotten defense system.
- **Attacks:** Lasers, punching combos, ground slams, summoning small turrets, rotating AoE attacks.
- **Strategy:**
 - **Physical Defense:** Prioritize high physical defense.
 - **Stun Opportunities:** Often vulnerable after a powerful attack, or if a specific component is targeted. Try to stun them for free hits.
 - **Component Targeting:** Some constructs might have destructible limbs or turrets that can be disabled first.
 - **Manage Summons:** Quickly defeat any summoned adds to prevent being overwhelmed.

C. The Master Tactician / Spellcaster

- **Description:** A more humanoid or intelligent-looking foe, often a rogue mage, a disgruntled Guardian, or a cunning monster leader.
- **Attacks:** Wide array of magical spells (projectiles, AoE zones, status effects), summoning illusions or weaker minions, teleportation.
- **Strategy:**
 - **Ranged Attacks:** If playing melee, you'll need to close the distance quickly or use rushing attacks. If playing ranged/magic, maintain distance.
 - **Interrupt Spells:** Some spells have long cast times; try to interrupt them with charged attacks or specific skills.
 - **Dispelling/Cleansing:** Bring items to remove negative status effects, as these bosses rely on them.
 - **Prioritize Adds:** Quickly eliminate summoned illusions or minions, as they can distract or harass you.

5. General Boss Battle Strategies (Universal)

These tips apply to nearly all major boss encounters:

- **Observe First, Attack Second:** For the first minute or so, focus purely on dodging and observing the boss's full repertoire of attacks. Identify safe zones and attack openings.
- **Patience is Key:** Don't get greedy. Land 1-3 hits during a safe opening, then prepare to dodge the next attack. Over-committing leads to punishment.
- **Stamina/RP Management:** Watch your RP closely. Using charged attacks or spells too often can deplete it, forcing you to use HP for regular attacks, making you vulnerable.
- **Heal Proactively:** Don't wait until your HP is critically low (below 25%). Use a healing item when you're around 50% HP or if you know a big attack is coming.
- **Utilize Companions:** Let your monster or human companions draw some aggro. Heal them if they get low to keep them in the fight.
- **Exploit Elemental Weaknesses:** If the boss has a known elemental weakness (e.g., Fire-type boss is weak to Water), use weapons, spells, or food buffs that utilize that element.
- **Learn the "Tells":** Every boss attack has a "tell" – a distinct animation, sound, or visual cue that signals the impending attack. Learn these tells to dodge effectively.
- **Keep Moving:** Standing still is a death sentence. Always be moving, even if just strafing, to avoid predictable attacks.
- **Practice Dodging/Guarding:** Master your dodge roll/dash and guard mechanics. They are your primary means of survival.
- **Don't Give Up:** Major bosses are designed to be challenging. You might die several times. Learn from each defeat, adjust your strategy, and come back stronger.

6. Post-Battle Rewards and Unlocks

Upon successfully defeating a major boss:

- **Significant EXP & Gold:** A huge boost to your character's level and wealth.
- **Unique Boss Drops:** These are invaluable, often rare materials needed for the strongest weapon, armor, and accessory recipes of the current game stage. They may also unlock new crafting recipes.
- **Story Advancement:** A cinematic or lengthy dialogue sequence will play, pushing the main narrative forward and revealing critical plot points.
- **New Areas Unlocked:** The path to the next major region of Azuma will open up, complete with new farming zones, resource nodes, and towns.
- **New Requests/NPCs:** Defeating a boss might trigger new requests on the board or introduce new NPCs relevant to the continuing story.

Conquering these major bosses defines your journey as a Guardian of Azuma. Each victory is a testament to your growth, pushing you closer to unraveling the deepest secrets of this magical land.

Endgame Setup and Final Showdown Preparation

You've explored vast regions, overcome numerous challenges, and unearthed many of Azuma's secrets. As the main story arcs converge, you'll feel the palpable anticipation of the final confrontation. "Endgame Setup" in *Rune Factory: Guardians of*

Azuma isn't just about preparing for one last battle; it's about refining every aspect of your character, farm, and relationships to face the ultimate threat to the land. This guide will ensure you are fully optimized and ready for the epic final showdown.

1. Defining "Endgame Setup"

At this stage, "endgame setup" means maximizing your protagonist's capabilities across all game systems, not just combat. It's about ensuring your farm is a self-sustaining powerhouse, your relationships are strong, and your crafting skills are honed to perfection. This holistic preparation will give you the edge in the final challenge.

2. Maxing Out Core Systems: Your Personal Powerhouse

Before facing the final boss, aim to push your various skills and systems to near their maximum potential.

A. Character Levels and Stats

- **Grinding:** If you haven't already, spend time in the highest-level dungeons to gain experience (EXP) and level up your character. Higher levels naturally boost your core stats (HP, RP, Attack, Defense, Magic Attack, Magic Defense).
- **Skill Mastery:** Focus on leveling up all relevant skills:
 - **Weapon Skills:** Maximize proficiency with your chosen weapon type (Sword, Spear, Axe, etc.) for increased damage.
 - **Magic Skills:** If you use magic, level up your various magic schools for stronger spells and reduced RP cost.
 - **Combat Skills (e.g., Dodge, Guard):** Higher levels in these passively improve your evasion and damage reduction.
 - **Life Skills (Farming, Cooking, Forging, Chemistry, Walking, Sleeping, Eating, Bathing):** These skills often provide passive stat boosts, increase RP efficiency, or unlock vital recipes. Even seemingly minor boosts add up.

B. Farm Optimization for Peak Production

- **Maximized Crop Yields:**
 - **Fertility:** Ensure all your farm plots have optimal soil fertility and health. Use fertilizers regularly.
 - **Runey Fields (if applicable):** Maintain high concentrations of Runes or similar elements on your farm for boosted crop growth and RP regeneration.
 - **High-Tier Crops:** Focus on growing the highest-tier, most profitable crops to generate maximum gold.
- **Monster Helpers:**
 - **Barn Expansion:** Ensure your monster barns are fully upgraded.
 - **Specialized Monsters:** Recruit and level up monsters that specialize in farm chores (watering, harvesting, tilling) to automate and maximize efficiency, freeing up your own RP.

- **Produce Powerhouse:** Your farm should now be a gold-generating machine, providing ample funds for high-tier crafting, equipment, and consumables.

C. Relationship Levels

- **Max Friendship:** Aim to reach maximum friendship (often 10 hearts) with all townsfolk, especially those who offer services (shopkeepers, blacksmith, doctor). This can unlock special items, discounts, and unique events.
- **Marriage Candidate:** If you plan to marry, ensure your chosen candidate's relationship level is maximized and all pre-marriage events are completed. Marriage itself might unlock special dialogue or even unique abilities.
- **Companion Proficiency:** For any human party members you've unlocked, maximize their friendship levels. This often boosts their combat effectiveness and unlocks their most powerful abilities.

3. Optimal Gear Acquisition: The Best of the Best

Your equipment is your primary defense and offense. At endgame, you should be aiming for the absolute best gear available.

A. Crafting the Ultimate Weapon

- **Top-Tier Recipes:** Ensure your Forging skill is maximized. Acquire the recipes for the strongest weapon type in each category (e.g., legendary sword, mighty axe). These are often obtained from boss drops, rare chests, or high-level requests.
- **Best Materials:** Seek out the rarest and most potent materials from the latest dungeons, post-game zones, and boss re-fights. These include high-tier ores, monster parts, and rare crystals.
- **Fusing & Upgrading:** Use the game's fusion/upgrading system to infuse your ultimate weapon with powerful abilities, status effects (e.g., Paralysis, Seal), and extra stats from rare items. *Don't forget to use items like 4-leaf clovers or rare monster drops as upgrade materials for massive stat boosts.*

B. Fortifying Your Armor and Accessories

- **Legendary Armor Sets:** Craft the highest-defense armor sets (head, body, shield, footwear).
- **Accessory Optimization:** Craft and equip accessories that provide significant boosts to HP, RP, all stats, or specific resistances (e.g., against poison, paralysis, or the final boss's primary element). Some unique accessories may offer powerful passive abilities.
- **Rune Abilities (if applicable):** Some high-tier gear or accessories might have slots for "Rune Abilities" or "Crystal Shards" that grant special passive effects or active skills.

C. Preparing Specialized Equipment

- **Elemental Resistances:** Identify the primary element(s) of the final boss (if known). Craft or upgrade gear with high resistance to those elements.
- **Status Effect Immunity:** If the final boss inflicts particularly nasty status effects (e.g., massive poison, permanent seal), try to

craft gear that offers immunity or high resistance to them.

4. Resource Hoarding: An Abundance of Consumables

You don't want to run out of critical items in the final battle.

- **Master Cook:** Maximize your Cooking skill. Prepare hundreds of the best HP/RP restoring dishes you know (e.g., high-level Sashimi, Gold Juice, Royal Curry). Cooked dishes are far more efficient than raw ingredients.
- **Alchemy Expert:** Maximize your Chemistry skill. Brew large quantities of powerful potions (healing, RP recovery) and status-curing items.
- **Buff Items:** Craft and stock up on temporary stat-boosting items (e.g., Power Drink for Attack, Shield Seed for Defense). These can provide a crucial edge during the boss's most dangerous phases.
- **Monster/Companion Food:** Ensure your monster companions have their favorite foods to boost their stats or recovery, and your human companions have their preferred gifts to max their friendship (which can boost their combat effectiveness).

5. Companion Optimization: Your Trusty Allies

You won't be fighting the final battle alone. Your companions are vital.

- **Human Party Members:**
 - **Max Friendship:** Ensure their friendship levels are at maximum for optimal performance and potential unique abilities.
 - **Best Equipment:** Equip them with the strongest weapons and armor you can provide. Don't hoard good gear just for yourself; share the wealth!
 - **Healing:** During the fight, remember to heal them if they get low.
- **Tamed Monsters:**
 - **Strongest Combat Monsters:** Choose your tamed monsters with the highest combat stats, resistances, and useful abilities (e.g., healing, tanking, elemental damage).
 - **Level Up:** Bring them into high-level dungeons to level them up.
 - **Feed & Upgrade:** Feed them their favorite items to boost their stats temporarily, and upgrade their monster barn for passive stat boosts.
 - **Riding (if applicable):** If you have a rideable monster, practice its unique attacks and movements.

6. Final Showdown Preparation: The Ultimate Strategy

This is it. The culmination of your journey.

- **Lore Recap:** Review your journal entries and talk to key NPCs one last time to fully understand the motivations of the final antagonist and the stakes involved.

- **Final Save:** Create a dedicated save file before entering the final dungeon/area. This allows you to retry or return if needed without losing significant progress.
- **Full HP/RP:** Ensure both your HP and RP are completely full before initiating the boss fight.
- **Boss Weaknesses/Resistances:**
 - **Research:** If possible, try to find hints about the final boss's elemental weaknesses or resistances from lore, previous encounters, or NPC dialogue.
 - **Status Effects:** Determine if it's susceptible to certain status effects (e.g., poison, seal).
- **Phase Management:** Be prepared for multiple phases. Final bosses often transform, gain new attacks, or summon powerful allies as their HP dwindles. Each phase might require a shift in strategy.
- **Environmental Awareness:** Pay attention to the boss arena. Are there any environmental hazards to avoid or elements you can use to your advantage?
- **Mindset:**
 - **Patience:** Don't rush. Learn the patterns, dodge effectively, and attack during openings.
 - **Adaptability:** Be ready to change your strategy on the fly if things aren't working.
 - **Focus:** Maintain concentration, especially during long fights.
 - **Enjoy It:** This is the peak of your adventure! Savor the challenge.

7. Post-Victory

Upon defeating the final boss:

- **Main Story Conclusion:** Experience the game's epic ending, credits, and resolution of the primary conflict.
- **Post-Game Content:** *Rune Factory* games typically unlock significant post-game content, including:
 - New high-difficulty dungeons.
 - Even stronger optional bosses.
 - New crafting recipes and materials.
 - Further relationship events and marriage proposals.
 - New Game Plus options.

By meticulously preparing every aspect of your Azuman life, you'll be more than ready to face the ultimate challenge and fulfill your destiny as the true Guardian of Azuma. Good luck!

Chapter 4

THE WORLD OF AZUMA — Maps and Locations

Dive into Azuma's vast and captivating geography with this comprehensive guide. This chapter provides detailed **town maps and key building** layouts, intricate **dungeon layouts and puzzle paths**, and insightful **regional maps with biome descriptions**. You'll also discover all essential **fast travel routes and hidden areas**, ensuring you can efficiently explore and master every corner of the world.

Town Maps and Key Buildings

The towns in *Rune Factory: Guardians of Azuma* are more than just places to sell your crops; they are the vibrant hearts of your adventure, teeming with life, services, and opportunities for connection. Mastering the layout of each town and understanding the purpose of its key buildings is essential for efficient daily routines, successful questing, and deepening your relationships with the local community.

1. The Importance of Town Maps

Your town map is an invaluable tool that provides an overhead view of the settlement, helping you quickly identify locations and navigate.

- **Quick Orientation:** Instantly see where you are in relation to shops, houses, and quest objectives.
- **NPC Tracking:** Many town maps display the current location of key NPCs, helping you find them for daily greetings, gifts, or specific quests.
- **Service Locations:** Easily locate the General Store, Clinic, Forge, and other vital services.
- **Quest Navigation:** Quest markers often appear on the map, guiding you to specific destinations or characters.
- **How to Access:** Typically, you can access the town map from your Main Menu (Esc on PC, + button on Switch) or by pressing a dedicated hotkey (M on PC, - on Switch). Some towns might have large, static maps displayed publicly as well.

2. General Town Layouts

While each town in Azuma will have its unique charm and architectural style, they often follow similar functional layouts.

A. Your Starting Town (e.g., Azure Village)

- **Central Hub:** Usually features a central square or plaza where festivals are held and the Request Board is located.
- **Clustered Shops:** Core shops (General Store, Clinic, Blacksmith) are often located relatively close to each other for convenience.
- **Residential Areas:** Houses of various NPCs are scattered around the town.
- **Outskirts:** Paths leading out to your farm, the first dungeon, or resource zones.
- **Initial Size:** Begins as a relatively small, easy-to-navigate area that expands as you progress.

B. Later Towns (Unlocked Mid-to-Late Game)

- **Larger & More Complex:** Subsequent towns you unlock will likely be larger, with more winding paths, distinct districts, and a greater number of NPCs.
- **Specialized Services:** May feature unique shops or facilities not found in your starting town (e.g., a high-end restaurant, a specialized magic shop, a larger monster barn).
- **New Biomes:** Their design will often reflect the biome they are situated in (e.g., a mountain town, a coastal village, a bustling city in a fertile plain).
- **More NPCs:** A wider array of characters, including new marriage candidates and quest givers.
- **Tip:** When you first arrive in a new town, take some time to walk around and familiarize yourself with its layout before diving into quests. Open your map frequently.

3. Key Buildings and Their Functions

Understanding what each building offers is crucial for managing your daily life and advancing your adventure.

A. Your Home

- **Location:** Often on the outskirts of your starting town, adjacent to your farm plot.
- **Purpose:** Your personal sanctuary.
- **Key Features:**
 - **Bed:** The most reliable way to restore all HP/RP and advance to the next day. Also a primary save point.
 - **Storage Box:** Your main inventory overflow. Store excess materials, crops, and items here. Essential for keeping your backpack clear.
 - **Refrigerator:** Stores food items, which may decay slower here.
 - **Shipping Bin:** Place items here to be automatically sold at the end of the day.
 - **Calendar:** Displays important dates like festivals and birthdays.
 - **Mailbox:** Where you receive letters, event notifications, or sometimes gifts.
- **Upgrades:** Can often be expanded through a carpenter NPC or the General Store, adding more rooms, storage, and possibly dedicated crafting stations.

B. General Store

- **Key NPC:** Shopkeeper (e.g., Kiko).
- **Purpose:** Your primary source for farming essentials and general goods.
- **Services:**
 - **Buy:** Seeds, basic tools, fishing rod, fertilizer, basic food items, cooking ingredients, sometimes simple accessories.
 - **Sell:** Your harvested crops, monster drops, extra items, or anything you wish to convert to gold.
- **Hours:** Typically open during daytime hours (e.g., 9 AM - 6 PM).
- **Tip:** Check daily for new stock as you progress. Sell high-value crops here.

C. Clinic / Hospital

- **Key NPC:** Doctor (e.g., Doctor Leo).
- **Purpose:** Restores your health and cures status ailments.
- **Services:**
 - **Healing:** Pay a fee to fully restore your HP and RP.
 - **Buy Medicines:** Purchase potions, antidotes, paralysis cures, etc.
- **Hours:** Generally similar to the General Store.
- **Tip:** A lifesaver if you're low on HP/RP after a dungeon dive. Always have some basic healing items from here or cooking before venturing out.

D. Forge / Blacksmith

- **Key NPC:** Blacksmith (e.g., Goro).
- **Purpose:** Where you craft and upgrade weapons, armor, and farming tools.
- **Services:**
 - **Crafting:** Use raw materials (ores, monster parts) to forge new equipment based on recipes you've learned.
 - **Upgrading:** Improve the stats of existing equipment by adding materials (costs gold and materials).
- **Hours:** Standard shop hours.
- **Tip:** Prioritize upgrading your farming tools early for efficiency. Later, focus on your primary weapon and armor.

E. Restaurant / Diner

- **Key NPC:** Chef/Cook (e.g., Master Chef Hiro).
- **Purpose:** Sells prepared food dishes.
- **Services:**
 - **Buy Cooked Food:** Dishes restore more HP/RP than raw ingredients and can provide temporary buffs.
 - **Sell Ingredients:** Can sometimes sell ingredients you're missing for your own cooking.
- **Hours:** May vary, sometimes closing earlier or later.
- **Tip:** If you haven't mastered cooking, buying dishes here is a good way to get powerful recovery items for dungeons.

F. Bathhouse / Hot Spring

- **Key NPC:** Bathhouse attendant.
- **Purpose:** A place to relax and fully restore your HP and RP (for a small fee).
- **Services:** Taking a bath. Some games include gender-specific times or mixed baths.
- **Hours:** Often open later than other shops.
- **Tip:** A convenient way to recover HP/RP if you're in town and don't want to go all the way back to your bed.

G. Monster Barn / Monster Taming Facilities

- **Key NPC:** Often managed by a specific rancher or dedicated NPC.
- **Purpose:** Houses your tamed monsters.
- **Services:**
 - **Build/Expand Barns:** Pay for construction or upgrades.
 - **Monster Care:** Tools and food for monsters.
 - **Recruitment:** Sometimes a specific NPC manages monster taming quests or advice.

- **Tip:** Recruit monsters for farm work to save your own RP, or for combat assistance in dungeons.

H. Town Hall / Elder's House

- **Key NPC:** Mayor or Elder (e.g., Elder Hana).
- **Purpose:** Often the center of town administration or where major story events occur.
- **Services:** May provide main quests, specific information about Azuma, or special events.
- **Tip:** Visit when your main quest objective points here.

4. Important Town Features (Non-Buildings)

- **Request Board:**
 - **Location:** Usually in a central plaza or near a prominent building (e.g., General Store).
 - **Purpose:** Where townsfolk post their requests (mini-quests).
 - **Tip:** Check daily! Requests are excellent for earning gold, gaining friendship, and acquiring specific items or recipes.
- **Shipping Bin:**
 - **Location:** Often right outside your house, and sometimes another larger one in town.
 - **Purpose:** Automated selling of items. Place anything you want to sell inside.
 - **Tip:** Use this daily for passive income.
- **Calendar:**
 - **Location:** Found in your house, sometimes in the town hall or General Store.
 - **Purpose:** Displays important dates for festivals, birthdays, and seasonal changes.
 - **Tip:** Plan your days around festivals for unique events and maximum friendship gains.
- **Festival Grounds:**
 - **Location:** Usually a large open area or central plaza in town.
 - **Purpose:** Where all festivals and major town events take place.
 - **Tip:** Participate in every festival for fun, unique mini-games, and significant relationship boosts.

5. Efficient Town Navigation Tips

- **Learn NPC Schedules:** Over time, you'll learn when shops are open and where specific NPCs tend to be at different times of the day.
- **Use the Mini-Map/Full Map:** Constantly refer to your map to quickly locate your objective or the NPC you're looking for.
- **Utilize Fast Travel:** Once unlocked, use any town-specific fast travel points (e.g., warp points within a large town) to save time.
- **Organize Your Inventory:** Keep your backpack organized so you can quickly find items for quests, gifts, or selling.
- **Establish a Routine:** Develop a daily town routine (e.g., check board, talk to key NPCs, sell items, visit shops) to maximize efficiency.

By understanding the layout and functions of Azuma's towns, you'll transform them from mere backdrops into essential hubs of your daily life, enabling smoother progression and a more immersive experience.

Dungeon Layouts and Puzzle Paths

Beyond the tranquil rhythm of farm life, the world of Azuma is riddled with ancient ruins, mystical caves, and treacherous labyrinths – its dungeons. These hostile environments are where you'll hone your combat skills, gather rare materials, and unravel the deeper mysteries of the land. Mastering their layouts and understanding their puzzle mechanics is crucial for efficient exploration, safe monster hunting, and ultimately, progressing the main story.

1. The Purpose of Dungeons

Dungeons in *Rune Factory: Guardians of Azuma* serve multiple vital functions:

- **Story Progression:** Most major story arcs culminate in a dungeon, where you'll find key artifacts, defeat powerful bosses, and unlock new narrative segments.
- **Resource Gathering:** Dungeons are the primary source of rare ores, unique monster drops, and specialized forageable items needed for high-tier crafting, upgrading weapons/tools, and advanced cooking.
- **Combat Training & Leveling:** The monsters within offer abundant experience points, allowing you to level up your character, weapon skills, and magic.
- **Monster Taming:** Many unique and powerful monsters reside in dungeons, waiting to be tamed and recruited as farm helpers or combat companions.
- **Exploration & Lore:** Dungeons often contain ancient texts, hidden rooms, and environmental storytelling that enrich Azuma's history and lore.

2. General Dungeon Structure

While each dungeon is unique, they generally follow a common hierarchical structure.

- **Entrances & Exits:** Every dungeon has a defined entrance (usually accessible from an overworld region) and an exit (often leading back to the overworld or a specific warp point).
- **Floors/Sections:** Dungeons are typically divided into multiple floors or distinct sections. Progressing usually involves finding a staircase, a portal, or clearing an obstacle. Each transition might involve a brief loading screen.
- **Main Path vs. Branching Paths:** Most dungeons have a relatively clear main path leading towards the boss. However, there will always be branching paths that lead to:
 - Dead ends with valuable resources (e.g., rare mining nodes, treasure chests).
 - Optional mini-bosses.
 - Hidden rooms or secret passages.
 - A shortcut back to an earlier part of the dungeon or the entrance.
- **Boss Arena:** The final section of a major dungeon culminates in a large, often unique, arena where the boss battle takes place.

3. Common Dungeon Layout Archetypes

Understanding these common design patterns can help you navigate more effectively.

- **Linear Progression:** The simplest design. You move from point A to point B, perhaps with a few small alcoves off the main path. Common for early-game tutorials or short quest dungeons.
 - *Strategy:* Follow the path, clear enemies, collect obvious resources.
- **Branching Path / "Tree" Structure:** The main path branches off into several smaller paths, some leading to dead ends, others circling back, and one progressing.
 - *Strategy:* Explore each branch fully before moving to the next. Use your map to mark explored areas.
- **Hub-and-Spoke:** A central large room or corridor acts as a "hub," with multiple paths (spokes) radiating outwards. You might need to clear paths or solve puzzles in one spoke to open another.
 - *Strategy:* Clear the hub, then systematically explore each spoke, returning to the hub after each.
- **Labyrinthine / Maze-like:** Features many interconnected paths, often with repetitive textures, making it easy to get lost. Common in mid-to-late game or optional challenges.
 - *Strategy:* Rely heavily on your map. Look for unique landmarks, breakable walls, or subtle cues. Consider dropping an item or using a marker spell (if available) to mark your path.
- **Vertical Dungeons:** Progresses significantly up or down through cliffs, towers, or deep chasms.
 - *Strategy:* Look for climbing points, hidden ledges, or jumping puzzles. Be mindful of fall damage.

4. Environmental Elements and Hazards

Dungeons are not just corridors; they are dynamic environments with elements that can help or hinder you.

- **Terrain:**
 - **Rough Ground:** Slows movement or drains RP.
 - **Water/Lava/Poison Pools:** Inflicts damage or status effects if walked through. Look for safe paths or jumping stones.
 - **Elevated Platforms/Ledges:** Requires jumping, climbing, or finding alternate routes.
- **Traps:**
 - **Pressure Plates:** Activates spikes, falling rocks, dart launchers, or opens/closes doors.
 - **Tripwires:** Triggers similar hazards.
 - **Falling Objects:** Rocks, icicles, or debris from the ceiling. Look for shadows or cracks.
 - **Poisonous Fumes/Gas:** Areas where standing too long inflicts poison.
- **Interactive Objects:**
 - **Breakable Obstacles:** Weak walls (smash with Hammer), thickets (chop with Axe), or web-covered passages (attack with Weapon/Fire Magic).
 - **Movable Blocks:** Push them to open paths or solve puzzles.

- **Rune/Glittering Spots:** Small glowing spots that instantly restore RP. Always pick them up!

5. Puzzle Types and Solutions

Dungeons often incorporate simple puzzles to break up combat and exploration.

- **Switch Puzzles:**
 - **Lever/Button Actuation:** Find and activate levers or buttons to open doors, extend bridges, or activate platforms. Often requires finding multiple switches in a specific order.
 - **Pressure Plates:** Stand on them to open a door, but the door closes when you step off. Might require pushing a heavy item onto it, or quickly dashing through.
- **Elemental Puzzles:**
 - **Fire/Ice Activation:** Use fire spells/items to melt ice blocks or light torches, or ice spells/items to extinguish flames or freeze water.
 - **Elemental Gates:** Requires hitting a specific elemental totem or switch with the correct element to open a path.
- **Light Puzzles:**
 - **Mirror Reflection:** Direct beams of light using movable mirrors to activate a sensor or unlock a door.
 - **Lighting Torches:** Find all unlit torches in a room and light them to reveal a path or secret.

- **Block/Crate Pushing:** Move blocks into specific positions to activate pressure plates, bridge gaps, or block enemy paths.
- **Lever/Gear Combinations:** Find multiple gears or levers and set them to the correct position (often hinted at by nearby lore or environmental clues) to open a large mechanism.
- **"Key" Item Puzzles:** Find a specific key, crest, or magical item within the dungeon to unlock a sealed door.
- **Riddle-Based:** Less common, but some dungeons might present simple riddles whose answers are found in the dungeon's lore or environmental details.
- **Tip:** When stuck on a puzzle, look for clues in the environment – glowing symbols, worn paths, suspicious cracks, or notes. Don't be afraid to backtrack.

6. Navigation and Exploration Tips

- **Use Your Map Religiously:** Uncover every inch of the map. It's your best friend for navigating complex dungeons. Pay attention to how areas connect.
- **Prioritize Save Points:** When you encounter a save point, use it immediately, especially after clearing a difficult section or finding valuable loot.
- **Manage HP and RP:** Keep a close eye on your health and rune points. Retreat or use recovery items before they get too low.

- **Bring the Right Tools:** Always carry your weapon, upgraded Axe (for wood/stumps), and upgraded Hammer (for rocks/ores).
- **Pack Consumables:** Stack up on healing foods/potions and RP recovery items.
- **Empty Inventory Beforehand:** Clear your inventory before entering a dungeon to maximize the loot you can carry out.
- **Mark Important Spots (if possible):** Some games allow you to place custom markers on your map. Use them for tough enemies, unique resource nodes, or unsolved puzzles.
- **Loot Everything:** Pick up all monster drops, forageables, and mining output. Even seemingly low-value items can be sold for profit or used in crafting later.
- **Don't Over-Extend:** If you're running low on resources or your companions are struggling, use a "Return" spell/item to go back to town. You can always come back tomorrow.
- **Understand Enemy Spawns:** Most enemies respawn when you re-enter a dungeon or after a set amount of in-game time. This allows for repeated farming of EXP and materials.
- **Observe and Learn:** Pay attention to new enemy types' attack patterns. Learning when to dodge and attack is crucial for survival.

By diligently exploring, solving puzzles, and understanding the ebb and flow of dungeon challenges, you'll uncover Azuma's deepest secrets and acquire the strength needed to face its ultimate threats.

Regional Maps and Biome Descriptions

As a Guardian of Azuma, your adventure will take you far beyond the familiar confines of your farm and starting town. The world of Azuma is a sprawling tapestry of diverse landscapes, each with its unique ecosystem, challenges, and hidden wonders. Understanding the **Regional Maps** and familiarizing yourself with the characteristics of each **Biome** is crucial for efficient resource gathering, strategic monster hunting, and fully immersing yourself in the rich environment.

1. The Importance of Regional Maps

Unlike town maps which detail a single settlement, regional maps provide a broader overview of entire geographic zones, connecting towns, dungeons, and various outdoor areas.

- **Global Navigation:** Your regional map (often called the World Map or Overworld Map) allows you to see the grand scale of Azuma, identifying how different areas are connected.

- **Planning Routes:** Strategize your daily expeditions, whether you're planning a trip to a distant mining spot, a specific monster habitat, or the entrance to a new dungeon.

- **Tracking Progression:** As you unlock new areas, they will appear on your regional map, providing a visual representation of your progress and the expanding world.

- **Fast Travel Hub:** The regional map often serves as the interface for any fast travel

systems you unlock.

- **How to Access:** Typically accessed from your Main Menu (Esc on PC, + button on Switch) under a "Map" or "World Map" tab. It might initially show only discovered regions, gradually revealing more as you explore.

2. Characteristics of Regional Maps

- **Overhead View:** Presents a bird's-eye view of large landmasses.
- **Connecting Paths:** Displays main roads, trails, and river routes that link various sub zones.
- **Key Icons:** Uses icons to denote:
 - **Towns/Villages:** Your home base and other settlements.
 - **Dungeon Entrances:** Gateways to hostile interior areas.
 - **Save Points/Warp Gates:** Locations where you can save or fast travel.
 - **Resource Nodes:** May show general areas where certain types of resources (e.g., dense forests for wood, mountain ranges for ore) are abundant.
 - **Player Position:** Always shows your current location.
- **Fog of War:** Undiscovered areas will typically be shrouded in a "fog of war" that clears as you explore.

3. Biome Descriptions: The Diverse Lands of Azuma

Each biome presents unique flora, fauna, and environmental challenges. Understanding these will help you prepare accordingly.

A. Verdant Hills / Grassy Plains (Starting Biome)

- **Description:** Lush, green landscapes with rolling hills, open fields, and gentle rivers. Features temperate weather and clear skies.
- **Resources:**
 - **Foraging:** Wild Grasses (Green, Yellow), basic Mushrooms, Turnip/Cabbage seeds (rarely).
 - **Woodcutting:** Common Trees (yields Wood).
 - **Mining:** Small rocks, Material Stone, Scrap Iron, Iron (rarely).
- **Monsters:** Woolies, Slimes, Goblins, Ants, Bees. (Weak to moderate difficulty).
- **Unique Features:** Often contains your first dungeon, initial farm plot, and the starting town. Good for early-game EXP and materials.

B. Whispering Woods / Bamboo Forests (Temperate/Oriental Forest)

- **Description:** Dense forests with tall trees (potentially bamboo thickets), winding paths, and a quieter, more enclosed atmosphere. May feature small streams or ponds.
- **Resources:**
 - **Foraging:** Unique mushrooms, specialty herbs, wild berries, perhaps bamboo shoots.
 - **Woodcutting:** Higher-quality Wood (e.g., Quality Wood,

Lumber+), specific tree types for unique lumber.
- **Mining:** Iron, Bronze, Silver (more common than Verdant Hills).
- **Monsters:** Forest-dwelling beasts (wild dogs, bears), insect swarms, forest spirits, tougher goblin variants. (Moderate difficulty).
- **Unique Features:** May contain hidden shrines, ancient trees, or a secluded waterfall. Often leads to a new town or a deeper dungeon.

C. Craggy Peaks / Volcanic Caverns (Mountain/Volcanic Biome)

- **Description:** Rugged, rocky terrain with steep inclines, perilous cliffs, and active volcanic elements (lava flows, geysers) or cold, windswept peaks.
- **Resources:**
 - **Foraging:** Fire/Ice elemental herbs, rare crystals, volcanic ash.
 - **Woodcutting:** Scarce trees, or fire-resistant/cold-resistant wood types.
 - **Mining:** Abundant high-tier ores (Silver, Gold, Platinum), rare crystals, and elemental stones (Fire Stone, Earth Stone, etc.).
- **Monsters:** Fire-elemental beasts (lava slimes, fire dragons), rock golems, winged creatures, stronger goblin/orc variants. (High difficulty).
- **Unique Features:** Often home to ancient mines, Dragon's Lairs, or the source of elemental disturbances. Requires good elemental resistance gear.

D. Frosted Expanse / Glacier Caves (Icy/Snowy Biome)

- **Description:** Vast, snow-covered plains, frozen lakes, and crystalline ice caves. Features slippery terrain and biting winds.
- **Resources:**
 - **Foraging:** Ice elemental herbs, snow-specific flowers, frozen fruits.
 - **Woodcutting:** Ice-resistant wood, or scarce trees.
 - **Mining:** Ice crystals, higher-tier metals (Platinum), and elemental stones (Ice Stone, Water Stone).
- **Monsters:** Ice wolves, snow golems, frosty elementals, arctic monsters, flying ice spirits. (High difficulty).
- **Unique Features:** May contain hidden ice temples, frozen ancient ruins, or unique fishing spots through ice holes. Cold resistance gear is essential.

E. Arid Dunes / Sunken Temple (Desert/Arid Biome)

- **Description:** Expansive sandy deserts, rock formations, and scorching temperatures. Might feature sandstorms or quicksand.
- **Resources:**
 - **Foraging:** Desert herbs, cacti, sun-baked fruits.
 - **Woodcutting:** Very scarce, possibly desert-specific resilient wood.
 - **Mining:** Unique desert minerals, ancient ores, Sun Stones, rare gems.

- **Monsters:** Sandworms, desert scorpions, fire elementals, desert bandits, mummified creatures. (Moderate to High difficulty).
- **Unique Features:** Often hides ancient temples, desert ruins, or oasis areas. Requires heat resistance or specific items to traverse safely.

F. Murky Swamps / Hidden Mire (Wetlands/Swamp Biome)

- **Description:** Waterlogged terrain, murky pools, dense reeds, and often a hazy, oppressive atmosphere. Slows movement.
- **Resources:**
 - **Foraging:** Poisonous plants, unique aquatic herbs, rare fungi.
 - **Woodcutting:** Water-resistant wood, or scarce.
 - **Mining:** Muddy ores, unique crystals.
- **Monsters:** Giant frogs, poisonous insects, plant monsters, corrupted spirits, aquatic beasts. (Moderate difficulty).
- **Unique Features:** May contain ancient, submerged ruins or isolated islands with rare resources. Can inflict poison or slow status.

G. Coastal Shores / Coral Reefs (Beach/Coastal Biome)

- **Description:** Sandy beaches, rocky coastlines, and clear waters extending to hidden coral reefs.
- **Resources:**
 - **Foraging:** Shells, unique seaweed, sea-based herbs.
 - **Woodcutting:** Driftwood, sturdy coastal trees.
 - **Mining:** Sandstone, unique coastal minerals.
- **Monsters:** Crabs, jellyfish, aquatic monsters, flying seabirds. (Low to Moderate difficulty).
- **Unique Features:** Excellent fishing spots for ocean fish. May lead to underwater dungeons or isolated islands.

H. Rune-Affected Zones / Mystical Realms (Unique Biomes)

- **Description:** Areas heavily influenced by concentrated Rune energy, often appearing fantastical, ethereal, or distorted. Can be visually stunning and contain unique environmental effects.
- **Resources:**
 - **Foraging:** Pure Rune Crystals, magical essence, rare elemental plants.
 - **Woodcutting:** Mystical wood types.
 - **Mining:** Pure elemental ores, high-tier magical minerals.
- **Monsters:** Pure elemental beings, corrupted spirits, unique magical creatures. (High to Very High difficulty).
- **Unique Features:** Often central to the main storyline, containing powerful Guardians, ancient secrets, or the final dungeons. May have unique puzzles or navigation challenges related to Rune energy.

4. Efficient Regional Exploration Tips

- **Use the World Map Frequently:** Always consult your regional map to plan your

route, identify undiscovered areas, and locate key points of interest.

- **Unlock Fast Travel:** Prioritize unlocking fast travel points (Warp Gates, Rune Circles) within each new region. This saves immense amounts of time.
- **Prepare for Biome Hazards:** Before entering a new biome, check the weather forecast, consider its typical monsters, and craft/equip gear to resist its primary elemental damage or status effects (e.g., heat resistance for deserts, cold resistance for snowy areas).
- **Bring Appropriate Tools:** An upgraded Axe for dense forests, an upgraded Hammer for mountains, and a good Fishing Rod for coastal areas.
- **Empty Inventory:** Always clear your inventory before venturing into a new, resource-rich biome to maximize your haul.
- **Don't Overextend:** If you're running low on HP/RP or struggling with the local monsters, use a Return spell/item to warp back to safety.
- **Explore Every Corner:** Even seemingly empty areas might hide a rare forageable, a secret mining node, or a hidden path to a unique sub-zone.
- **Observe Monster Behavior:** Note how monsters in new biomes react. Some are aggressive, others are docile until attacked.
- **Resource Respawn:** Remember that most resources (forageables, mining nodes) respawn daily or after a few in-game days. Plan repeat visits.

By mastering the regional maps and understanding the unique characteristics of each biome, you'll efficiently traverse the vast and wondrous world of Azuma, uncovering its every secret and fulfilling your destiny as its Guardian.

Fast Travel Routes and Hidden Areas

While exploring the vast world of Azuma is a core part of the adventure in *Rune Factory: Guardians of Azuma*, efficient travel is essential for managing your daily tasks, completing quests, and maximizing your time. Understanding the **Fast Travel Routes** and knowing how to find **Hidden Areas** will significantly enhance your exploration and resource gathering.

1. Fast Travel Systems

Rune Factory: Guardians of Azuma offers various methods to quickly traverse the map. Understanding each system and when to use it is key to efficient gameplay.

A. World Map Warp Points

- **Description:** Designated locations on the regional map that allow instant teleportation between them.
- **Mechanics:**
 - **Activation:** Warp points are typically activated by interacting with a specific object (e.g., a glowing stone tablet, a Rune circle). You usually need to discover and activate a warp point before you can use it.
 - **World Map Access:** Once activated, warp points appear on your regional map. Selecting one allows you to instantly travel to it from anywhere on the world map.

- **Cost:** Usually free, but some systems might have a small in-game time cost (e.g., using a warp consumes an hour).
- **Types:**
 - **Town Warp Points:** Allow quick travel between different towns. Essential for managing relationships, buying supplies, and fulfilling town-specific quests.
 - **Dungeon Entrances:** Warp directly to the entrance of cleared dungeons. Useful for repeated resource gathering or monster taming.
 - **Regional Hubs:** Connect major areas within a large region, cutting down travel time considerably.

B. Town-Specific Warp Points

- **Description:** Smaller-scale warp systems within a single town, allowing rapid movement between key locations.
- **Mechanics:**
 - **Activation:** Often available by default or unlocked after a certain point in the story or by upgrading the town.
 - **In-Town Map:** Displayed on the town map. Select a warp point to instantly move there.
 - **Limited Range:** Only works within the confines of a single town.
- **Examples:**
 - Warp between the General Store, your house, the town square, and the blacksmith within a large town.

C. Return Spell/Item

- **Description:** A magical spell or a consumable item that instantly teleports you back to your house or the entrance of the current area.
- **Mechanics:**
 - **Acquisition:** Typically learned early in the game (spell) or purchasable from a shop (item).
 - **Usage:** Cast the spell or use the item from your inventory.
 - **One-Way Trip:** Only allows you to return. You'll have to travel back manually or use another fast travel method.
- **Use Cases:**
 - Escaping a dangerous dungeon when low on HP/RP.
 - Quickly returning home to sleep and save at the end of the day.

D. Mounts

- **Description:** Rideable monsters that significantly increase your movement speed on the world map.
- **Mechanics:**
 - **Taming:** Requires taming a specific monster type (e.g., a large wolf, a bird).
 - **Summoning:** Summon the mount from your monster party.
 - **Speed Boost:** While mounted, your movement speed is greatly increased.
- **Additional Benefits:**

- Some mounts might have special abilities (e.g., jumping over obstacles, gliding).

2. Hidden Areas

The world of Azuma is full of secrets. Hidden Areas offer unique rewards and challenges for those who venture off the beaten path.

A. Types of Hidden Areas

- **Secret Passages:**
 - **Description:** Concealed paths within dungeons or on the world map.
 - **Discovery Methods:** Look for breakable walls, suspicious cracks, hidden switches, or interactable objects.
 - **Rewards:** May lead to treasure chests, rare resources, mini-boss encounters, or shortcuts.
- **Hidden Rooms:**
 - **Description:** Isolated chambers within dungeons, not immediately visible on the map.
 - **Discovery Methods:** Often behind secret passages, or require solving a puzzle to reveal.
 - **Rewards:** Typically contain valuable loot, rare crafting materials, or lore fragments.
- **Unmarked Locations on the World Map:**
 - **Description:** Areas not explicitly labeled on the regional map.
 - **Discovery Methods:** Explore off the main roads, follow winding paths, or look for unusual landmarks.
 - **Rewards:** May contain unique resource nodes, rare monsters, small side quests, or scenic vistas.
- **Time- or Weather-Dependent Areas:**
 - **Description:** Locations accessible only at specific times of day or during certain weather conditions.
 - **Discovery Methods:** Observe the environment and experiment. A path might be revealed only at night, or a cave entrance might be accessible only during rain.
 - **Rewards:** Often contain unique items or monsters that are only available at that time.
- **Event-Triggered Areas:**
 - **Description:** Locations that become accessible only after completing a specific quest or reaching a certain point in the story.
 - **Discovery Methods:** Follow the main questline and pay attention to NPC dialogue.
 - **Rewards:** May be essential for story progression or unlock powerful equipment.

B. Finding Hidden Areas: Tips and Techniques

- **Explore Thoroughly:** Don't just stick to the main paths. Check every corner of the map.
- **Observe Your Surroundings:** Look for anything out of the ordinary: suspicious walls, unusual patterns, interactable objects.

- **Listen for Clues:** Pay attention to NPC dialogue. They might hint at hidden locations.
- **Experiment:** Try interacting with the environment in different ways. Break walls, push blocks, activate switches.
- **Use Your Map:** Even if an area isn't marked, your map can reveal unexplored sections.
- **Check Back Regularly:** Hidden areas might become accessible after certain events or at different times.
- **Use Special Abilities:** If you have abilities like gliding or wall-climbing, use them to explore otherwise inaccessible areas.

By mastering fast travel and diligently searching for hidden areas, you'll uncover all the secrets that the world of Azuma has to offer, making your journey as a Guardian both efficient and rewarding.

Chapter 5

SECRETS OF SUCCESS – Tips, Tricks & Pro Strategies

Unlock your full potential as a Guardian of Azuma with this comprehensive guide to mastering the game's intricate systems. Discover advanced **combat mechanics and elemental matchups** to dominate any foe, optimize your **farming efficiency with seasonal planning**, and delve into **crafting upgrades and optimal recipes** for powerful gear. Learn how to **build relationships for hidden bonuses**, master **resource gathering and money-making tips**, and even uncover exciting **Easter Eggs and developer secrets**.

Combat Mechanics and Elemental Matchups

While Azuma invites you to live a peaceful life of farming and friendship, the call to adventure is never far. Mastering the intricate **combat mechanics** and understanding the vital role of **elemental matchups** are crucial for surviving treacherous dungeons, defeating formidable bosses, and safeguarding the land. This guide will elevate your fighting prowess from basic skirmishes to strategic mastery.

1. Core Combat Controls and Actions (Recap)

Before diving deep, let's briefly recall the fundamental actions that form the basis of all combat.

- **Basic Attack:** Your primary offensive action. Typically a quick, single hit or a short combo. (LMB on PC, A on Switch). Consumes minimal RP.
- **Charged Attack:** Hold down the attack button for a more powerful strike, often with a wider area of effect or unique properties. Consumes more RP. (RMB on PC, Y on Switch).
- **Dodge/Dash:** A quick evasion move that grants temporary invincibility frames, allowing you to avoid damage. Essential for surviving strong attacks. (B on Switch, dedicated key on PC).
- **Guard/Block:** Reduces incoming damage when timed correctly. Less effective against unblockable attacks or powerful boss moves. (RMB on PC, dedicated key on Switch).
- **Use Item:** Access your quick slot bar to consume healing items or buffs. (Number Keys on PC, L/R Shoulder Buttons to cycle, then A on Switch).

2. Weapon Types and Playstyles

Rune Factory: Guardians of Azuma offers a diverse arsenal, each weapon type catering to different combat preferences. Experiment to find what suits you best.

- **One-Handed Swords:**
 - **Pros:** Balanced attack speed and power, excellent for consistent damage and quick dodges. Often allows for a shield.
 - **Cons:** Shorter range.

- **Playstyle:** Versatile, good for beginners, adaptable to various situations.
- **Two-Handed Swords:**
 - **Pros:** High damage per hit, wider attack arcs, good for crowd control.
 - **Cons:** Slower attack speed, no shield, less mobility during combos.
 - **Playstyle:** Heavy hitter, relies on timing and positioning to unleash devastating blows.
- **Spears:**
 - **Pros:** Excellent reach, allowing you to attack from a safer distance. Good for poking and keeping enemies at bay.
 - **Cons:** Can feel less impactful on single hits, narrow attack arcs.
 - **Playstyle:** Ranged melee, safe and methodical.
- **Axes:**
 - **Pros:** High damage, capable of breaking enemy guards and stunning. Often doubles as a chopping tool.
 - **Cons:** Very slow attack speed, leaves you vulnerable during animations.
 - **Playstyle:** Powerful but risky, requires precise timing and openings.
- **Hammers:**
 - **Pros:** Extremely high damage, excellent for stunning enemies and breaking armor. Doubles as a mining tool.
 - **Cons:** Slowest attack speed, highest RP consumption, limited combo potential.
 - **Playstyle:** Burst damage, relies on charged attacks and stun opportunities.
- **Fists (Gloves):**
 - **Pros:** Fastest attack speed, relies on rapid combos and close-quarters combat. Often allows unique martial arts skills.
 - **Cons:** Very short range, lower damage per hit (but high DPS), requires constant aggression.
 - **Playstyle:** Aggressive, combo-focused, high-risk/high-reward.
- **Magic (Staves/Wands):**
 - **Pros:** Ranged attacks, powerful AoE spells, access to healing and status effects.
 - **Cons:** Relies heavily on RP, often lower physical defense, can be vulnerable when casting.
 - **Playstyle:** Tactical, crowd control, support, requires careful RP management.

3. Basic Combat Strategy

Beyond simply mashing buttons, mindful combat elevates your effectiveness.

- **Target Prioritization:** In groups, identify and eliminate dangerous enemies first (e.g., ranged attackers, healers, or those with annoying status effects).
- **Positioning:** Always be aware of your surroundings. Avoid getting cornered or surrounded. Use the environment (e.g., narrow corridors) to funnel enemies.

- **Hit-and-Run:** For tougher enemies, get a few hits in after they complete an attack, then immediately prepare to dodge their next move. Don't get greedy.
- **Guard Break:** Observe enemies (especially bosses) for a "guard break" gauge or visual cue. Landing specific attacks can deplete this, opening them up for massive damage.
- **Monster Companions:** Your tamed monsters are invaluable allies. They can draw enemy aggro, deal damage, or provide support. Remember to heal them with food if they get low on HP.

4. Special Combat Mechanics

- **Critical Hits:** Attacks that deal significantly more damage. Crit chance is often tied to your Luck stat, weapon attributes, and certain skills.
- **Status Effects (Inflicting & Resisting):**
 - **Positive (Buffs):** Increase your stats (e.g., Attack Up, Defense Up, Speed Up) or grant temporary effects. Applied via certain foods, spells, or accessories.
 - **Negative (Debuffs):** Affect enemies (Poison, Paralysis, Seal, Sleep, Stun). Applied via weapon attributes, magic, or monster abilities.
 - **Receiving Debuffs:** Enemies can also inflict debuffs on you. Carry status-curing items or equip gear with resistance.
- **Unique Skills/Spells:** As you level up weapon skills or magic skills, you'll unlock powerful new active abilities that consume more RP but have devastating effects. Master their timings.
- **Throwing:** Some items (e.g., throwing knives, certain crops) can be thrown at enemies for minor damage or to trigger elemental effects.

5. Elemental System: The Heart of Strategic Combat

Rune Factory: Guardians of Azuma likely employs a robust elemental system, which dictates weaknesses and resistances. Exploiting this is paramount for high-level combat.

A. The Elements of Azuma

While specifics may vary, *Rune Factory* games typically feature a core set of elements:

- **Fire:** Associated with heat, burning, and explosive damage.
- **Water:** Associated with cold, freezing, and fluid attacks.
- **Earth:** Associated with physical impact, stunning, and stability.
- **Wind:** Associated with speed, piercing, and aerial attacks.
- **Light:** Associated with holy damage, purity, and healing.
- **Dark:** Associated with shadows, curses, and draining effects.
- **Love/Neutral:** Often represents non-elemental or 'true' damage, or positive effects.
- **Poison/Seal/Paralysis:** These are usually distinct status effects rather than core elements, though some monsters might be associated with them.

B. Elemental Matchups (The "Elemental Wheel/Triangle")

Elements usually have strengths and weaknesses against each other. A common setup is:

- **Fire > Wind > Earth > Water > Fire** (a cyclic chain)
- **Light <> Dark** (Light is strong against Dark, and vice-versa, or one is simply 'holy' and the other 'unholy')
- **Neutral/Love** is typically effective against most, or no, elements.

How it Works:

- Attacks of an element strong against an enemy's inherent element/weakness will deal **bonus damage**.
- Attacks of an element weak against an enemy's inherent element/resistance will deal **reduced damage**.
- Enemies will have innate resistances to certain elements and weaknesses to others.

C. Applying Elemental Strategy

1. **Identify Enemy Elements/Weaknesses:**
 - **Visual Cues:** Enemies might glow with a specific color (red for fire, blue for water).
 - **Lore/Monster Book:** Your monster encyclopedia or character dialogue might provide hints.
 - **Experimentation:** Hit enemies with different elemental attacks and observe the damage numbers. Larger numbers indicate a weakness.
2. **Equip Elemental Weapons:** Craft or find weapons imbued with specific elemental properties. Switch weapons to match the current enemy type.
3. **Use Elemental Magic:** If you use magic, ensure you have spells of various elements to exploit weaknesses.
4. **Craft Elemental Resistance Gear:** Before a major boss fight or entering a new biome, craft armor or accessories that offer high resistance to the primary element of the dominant enemies in that area. This drastically reduces incoming damage.
5. **Cook Elemental Buffs:** Certain cooked dishes can grant temporary elemental attack boosts or resistances.

6. Advanced Combat Tips

- **Buff/Debuff Management:** Before a tough fight, use buffing items (attack up, defense up) on yourself and your companions. During a boss fight, try to apply debuffs (Poison, Paralysis) to the boss.
- **Analyze Boss Patterns:** Major bosses have distinct phases and attack sequences. Identify the "tells" for their most powerful attacks and learn when their vulnerability windows occur. Patience and observation are key.
- **Crowd Control:** For large groups of enemies, use AoE weapon attacks (e.g., two-handed sword swings, hammer slams) or area-of-effect spells to manage them effectively.
- **Optimal Skill Use:** Don't just spam your powerful skills. Use them strategically during enemy openings or to interrupt dangerous attacks.

- **Environmental Advantage:** Utilize the environment. Draw enemies into choke points, use obstacles for cover, or exploit environmental hazards.

7. HP and RP Management in Combat

These two bars are your lifeline.

- **RP for Offense:** High-damage charged attacks, powerful spells, and special skills all consume RP. Manage it carefully. Use RP-restoring foods to extend your offensive capabilities.
- **HP for Survival:** If your RP depletes, your attacks will start consuming HP, putting you in extreme danger. Always carry HP-restoring foods or potions.
- **Healing Timing:** Don't wait until you're at critical HP. Use a healing item when your HP is around 50% or after taking a significant hit, especially before an expected powerful enemy attack.
- **Emergency Retreat:** If overwhelmed or critically low, don't be afraid to use a "Return" spell/item to escape a dungeon and regroup. It's better to lose a bit of progress than to be defeated entirely.

By diligently practicing these combat mechanics and strategically applying elemental knowledge, you will transform from a novice adventurer into a formidable Guardian, ready to face any threat Azuma throws your way.

Farming Efficiency and Seasonal Planning

In *Rune Factory: Guardians of Azuma*, your farm is the cornerstone of your adventure. It's your primary source of income, a supplier of vital resources, and a place to relax between dungeon delves. Mastering **farming efficiency** and understanding **seasonal planning** are crucial for maximizing your yields, optimizing your daily routine, and ensuring a thriving homestead.

1. Understanding Seasons

The passage of time in *Rune Factory* is divided into distinct seasons, each with unique characteristics that affect your crops and farming activities.

- **Spring:** Often mild, with balanced rainfall. A good time for planting a wide variety of crops.
- **Summer:** Hot and sunny, with less rainfall. Certain crops thrive in the heat, while others require more watering.
- **Autumn:** Cooler, with moderate rainfall. Harvest season for many crops.
- **Winter:** Cold, with snowfall. Most crops cannot be grown outdoors. Focus on indoor activities like crafting or monster care.
- **Calendar:** A calendar in your house displays the current date, season, and upcoming festivals. Pay close attention to it.

2. Basic Farming Techniques (Recap)

- **Clearing Land:** Use your Axe to remove trees/stumps and your Hammer to break rocks/boulders.

- **Tilling:** Use your Hoe to till the cleared land into plantable squares.
- **Planting:** Select seeds from your inventory and plant them in tilled squares.
- **Watering:** Water your crops daily with the Watering Can.
- **Harvesting:** Interact with fully grown crops to harvest them.
- **Shipping:** Place harvested crops in the Shipping Bin for automatic sale at the end of the day.

3. Maximizing Crop Growth

- **Soil Quality:**
 - **Fertility:** Depletes over time. Use fertilizer to replenish it. Higher fertility means faster growth and better yields.
 - **Soil Health:** Can be affected by weeds or certain crop types. Rotate crops to maintain soil health.
 - **Crop Level:** Planting the same crop repeatedly on the same plot increases its level, resulting in higher-quality harvests.
- **Watering:** Water your crops daily. Neglecting to water slows growth and reduces yield.
- **Sunlight:** Most crops require sunlight. Avoid planting them in shaded areas.
- **Season:** Plant crops that are suited to the current season. Planting out-of-season crops results in stunted growth or death.
- **Runey/Element Concentration (If Applicable):** Some games feature Runey or elemental systems that affect crop growth. Maintain a balanced concentration of these elements on your farm for optimal results.
- **Crop Type:** Different crops have different growth times, yields, and selling prices. Plan your planting accordingly.

4. Efficient Daily Routine

- **Early Start:** Begin your day as early as possible to maximize the time you have for farming and other activities.
- **Prioritize Watering:** Water your crops first thing in the morning.
- **Harvest Mature Crops:** Harvest any fully grown crops.
- **Plant New Seeds:** Replenish your fields with new seeds. Consider planting a variety of crops for a balanced income.
- **Fertilize Regularly:** Check your soil fertility and apply fertilizer as needed.
- **Weed Removal:** Remove any weeds that appear on your farm. They lower soil health.
- **Automated Assistance:** Recruit monsters with farm work abilities (watering, harvesting) to automate tasks and save your RP.

5. Seasonal Crop Planning

- **Spring:** Good for a variety of crops. Fast-growing crops like turnips and cucumbers are good for early income.
- **Summer:** Heat-loving crops like corn, tomatoes, and pineapples thrive. Requires more frequent watering.
- **Autumn:** Harvest season for many crops planted in spring and summer. Good time

for planting root vegetables like sweet potatoes and carrots.

- **Winter:** Most outdoor crops cannot be grown. Focus on indoor activities, crafting, and preparing for the next spring. Some games may allow growing specific winter crops in greenhouses.
- **Crop Guide:** Consult the in-game crop guide or online resources to see which crops grow best in each season and their growth times.

6. Maximizing Profits

- **High-Value Crops:** Focus on growing crops with high selling prices.
- **Multiple Harvests:** Some crops can be harvested multiple times before needing to be replanted, increasing your yield.
- **Crop Level:** Higher-level crops sell for more.
- **Processed Goods:** Cooking and crafting can increase the value of your crops.
- **Shipping Bonuses:** Certain festivals or events may offer bonus prices for specific crops.
- **Storage:** Store excess crops in your refrigerator to prevent spoilage and sell them when prices are highest.

7. Automating Your Farm

- **Monster Helpers:** Tamed monsters with farm work abilities can automate watering, harvesting, and even tilling.
- **Irrigation Systems:** Some games may allow you to build automated watering systems.
- **Harvesting Tools:** Upgraded tools can increase your harvesting speed.

8. Advanced Farming Techniques

- **Crop Rotation:** Planting different crops in the same plot each season can help maintain soil health and prevent disease.
- **Intercropping:** Planting multiple types of crops in the same field can maximize yield and create a more diverse ecosystem.
- **Greenhouses:** If available, greenhouses allow you to grow out-of-season crops.
- **Seed Maker:** If available, use a seed maker to create higher-level seeds.

By mastering these farming techniques and planning your crops according to the seasons, you'll create a thriving and efficient farm that provides you with a steady income, vital resources, and a peaceful retreat from the challenges of adventuring.

Crafting Upgrades and Optimal Recipes

Beyond farming and fighting, **crafting** is the third pillar of your success in *Rune Factory: Guardians of Azuma*. Mastering the various crafting disciplines – **Forging**, **Chemistry**, and **Cooking** – allows you to create powerful weapons, resilient armor, potent medicines, and delicious dishes. This guide will walk you through upgrading your crafting stations and discovering optimal recipes to maximize your efficiency and power.

1. Understanding the Crafting Disciplines

Each crafting discipline serves a unique purpose and has its own associated skill level. Leveling these skills is crucial, as it unlocks new recipes, reduces RP consumption for crafting, and can even improve the quality of your creations.

A. Forging (Weapons & Armor)

- **Station:** Forge / Blacksmithing Table
- **Purpose:** Create and upgrade weapons (swords, spears, axes, hammers, fists, staves) and armor (shields, headwear, bodywear, footwear).
- **Key Materials:** Ores (Iron, Bronze, Silver, Gold, Platinum, Orichalcum), monster drops (Claws, Fangs, Scales, Furballs), elemental crystals.
- **Associated Skill:** Forging

B. Chemistry (Medicines & Potions)

- **Station:** Chemistry Set / Pharmacy Lab
- **Purpose:** Brew healing potions, RP recovery drinks, status-curing agents (Antidotes, Paralysis Cures), and temporary stat-boosting elixirs.
- **Key Materials:** Foraged grasses, herbs, monster fluids, rare crystals.
- **Associated Skill:** Chemistry

C. Cooking (Food & Dishes)

- **Station:** Kitchen / Cooking Utensils (Frying Pan, Pot, Oven, Mixer, Steamer)
- **Purpose:** Transform raw ingredients into prepared dishes that offer significantly higher HP/RP recovery, powerful temporary buffs, and valuable selling prices.
- **Key Materials:** Farmed crops, monster products (milk, eggs), fish, wild forageables.
- **Associated Skill:** Cooking

2. Acquiring and Learning Recipes

You won't know all recipes from the start. Learning new ones is an integral part of crafting progression.

- **Recipe Bread (Recipe Bread +):** The most common method. Consume "Recipe Bread" (or "Recipe Bread+" for higher-tier recipes) which can be:
 - Purchased from the General Store or Restaurant.
 - Obtained from monster drops in dungeons.
 - Found in treasure chests.
 - Received as quest rewards.
 - *Tip: Save often before eating Recipe Bread. If you don't learn a new recipe, you can reload and try again until you do, but this only works if your skill level is high enough for a potential new recipe.*
- **Skill Level Up:** As your crafting skill levels increase, you'll automatically learn a handful of new, basic recipes.
- **Request Board Quests:** Many villager requests will reward you with specific recipes upon completion.
- **NPC Dialogue/Events:** Some NPCs might give you recipes after certain friendship levels or specific character events.
- **Exploring & Discovery:** Rare recipes might be found in hidden chests in dungeons or as drops from boss monsters.

3. Crafting Upgrades: Enhancing Your Workshop

Upgrading your crafting stations significantly improves your efficiency and capability.

A. Buying/Crafting New Stations

- **Initial Tools:** You usually start with a basic cooking pot.
- **Purchasing:** Visit the General Store, Blacksmith, or a specialized furniture shop to buy more advanced crafting stations (e.g., Frying Pan, Oven, Mixer for cooking; a dedicated Chemistry Set).
- **Crafting:** Some advanced stations might need to be crafted yourself after acquiring the necessary recipe and materials.

B. Station Upgrades / Expansions (Your House)

- **House Upgrades:** Your first step to advanced crafting might be upgrading your house. Talk to the carpenter (often the General Store owner or a dedicated NPC) to expand your house. Larger houses provide space for more crafting stations and possibly specialized crafting rooms.
- **Benefits:** More space, better efficiency, potentially passive boosts to crafting success rate or quality.

4. Optimal Recipes: Maximizing Efficiency and Power

Not all recipes are created equal. Focus on those that provide the best returns for your effort and materials.

A. Forging: The Best Gear

- **Optimal Weapons:**
 - **Focus on High Base Attack:** Prioritize weapons with the highest base attack stat.
 - **Elemental Matching:** Craft weapons with elemental properties that match the weaknesses of the enemies in your current or upcoming dungeon.
 - **Status Infliction:** Weapons that have a chance to inflict Paralysis, Seal, or Sleep are incredibly useful for crowd control or boss stunning.
- **Optimal Armor:**
 - **High Defense & Magic Defense:** Craft armor with balanced physical and magical defense.
 - **Elemental Resistances:** Prioritize armor pieces that offer resistance to common elemental damage types (e.g., Fire, Water) or specific elements of a challenging boss.
 - **Status Resistance:** Craft accessories that boost resistance to debilitating status effects (e.g., Poison Resistance, Paralysis Resistance).
- **Upgrade Materials (Critical!):**
 - **Use Rare Items:** When upgrading equipment, using rare monster drops, boss drops, gems (e.g., Diamonds, Emeralds), or rare crops can significantly boost stats.
 - **Quality over Quantity:** A single high-level upgrade material is often better than many low-level ones.

- **Level 10 Upgrades:** Maxing out an item to +10 often unlocks its full potential or a hidden bonus.
- **Forge Skill Level:** Higher Forging skill reduces RP cost, increases success rate, and can lead to higher quality (and thus stronger) crafted items.

B. Chemistry: Potent Elixirs

- **Optimal Healing Potions:** Focus on the highest-tier healing potion recipes (e.g., Relax Tea, Healing Potion X) for maximum HP/RP recovery.
- **Status Cures:** Always have a stock of universal status cures (e.g., Antidote, Para-Gone) or specialized ones for specific boss fights.
- **Stat Buffs:** Identify recipes for temporary stat-boosting potions (e.g., Attack Potion, Defense Potion, Energy Drink) that are invaluable for boss battles or difficult dungeon crawls.
- **Chemistry Skill Level:** Higher Chemistry skill increases the potency of potions and reduces RP cost.

C. Cooking: Culinary Powerhouses

- **Optimal HP/RP Recovery:**
 - **Juices:** Fruit juices (e.g., Grape Juice, Pineapple Juice) are often excellent for RP recovery.
 - **Soups/Stews:** Hearty soups and stews (e.g., Seafood Gratin, Curry Rice) provide massive HP and RP recovery.
 - **Sashimi:** Simple to make with fresh fish, often provides good HP/RP.
- **Temporary Buffs:**
 - **Attack/Defense Boost:** Certain dishes provide temporary boosts to your combat stats.
 - **Elemental Resistance:** Meals can temporarily boost your elemental resistances, crucial for elemental boss fights.
 - **Status Resistances:** Some dishes can grant temporary immunity or high resistance to status effects.
- **Selling for Profit:** Cooked dishes often sell for significantly more than their raw ingredients. Cook high-level, high-value crops (e.g., Gold Potato, high-level pineapples) into dishes.
- **Gifts:** Cooked dishes are almost universally loved as gifts by townsfolk, quickly boosting friendship.
- **Cooking Skill Level:** Higher Cooking skill increases the quality of dishes, restores more HP/RP, and reduces RP cost.

5. Crafting Efficiency Tips

- **Hoard Materials:** Always collect all raw materials (ores, monster drops, crops). You never know when you'll need them for a new recipe.
- **Level Up Systematically:** Don't neglect any crafting skill. Keep crafting even low-level items to gradually increase your skill.
- **Cook Daily Meals:** Make cooking a part of your daily routine. It's a great way to use excess crops, restore RP, and level up your skill.
- **Check Recipes First:** Before adventuring, check what materials you need for desired

upgrades or recipes. This helps you target specific monster drops or mining nodes.
- **Farm for Specific Resources:** If a recipe requires a rare monster drop or a specific high-tier ore, dedicate a day to farming that dungeon or area.
- **Use Monster Products:** Tamed monsters can provide consistent sources of Milk, Eggs, Fur, and other valuable crafting ingredients.
- **Sell Excess Crafted Items:** High-quality crafted items, especially cooked dishes, can be very profitable.

By diligently upgrading your crafting stations, learning optimal recipes, and managing your materials, you will become a self-sufficient powerhouse in Azuma, capable of forging your own destiny and overcoming any challenge.

Building Relationships and Hidden Bonuses

While battling fierce monsters and cultivating bountiful crops are central to your journey in *Rune Factory: Guardians of Azuma*, the heart of the game truly lies in the vibrant community you join. Building meaningful **relationships** with the townsfolk is not merely a social pastime; it's a deep and rewarding system that unlocks unique stories, powerful advantages, and a hidden layer of bonuses crucial for your overall success.

1. The Relationship System: Hearts and Friendship Points

Every named NPC in Azuma has a **Friendship Level** (often represented by hearts, typically 0-10 or 0-15). This level increases as you interact positively with them.

- **How to Track:** You can typically view the friendship levels of all characters in your Main Menu (often under a "Relationships" or "Townsfolk" tab). Their current heart level will be displayed.
- **Relationship Categories:**
 - **Villagers/Friends:** All general townsfolk. Increasing their friendship unlocks character events and general benefits.
 - **Marriage Candidates (Bachelors/Bachelorettes):** Specific characters with whom you can pursue a romantic relationship, leading to dating and eventually marriage. These often have higher friendship caps and specific romantic events.
 - **Monster Companions:** Your tamed monsters also have a friendship level, which directly impacts their combat effectiveness and passive abilities.

2. Core Ways to Build Relationships

Consistency and thoughtfulness are key to forging strong bonds.

A. Talking Daily

- **Impact:** The simplest and most fundamental way to gain friendship points. Just greeting an NPC once a day will provide a small, consistent boost.
- **Tip:** Make it a part of your daily routine to talk to every named NPC you encounter. Even a quick "hello" adds up over time.

B. Giving Gifts

- **Impact:** The most significant and rapid way to increase friendship. The effect varies wildly based on whether the gift is liked, loved, disliked, or hated.
- **Likes (Small Heart Increase):** Most NPCs have a list of items they "like." These give a decent friendship boost.
- **Loves (Large Heart Increase):** Each NPC has one or two "loved" items. Giving these provides a massive friendship boost, often making them glow or react enthusiastically.
- **Dislikes (Small Heart Decrease):** Giving an NPC something they dislike will slightly decrease friendship.
- **Hates (Large Heart Decrease):** Giving a hated item will significantly decrease friendship and can be hard to recover from.
- **Universal Likes/Dislikes:**
 - **Universal Likes:** Cooked dishes are almost universally liked by all NPCs. High-level cooked dishes often provide the biggest boosts.
 - **Universal Dislikes:** Weeds, scraps, failed cooking dishes, or very common monster drops are often disliked or hated.
- **Tip:** Pay close attention to NPC dialogue! They will often drop hints about their favorite foods, materials, or hobbies. Check their character profile in the menu for more explicit hints. Gift them their loved item on their birthday for an enormous bonus!

C. Completing Requests

- **Request Board:** The primary source of villager quests, posted on a central board (e.g., outside the General Store).
- **Direct Requests:** Sometimes, an NPC will give you a quest directly if you talk to them repeatedly or trigger a specific event.
- **Impact:** Completing a request provides substantial friendship points with the quest giver, along with gold and item rewards.
- **Tip:** Check the Request Board daily. Prioritize requests from NPCs you want to befriend faster, or those that offer valuable item/recipe rewards.

D. Participating in Festivals

- **Impact:** Festivals provide unique opportunities for massive, town-wide friendship gains. Simply attending and participating in festival activities (e.g., fishing contest, cooking contest, martial arts tournament) boosts friendship with all attendees.
- **Tip:** Check your calendar and make sure to attend every festival. Winning contests often grants bonus friendship points.

E. Story Progression and Character Events

- **Impact:** As you progress through the main story, and as your friendship levels increase, unique "Character Events" will trigger. These often involve specific dialogue choices or minor quests that deepen your understanding of an NPC and provide significant friendship boosts.
- **Romantic Events:** For marriage candidates, specific "Love Events" will trigger at certain friendship/love levels, progressing your romantic relationship.

3. Hidden Bonuses and Unlocks from Strong Relationships

Beyond the warm feeling of friendship, high relationship levels offer tangible, in-game benefits that streamline your gameplay.

A. Expanded Shop Inventories and Discounts

- **Benefit:** Shopkeepers (General Store, Blacksmith, Clinic, Restaurant) will begin to sell new, higher-tier items, better seeds, advanced crafting recipes, or more potent medicines as your friendship with them increases. They might also offer discounts on their services.
- **Example:** A higher friendship with the Blacksmith might unlock recipes for powerful weapons or allow for cheaper equipment upgrades.

B. New Side Quests and Requests

- **Benefit:** NPCs will offer more complex and rewarding side quests as your friendship grows. These quests often lead to rare materials, unique items, or new areas.
- **Example:** A research-oriented NPC might ask you to delve into a dangerous dungeon to find a rare artifact, but only after they trust you.

C. Combat Assistance and Party Members

- **Benefit:** Many NPCs can eventually join your party in dungeons as companions. Their effectiveness in combat often scales with their friendship level. Higher friendship can unlock their most powerful abilities or make them tankier.
- **Monster Companions:** Higher friendship with tamed monsters increases their stats (HP, Attack, Defense) and their efficiency in farm work.

D. Cooking and Crafting Recipes

- **Benefit:** Some NPCs might gift you unique recipes for cooking, forging, or chemistry once your friendship reaches a certain level or you complete specific events.
- **Example:** A master chef might teach you their signature dish recipe.

E. Access to Exclusive Areas or Lore

- **Benefit:** Certain areas of Azuma might be locked behind an NPC's permission, which is granted only after achieving a high friendship level. They might also share crucial lore or hints about secrets only known to trusted friends.

F. Marriage and Family

- **Benefit:** The ultimate social bonus! Marrying a bachelor/bachelorette unlocks new character events, special dialogue, and the possibility of having a child. Your spouse might also offer unique daily services or combat support.

G. Passive Stat Boosts (Subtle)

- **Benefit:** While not always explicitly stated, simply having a high total friendship level across the town can subtly contribute to your character's overall well-being, potentially boosting HP, RP, or Luck.

4. Tips for Maximizing Relationships

- **The Daily Routine:** Make it a habit: Talk to everyone you can reach, check the Request Board, and give a loved gift to at least one key NPC.
- **Birthday Blitz:** Mark birthdays on your calendar! A loved gift on an NPC's birthday provides an enormous friendship boost – often several hearts at once.
- **Gift Hoarding:** Keep a small stock of common "liked" gifts for everyone, and save rarer "loved" items for special occasions (like birthdays) or when you want to quickly boost someone.
- **Prioritize Shopkeepers:** Befriending shopkeepers first ensures you get better access to crucial supplies earlier in the game.
- **Balance Socializing with Other Activities:** Don't neglect your farm or adventuring. Use your profits to buy gifts, and your dungeon runs to find materials for requests.
- **Listen and Learn:** Pay attention to dialogue. Characters often tell you what they like or what's important to them.
- **Don't Give Hated Gifts:** Seriously, avoid it at all costs. It's not worth the penalty. If you accidentally do, quickly give a loved gift to mitigate the damage.

By actively engaging with the vibrant personalities of Azuma, your journey will be richer, more rewarding, and filled with unexpected advantages that will aid you in becoming the true Guardian the land needs.

Resource Gathering and Money-Making Tips

In *Rune Factory: Guardians of Azuma*, your success hinges on a delicate balance between adventuring and domestic life. While exploring dungeons and battling monsters is essential, **resource gathering** and efficient **money-making** strategies are equally crucial for acquiring the materials and funds needed to upgrade your equipment, expand your farm, and ultimately, save the land. This guide will provide you with a comprehensive understanding of how to maximize your resource collection and generate a steady income.

1. Resource Gathering: The Foundation of Progress

Resources are the raw materials for crafting, cooking, and building. Efficient gathering is key to self-sufficiency.

A. Mining

- **Tool:** Hammer (Upgraded Hammer for better yields and access to higher-tier nodes)
- **Locations:**
 - **Mining Points:** Rocks and ore veins found on the world map and within dungeons.
 - **Specific Biomes:** Different biomes yield different ores (e.g., Iron in grassy areas, Silver in forests, Gold in mountains).
- **Ores:** Iron, Bronze, Silver, Gold, Platinum, Orichalcum (used for forging weapons and armor).
- **Gems:** Emeralds, Rubies, Sapphires, Diamonds (used for weapon/armor upgrades, selling for high prices).
- **Tips:**
 - **Upgrade Your Hammer:** A better hammer breaks rocks faster and gives you a chance for double or triple ore drops.

- **Target Specific Ores:** If you need a particular ore, focus on mining in the biome where it's most common.
- **Mining Points Respawn:** Mining points respawn daily or after a few in-game days. Remember their locations for repeat visits.
- **Luck Stat:** Higher Luck increases your chance of finding rare ores and gems.
- **Mining Skills:** Leveling up your Mining skill increases yield and reduces RP consumption.

B. Woodcutting

- **Tool:** Axe (Upgraded Axe for faster chopping and better wood quality)
- **Locations:**
 - **Trees:** Found in forests and wooded areas on the world map.
- **Wood Types:** Wood, Lumber, Quality Wood (used for crafting furniture, building upgrades).
- **Tips:**
 - **Upgrade Your Axe:** A better axe chops faster and yields higher-quality wood.
 - **Target Specific Trees:** Different tree types yield different kinds of wood.
 - **Wood Respawn:** Trees respawn daily or after a few in-game days.
 - **Strength Stat:** Higher Strength increases the amount of wood you get per chop.
 - **Axe Skills:** Leveling up your Axe skill reduces RP consumption and increases yield.

C. Foraging

- **Tool:** None (Your hands)
- **Locations:**
 - **Wild Plants:** Found scattered throughout the world map, often near rivers, in forests, or in specific biomes.
- **Items:** Wild grasses, herbs, flowers, mushrooms, fruits, vegetables. (Used for cooking, crafting, or selling).
- **Tips:**
 - **Explore Thoroughly:** Check every corner of the map.
 - **Seasonal Items:** Different forageable items appear in different seasons.
 - **Time of Day:** Some items might only appear at specific times of day.
 - **Luck Stat:** Higher Luck increases your chance of finding rarer forageable items.
 - **Foraging Skills:** Leveling up your Foraging skill increases the number of items you find.

D. Fishing

- **Tool:** Fishing Rod (Upgraded Fishing Rod for better catches)
- **Locations:**
 - **Fishing Spots:** Rivers, lakes, and coastal areas. Look for shimmering water.
- **Items:** Various types of fish (used for cooking, selling, or gifting).
- **Tips:**
 - **Upgrade Your Rod:** A better rod allows you to catch rarer and more valuable fish.
 - **Bait:** Some games may have bait systems. Use the correct bait to attract specific fish.
 - **Fishing Skills:** Leveling up your Fishing skill makes it easier to reel in fish.
 - **Time of Day/Weather:** Some fish might only appear at specific times or during certain weather conditions.

E. Monster Drops

- **Tool:** Your weapon!
- **Locations:**
 - **Dungeons:** Monsters in dungeons drop various items.
- **Items:** Claws, fangs, scales, fur, fluids, elemental stones (used for crafting weapons, armor, and potions).
- **Tips:**
 - **Target Specific Monsters:** If you need a particular drop, hunt the monster that carries it.
 - **Luck Stat:** Higher Luck increases the chance of rare monster drops.
 - **Weapon Skills:** Higher weapon skills can increase drop rates.
 - **Monster Info:** Check your monster encyclopedia for drop lists.

2. Money-Making Strategies: Building Your Fortune

A steady income is crucial for buying seeds, upgrading equipment, and expanding your farm.

A. Crop Farming (The Reliable Source)

- **Maximize Yields:**
 - **Fertilize:** Keep your soil fertility high for faster growth and better yields.
 - **Water Daily:** Water your crops every day.
 - **Crop Level:** Plant the same crop repeatedly to increase its level, resulting in higher-quality and more valuable harvests.
 - **Seasonal Planning:** Plant crops that thrive in the current season.
- **High-Value Crops:**
 - **Research:** Consult the in-game crop guide or online resources to identify the most profitable crops.
 - **Multiple Harvests:** Some crops can be harvested multiple times before needing replanting.
- **Processed Goods:**
 - **Cooking:** Cooking raw crops into dishes significantly increases their selling price.
 - **Crafting:** Some crops can be used in crafting recipes for even higher profits.
- **Shipping Bonuses:**
 - **Festivals:** Some festivals offer bonus prices for specific crops.
 - **Daily Prices:** Check the General Store daily. Sometimes they offer higher prices for certain items.

B. Monster Products (The Consistent Source)

- **Tame Monsters:** Tame monsters that produce valuable items (milk, eggs, fur).
- **Monster Barn:** Upgrade your monster barn to house more monsters.
- **Daily Collection:** Collect monster products daily and ship them.

C. Mining and Selling Ores/Gems (The High-Risk, High-Reward Source)

- **High-Value Ores/Gems:** Focus on mining for rarer ores and gems, which sell for significantly more.
- **Luck Stat:** Increase your Luck to improve your chances of finding valuable gems.
- **Upgrade Your Hammer:** A better hammer gives you a chance for double or triple ore drops.

D. Fishing (The Relaxing Source)

- **High-Value Fish:** Catch rare and large fish, which sell for more.
- **Upgrade Your Rod:** A better rod allows you to catch rarer fish.

- **Bait (If Applicable):** Use the correct bait to attract specific, valuable fish.

E. Completing Requests (The Socially Rewarding Source)

- **Check the Request Board Daily:** Completing requests provides gold rewards in addition to friendship points.
- **Prioritize High-Reward Requests:** Some requests offer significantly more gold than others.

F. Selling Crafted Items (The Skill-Based Source)

- **Craft High-Quality Items:** Craft weapons, armor, potions, and dishes with high stats or effects.
- **Level Up Crafting Skills:** Higher crafting skills result in better quality items that sell for more.

G. Monster Taming and Selling (The Risky Source)

- **Capture Strong Monsters:** Tame high-level monsters with good stats.
- **Sell to a Specific NPC:** Some games have an NPC who buys tamed monsters.

3. Tips for Efficiency and Maximizing Profits

- **Daily Routine:** Develop a daily routine that balances resource gathering with crop maintenance.
- **Prioritize Upgrades:** Invest your profits in upgrading your tools (Axe, Hammer, Fishing Rod) and crafting stations.
- **Storage:** Use your storage box to store excess resources and crops.
- **Sell Strategically:** Don't sell everything immediately. Wait for festivals or daily price bonuses.
- **Cook and Craft:** Processing raw materials into cooked dishes or crafted items significantly increases their value.
- **Automate:** Recruit monsters to automate farming chores and resource gathering.
- **Plan Ahead:** Check recipes and upgrade requirements before adventuring to know what resources to gather.
- **Explore Thoroughly:** Don't neglect any area. You might find valuable resources in unexpected places.
- **Luck Stat:** Increasing your Luck stat is beneficial for both resource gathering and money-making.

By mastering these resource gathering and money-making strategies, you'll ensure a steady flow of both materials and gold, empowering you to conquer any challenge and build a prosperous life in Azuma.

Easter Eggs and Developer Secrets

The world of Azuma is vast and meticulously crafted, and like many beloved games, *Rune Factory: Guardians of Azuma* is expected to hide charming **Easter Eggs** and subtle **Developer Secrets** for dedicated players to discover. While the game's release date is set for June 5, 2025, meaning specific in-game secrets are yet to be unveiled, this guide will prepare you for the types of hidden gems you might find, how to look for them, and why they add an extra layer of enjoyment to your adventure.

1. What are Easter Eggs and Developer Secrets?

- **Easter Eggs:** These are intentional inside jokes, hidden messages, references to other games/media, or quirky features placed by the developers. They don't usually impact gameplay but offer a fun nod to observant players.

- **Developer Secrets:** These can range from hidden areas with unique loot, secret characters, or alternative game mechanics that are not immediately obvious. Sometimes, they're simply "behind-the-scenes" details that offer insight into the game's creation.

2. Common Types of Secrets in the *Rune Factory* Series (and what to expect in Azuma)

Drawing from the rich history of the *Rune Factory* franchise, here are some typical secrets players might anticipate:

A. References to Previous *Rune Factory* Games

- **Returning Characters/Mentions:** A subtle portrait in a shop, an NPC mentioning a character from a previous game, or a legendary item named after a past protagonist.
- **Location Nods:** A rare book describing a place from a previous *Rune Factory* title, or a piece of dialogue referencing a past kingdom.
- **Familiar Recipes/Items:** A unique recipe or a particular item that has consistently appeared across the series.

B. Pop Culture and Gaming References

- **Dialogue Quirks:** NPCs might occasionally say lines that reference popular memes, movies, or other video games.
- **Environmental Details:** A specific object or arrangement of items that mirrors a scene or iconic element from another franchise.
- **Item Descriptions:** The flavor text for certain items might contain a clever pun or a subtle reference.

C. Developer Signatures and Inside Jokes

- **Hidden Messages:** Developers might hide their names, initials, or inside jokes in obscure places (e.g., carved into a tree, a sign in a forgotten corner).
- **NPC Quirks:** A character might have an unusual hobby or dialogue line that is a private joke among the development team.
- **Behind-the-Scenes Nods:** Occasionally, a book or dialogue might hint at the game's development process or initial concepts.

D. Gameplay-Related Secrets

- **Hidden Areas with Unique Loot:** Secret rooms in dungeons, hidden paths in overworld maps, or obscure corners of towns might contain rare treasure chests, powerful equipment, or unique resources.
- **Secret Bosses/Enemies:** Incredibly tough optional bosses that don't directly relate to the main story but offer a formidable challenge and unique drops. These are often found in very remote or hidden areas.
- **Rare Item Spawns:** Extremely rare items or resources that only appear under very specific, obscure conditions (e.g., a specific weather pattern, time of day, or phase of the moon).
- **Alternative Dialogue/Endings:** Making unusual choices in quests or reaching specific relationship levels might unlock unique dialogue branches or subtle variations in the game's ending.

3. How to Discover Secrets in Azuma

Finding these hidden gems often requires a blend of curiosity, persistence, and keen observation.

- **Explore Every Nook and Cranny:** Don't just stick to the main path. Investigate dead ends, walk along walls, check behind waterfalls, and look under bridges.
- **Interact with Everything:** Try pressing your interact button (E / A) on seemingly mundane objects. Bookshelves, signposts, unique rocks, or odd pieces of scenery can sometimes yield hidden dialogue or items.
- **Listen to NPC Dialogue Carefully:** Sometimes, NPCs will drop subtle hints about secrets or unusual occurrences, especially if you've built a strong friendship with them.
- **Experiment with Tools:** Use your Axe on suspicious trees, your Hammer on cracked walls, or your Fishing Rod in unusual bodies of water.
- **Pay Attention to Time and Weather:** Some secrets are only accessible or visible at certain times of the day, night, or during specific weather conditions.
- **Revisit Areas:** What might seem like a dead end early on could become accessible later after a story event or an upgrade.
- **Check Item Descriptions:** The flavor text for weapons, armor, and common items can sometimes contain humorous or secretive lore.
- **Monitor Achievement/Trophy Lists:** These lists sometimes hint at hidden objectives or unique interactions.

4. The Community's Role in Discovery

Due to the sheer number of potential secrets, the *Rune Factory* community often plays a vital role in discovering and documenting them.

- **Online Forums and Wikis:** After the game's release, dedicated fans will often share their discoveries on game forums, wikis, and social media platforms.
- **YouTube and Streamers:** Content creators often make videos showcasing hidden content, making them easy to find for others.

Embrace the joy of discovery in *Rune Factory: Guardians of Azuma*. The most rewarding secrets are often those you stumble upon yourself, adding a personal touch to your grand adventure. Happy hunting, Guardian!

Chapter 6

SOWING PROSPERITY – Mastering Farming and Seasons

Transform your farm into a thriving enterprise with this in-depth guide to Azuman agriculture. Discover comprehensive **seasonal crop guides** for optimal yields, master **soil management and fertilizer** techniques to boost quality, and learn about essential **tool upgrades and automation** for maximum efficiency. Plus, delve into the intricacies of **greenhouse mechanics** to farm year-round, ensuring your prosperity never wanes.

Seasonal Crop Guides

The rhythm of your farm in *Rune Factory: Guardians of Azuma* is intrinsically tied to the changing seasons. Just as in real life, different crops thrive in different climates, and understanding this seasonal cycle is the cornerstone of maximizing your farm's productivity and profitability. Mastering these **Seasonal Crop Guides** will transform your humble patch into a thriving enterprise, ensuring a steady flow of income and vital resources year-round.

1. Understanding the Seasons and Their Impact

Azuma experiences four distinct seasons: **Spring**, **Summer**, **Autumn**, and **Winter**. Each season lasts for a set number of days (typically 30 days per season in *Rune Factory* games, though this can vary).

- **Growth Conditions:** Each crop has a preferred season. Planting a crop in its designated season leads to optimal growth speed and higher yields. Planting out-of-season crops will result in significantly slower growth, withered crops, or even instant death upon planting.
- **Weather:** Seasons influence weather patterns (e.g., more rain in Spring/Autumn, less in Summer, snow in Winter), which affects your daily watering needs.
- **Festivals:** Important festivals are tied to specific dates within each season.

2. Reading Crop Information

Before planting, always check a seed's information. This is usually found in your inventory or at the General Store.

- **Growing Season:** Indicates which season(s) the crop will grow in. This is the most crucial piece of information.
- **Growth Time:** How many days it takes for the crop to fully mature.
- **Harvests:**
 - **Single Harvest:** The crop grows once, you harvest it, and the plant disappears (e.g., Turnip, Cabbage). You need to re-till and replant.
 - **Multiple Harvests (Regrowth):** The crop grows to maturity, you harvest it, and it regrows new produce after a few days without needing to replant (e.g., Cucumber, Corn). These are excellent for consistent income.
- **Selling Price:** The base price of the harvested crop.

- **Crop Level:** The quality level of the crop (e.g., Level 1, Level 5). Higher levels sell for more and are better for cooking/crafting.

3. Spring: The Season of Rebirth and Early Profits

Spring is your first and most vital farming season. It's forgiving and offers quick returns.

- **Climate:** Mild temperatures, balanced rainfall. Ideal for starting your farm.
- **Recommended Early-Game Crops:**
 - **Turnips:** Very fast growth time (often 4-5 days). Excellent for quick early gold and leveling your Farming skill. Single harvest.
 - **Cabbages:** Longer growth than Turnips, but higher selling price. Single harvest.
 - **Cucumbers:** Multiple harvests after initial growth. Good for consistent income throughout Spring. Also useful for cooking and gifting.
 - **Strawberries:** Multiple harvests. Good early cash crop.
- **Mid/Late-Game Spring Crops:**
 - **High-Level Crops:** Focus on getting high-level versions of the above for better profit.
 - **Green Peppers:** Another multi-harvest option.
 - **Potatoes:** Good mid-tier single harvest crop.
- **Spring Tips:**
 - Clear as much land as your RP allows.
 - Plant heavily. Prioritize multiple-harvest crops for steady income.
 - Use your early profits to upgrade your farming tools (Hoe, Watering Can) and buy more seeds.

4. Summer: The Season of Growth and Endurance

Summer brings the heat, favoring crops that love abundant sunlight. Be mindful of potential dry spells.

- **Climate:** Hot and sunny. May have less rainfall, requiring more diligent watering.
- **Recommended Early-Game Summer Crops:**
 - **Corn:** Multiple harvests. High selling price and versatile for cooking/monster feed. A great income generator.
 - **Tomatoes:** Multiple harvests. Good for cooking.
 - **Pineapples:** Very long growth time, but extremely high selling price per harvest. Multiple harvests. Plant early in the season!
- **Mid/Late-Game Summer Crops:**
 - **Pumpkins:** High selling price. Single harvest.
 - **Onions:** Used in many cooking recipes.
 - **Grapes:** Multiple harvests. Good for juices and gifts.
- **Summer Tips:**
 - Water your crops thoroughly, especially on sunny days. Consider upgrading your Watering Can to water more squares at once.

- Plant Pineapples as early as possible in Summer to maximize their harvests before Autumn.
- Be aware of any summer-specific monster incursions if they affect your farm.

5. Autumn: The Season of Harvest and Preparation

Autumn brings a cooler climate, ideal for a wide variety of crops and preparing for the lean winter months.

- **Climate:** Cooler temperatures, often with more rainfall than summer.
- **Recommended Early-Game Autumn Crops:**
 - **Sweet Potatoes:** Very profitable and quick-growing single harvest crop. Excellent for making money.
 - **Carrots:** Used in many recipes.
 - **Spinach:** Quick growth, good for cooking.
- **Mid/Late-Game Autumn Crops:**
 - **Bell Peppers:** Multi-harvest, good for cooking.
 - **Eggplants:** Multi-harvest.
 - **Yams:** Similar to Sweet Potatoes, very profitable.
- **Autumn Tips:**
 - Maximize planting of high-profit single-harvest crops like Sweet Potatoes to build up gold for winter.
 - Save some higher-level seeds for spring planting.
 - Stockpile non-seasonal cooking ingredients to get through winter.

6. Winter: The Dormant Season (Outdoor Challenges)

Winter is typically the most challenging season for outdoor farming.

- **Climate:** Cold, with frequent snowfall. Most outdoor crops cannot grow.
- **Outdoor Farming:** Unless you have very specific high-level soil conditions or unique winter crops, outdoor farming is largely impossible. Your crops will likely wither.
- **Focus Areas:**
 - **Indoor Activities:** Dedicate time to crafting (Forging, Chemistry), Cooking, and building relationships.
 - **Dungeon Diving:** Winter is an excellent time for extensive dungeon exploration, as you don't need to prioritize farm chores.
 - **Monster Care:** Focus on your monster barns, collecting monster products, and leveling up your monster companions.
 - **Greenhouse Farming:** This is where greenhouses become invaluable (see next section).
- **Recommended Winter Crops:**
 - **None (Outdoor):** For most crops, avoid planting outdoors.
 - **Winter-Specific Crops (if available):** Some *Rune Factory* games might have one or two unique winter crops that grow slowly in the snow.
- **Winter Tips:**

- Use the profits from Autumn to fund house upgrades, buy new tools, and prepare for Spring.
- Keep your tools upgraded for easier farming in the coming seasons.
- Focus on leveling up skills that don't depend on outdoor farming.

7. Perennial Crops (If Applicable)

- **Description:** Some crops, typically fruits like Grapes, Strawberries, or specific trees, may be "perennial," meaning they survive across multiple seasons once planted, and continue to yield produce.
- **Benefits:** Excellent long-term investments, providing consistent income without constant replanting.
- **Tip:** If you discover a perennial crop, consider dedicating a portion of your farm to it for stable, multi-seasonal profits.

8. Crop Leveling and Seeds

- **Increasing Crop Level:** Repeatedly planting crops in the same tilled soil (especially if soil health is good) or using certain fertilizers can increase the level of the harvested crop.
- **Seed Maker:** Once unlocked, a Seed Maker allows you to convert harvested crops into seeds of the same level, allowing you to gradually increase the quality of your seeds.
- **Benefit:** Higher-level crops sell for significantly more gold and make better ingredients for cooking and crafting.

9. Greenhouse Integration (Brief Mention)

- **Purpose:** Greenhouses (detailed in a separate section) are facilities that allow you to grow crops year-round, regardless of the outdoor season. They are invaluable for continuous income and growing rare, out-of-season crops.
- **Tip:** Work towards building a greenhouse as soon as possible, especially before Winter.

By meticulously planning your farm based on Azuma's seasons, understanding the unique needs of each crop, and consistently upgrading your tools, you'll ensure a bountiful harvest and sow the seeds of prosperity throughout your entire adventure.

Soil Management and Fertilizers

Beyond simply tilling and watering, the true secret to a flourishing farm in *Rune Factory: Guardians of Azuma* lies beneath your feet: **soil management**. The health and quality of your farm's soil directly impact crop growth speed, yield, and most importantly, the level of your harvested produce. Mastering **fertilizers** and understanding your soil's properties will unlock unparalleled farming efficiency and profitability.

1. The Vital Role of Healthy Soil

Think of your soil as the living foundation of your farm. Healthy, fertile soil translates directly into:

- **Faster Growth:** Crops mature more quickly, allowing for more harvests per season.
- **Increased Yields:** More crops harvested from a single square.
- **Higher Quality (Crop Level):** Crops will naturally grow to higher levels, significantly

increasing their selling price and effectiveness as cooking/crafting ingredients.
- **Disease Prevention:** Healthy soil can sometimes reduce the chance of crops withering or getting diseased.
- **Reduced RP Consumption:** Stronger soil can sometimes reduce the RP cost of certain farming actions on that square.

2. Understanding Soil Statistics

Every tilled square of your farm has underlying statistics that change over time. You can typically check these by tilling the square with your hoe or by standing on it and checking the in-game display.

- **Fertility (or Growth Rate):** This is the most crucial stat. It dictates how fast crops grow. It naturally decreases with each day a crop is planted or harvested.
 - **Low Fertility:** Stunted growth, slower maturation.
 - **High Fertility:** Rapid growth, quicker harvests.
- **Soil Health (or HP/Endurance):** Represents the overall vitality and resilience of the soil. It decreases when crops wither, are exposed to bad weather, or certain tools are overused. When soil HP reaches zero, the square becomes "exhausted" or "dead," unable to grow crops until revived.
- **Quality Level:** The inherent level of the soil itself. This is often harder to change than fertility but directly impacts the final crop level.
- **Size (or Max Level):** Represents the maximum level a crop can achieve on that square without additional enhancements. This often increases as you grow crops consistently on the same spot.
- **Attribute/Element (less common in all RF games):** Some games have soil that can absorb elemental attributes, affecting crop growth or granting elemental properties to harvests.

3. Factors Affecting Soil Health

- **Planting & Harvesting:** Every time a crop is planted or harvested, it draws nutrients, reducing soil fertility.
- **Weeds:** Leaving weeds on your farm drains soil health from adjacent squares.
- **Monsters:** Wild monsters wandering onto your farm can damage soil.
- **Overuse of Tools:** Repeatedly using your hoe or sickle on the same square without planting can deplete soil health.
- **Weather:** Severe weather (e.g., prolonged storms, blizzards) can negatively impact soil health.
- **Withered Crops:** Crops that wither due to out-of-season planting or neglect will significantly damage the soil they were on.

4. Fertilizers: Your Soil's Best Friend

Fertilizers are consumable items that directly improve various soil statistics. They are essential for maintaining high-quality farm plots.

A. Basic Fertilizer / Formula A (General Purpose)

- **Acquisition:** Often purchasable from the General Store, craftable via Chemistry, or dropped by certain monsters.

- **Effect:** Primarily boosts **Fertility (Growth Rate)**. This is your workhorse fertilizer for ensuring consistent, speedy growth.
- **Use:** Apply regularly to plots where crops are growing or after harvesting to prepare for new planting.

B. Greenifier / Formula B (Quality Enhancer)

- **Acquisition:** Often more expensive to buy or requires higher Chemistry skill to craft. Sometimes a rare monster drop.
- **Effect:** Significantly boosts **Quality Level** and **Size** of the soil. This helps crops grow to higher levels.
- **Use:** Apply to plots where you want to grow high-level crops. Ideal for perennial crops or long-growth crops that you want to maximize.

C. Withered Grass / Corn / 4-Leaf Clover (Soil Revitalizers & Boosters)

- **Withered Grass:** The default way to restore depleted **Soil Health**. Simply apply it to an "exhausted" or low-health square.
- **Corn (Processed):** Cooked Corn (Corn Gratin, etc.) can be used as fertilizer to restore Soil Health and a bit of Fertility.
- **4-Leaf Clover:** A rare forageable or monster drop. Applying it to a tilled square gives a massive, often permanent, boost to **Soil Quality Level** and **Max Size**. Extremely valuable.
- **Use:** Withered Grass/Corn are used for maintenance and recovery. 4-Leaf Clovers are for creating "super plots" for highest-level crops.

D. Root/Giantizer (Specialty Fertilizers)

- **Acquisition:** Often later-game purchases or high-level Chemistry recipes.
- **Root:** Increases the chance of crops producing higher-level seeds when harvested.
- **Giantizer:** Makes specific large crops (like turnips, potatoes, corn) grow into giant versions when planted in a 2x2 grid and watered simultaneously. Giant crops sell for significantly more and provide unique crafting materials.
- **Use:** Root for seed production. Giantizer for maximizing profit from giant crops.

5. Application Methods and Timing

- **How to Apply:** Equip the fertilizer from your quick slot or inventory and use it on a tilled farm square.
- **Timing:**
 - **Basic Fertilizer:** Apply daily or every few days to maintain high fertility, especially for multi-harvest crops or during long growth periods. Apply after harvesting and before replanting.
 - **Greenifier:** Apply when you first plant a new crop on a plot you want to level up. Repeated application on the same plot over time will further increase its quality level.
 - **Withered Grass/Corn:** Use when soil health is low, or a square becomes exhausted.
 - **4-Leaf Clover:** Use once on a prime square you want to dedicate to ultra high-level crops.

6. Tools for Soil Management: Beyond the Hoe

- **Hoe:** Not just for tilling! Your hoe's skill level and upgrades affect how much RP is consumed per till and the initial soil health of newly tilled squares.
- **Sickle:** Used to cut down crops. A low-level sickle might cut down the entire plant (including regrowth crops), but a **high-level sickle (e.g., Gold Sickle, Platinum Sickle)** can cut down fully grown crops *without destroying the root*, allowing you to re-till and replant in the same spot, saving RP and preserving some soil stats. Crucial for managing perennial crops or resetting plots without full degradation.

7. Optimal Soil Management Tips

- **Balanced Use of Fertilizers:** Use Basic Fertilizer for daily growth, Greenifier for long-term quality, and Withered Grass/Corn for health recovery.
- **Rotate Crops:** Don't grow the same crop repeatedly on the same square without break. Rotate crop types or leave a square fallow for a few days to allow soil to recover.
- **Clear Weeds Promptly:** Weeds actively drain soil health. Remove them daily.
- **Upgrade Your Sickle:** A high-level sickle is indispensable for maintaining soil quality, especially for multi-harvest crops that you want to reset.
- **Dedicated "Leveling" Plots:** Designate a few squares on your farm (ideally with a 4-Leaf Clover applied) specifically for growing high-level crops or crops you want to turn into high-level seeds with the Seed Maker.
- **Check Soil Stats Regularly:** Get into the habit of checking the fertility and health of your plots, especially for your most valuable crops.
- **Monster Helpers:** Some tamed monsters can assist with farm work, including fertilizing or harvesting, saving your RP.

By meticulously managing your soil and strategically applying fertilizers, you'll ensure your Azuman farm remains a powerhouse of growth, yielding not just prosperity, but also the high-quality ingredients and materials needed for your greatest adventures.

Tool Upgrades and Automation

As a Guardian of Azuma, your days are a delicate balance of adventuring and nurturing your farm. To truly excel at both, you'll need to move beyond basic equipment. **Tool upgrades** are essential for boosting your efficiency, reducing your daily RP consumption, and unlocking access to higher-tier resources. Complementing this, **automation** through monster helpers and advanced farm facilities will transform your homestead into a self-sustaining powerhouse, freeing you to pursue grander adventures.

1. The Indispensable Value of Tool Upgrades

Upgrading your farming tools is one of the most impactful investments you can make. The benefits are profound:

- **Increased Efficiency:** Perform tasks faster and clear larger areas with fewer swings.
- **Reduced RP Consumption:** Each upgrade typically lowers the RP cost per use, allowing you to do more work in a day before tiring.

- **Access to Higher-Tier Resources:** Stronger tools can break tougher rocks, chop down larger trees, or harvest higher-level crops that weaker tools cannot.
- **Improved Quality & Yield:** Upgraded tools can increase the quality of materials gathered (e.g., higher-level wood/ores) or improve crop yields.
- **Unlocking New Functionality:** Some upgrades unlock entirely new ways to use a tool (e.g., charged attacks covering larger areas).

How Tool Upgrades Work:

1. **Access the Forge:** Visit the Blacksmith in town (e.g., Goro) or use a personal Forge if you've built one in your home.
2. **Select Upgrade:** Choose the tool you wish to upgrade.
3. **Materials & Gold:** Each upgrade level requires specific materials (primarily ores, but also monster drops or gems) and a gold fee.
4. **Forging Skill:** Your own Forging skill level must meet or exceed the requirement for the desired upgrade.
5. **Success Rate:** Higher Forging skill and using higher-quality materials can increase the success rate, preventing wasted materials.

2. Detailed Tool Upgrade Breakdown

Each core farming tool has its own upgrade path, offering unique benefits.

A. Hoe Upgrades

- **Purpose:** Tills land for planting.
- **Upgrade Benefits:**
 - **Wider Area:** Later upgrades allow you to till larger squares at once (e.g., 1x3, 3x3, 5x5).
 - **Reduced RP:** Each tier reduces the RP cost per square tilled.
 - **Improved Soil Health:** Tilling with a better hoe can sometimes leave the soil in better initial condition.
- **Progression (Examples):** Basic Hoe → Iron Hoe → Bronze Hoe → Silver Hoe → Gold Hoe → Platinum Hoe → Legendary Hoe.
- **Materials:** Primarily various Ores (Iron, Bronze, Silver, etc.).

B. Watering Can Upgrades

- **Purpose:** Waters crops.
- **Upgrade Benefits:**
 - **Increased Capacity:** Holds more water, reducing trips to refill.
 - **Wider Area:** Later upgrades allow you to water larger areas at once (e.g., 1x3, 3x3, 5x5).
 - **Reduced RP:** Lowers RP cost per square watered.
- **Progression (Examples):** Basic Watering Can → Iron Watering Can → Bronze Watering Can → Silver Watering Can → Gold Watering Can → Platinum Watering Can → Legendary Watering Can.
- **Materials:** Primarily various Ores.

C. Axe Upgrades

- **Purpose:** Chops trees and stumps.
- **Upgrade Benefits:**
 - **Increased Damage/Chop Power:** Chops down trees faster (fewer swings).
 - **Stump Clearing:** Allows you to chop down larger, tougher stumps that block farm land.
 - **Higher Wood Quality:** Chance to yield higher-level wood (e.g., Quality Wood, Lumber+).
 - **Reduced RP:** Lowers RP cost per chop.
- **Progression (Examples):** Basic Axe → Iron Axe → Bronze Axe → Silver Axe → Gold Axe → Platinum Axe → Legendary Axe.
- **Materials:** Primarily various Ores, sometimes specific monster drops.

D. Hammer Upgrades

- **Purpose:** Breaks rocks and mining nodes.
- **Upgrade Benefits:**
 - **Increased Damage/Break Power:** Breaks rocks and ore nodes faster.
 - **Access to Tougher Nodes:** Allows you to smash larger, tougher rocks and ore veins that yield rare minerals.
 - **Higher Ore Quality:** Chance to yield higher-level ores and gems.
 - **Reduced RP:** Lowers RP cost per smash.
- **Progression (Examples):** Basic Hammer → Iron Hammer → Bronze Hammer → Silver Hammer → Gold Hammer → Platinum Hammer → Legendary Hammer.
- **Materials:** Primarily various Ores, sometimes specific monster drops.

E. Sickle Upgrades

- **Purpose:** Cuts grass, weeds, and crops.
- **Upgrade Benefits:**
 - **Wider Area:** Cuts a larger area at once.
 - **Higher-Quality Fodder:** Yields more or higher-quality Fodder (for feeding monsters).
 - **Crop Harvesting (Crucial!):** Higher-level sickles can cut down crops without destroying their roots, allowing you to re-till and replant *while preserving the crop's level and soil health*. This is invaluable for high-level crop farming.
 - **Reduced RP:** Lowers RP cost per swing.
- **Progression (Examples):** Basic Sickle → Iron Sickle → Bronze Sickle → Silver Sickle → Gold Sickle → Platinum Sickle → Legendary Sickle.
- **Materials:** Primarily various Ores, sometimes monster parts.

F. Fishing Rod Upgrades

- **Purpose:** Catches fish.
- **Upgrade Benefits:**
 - **Increased Range:** Cast your line further.

- **Easier Catches:** Makes reeling in fish easier.
- **Rarer Catches:** Increases your chance of catching rarer, larger, or more valuable fish.
- **Reduced RP:** Lowers RP cost per cast.

- **Progression (Examples):** Basic Fishing Rod → Iron Fishing Rod → Bronze Fishing Rod → Silver Fishing Rod → Gold Fishing Rod → Platinum Fishing Rod → Legendary Fishing Rod.
- **Materials:** Primarily various Ores, sometimes monster fluids or specific fish parts.

3. Farming Automation: Working Smarter, Not Harder

Once you've upgraded your tools, the next step is to introduce automation to free up your precious time and RP.

A. Monster Helpers

- **Concept:** Tamed monsters can be assigned to perform farm chores, allowing you to focus on adventuring, crafting, or socializing.
- **Mechanics:**
 - **Taming:** Befriend various monsters (often by giving them liked items).
 - **Monster Barn:** You'll need to build and upgrade Monster Barns to house more monsters.
 - **Assigning Tasks:** In the monster barn menu, you can assign monsters to specific tasks like "watering," "harvesting," or "tilling." Their efficiency depends on their friendship level and stats.
- **Benefits:**
 - **Save RP:** You no longer need to spend your own RP on assigned chores.
 - **Consistent Work:** Monsters work daily, regardless of your activities.
 - **Increased Productivity:** You can cover more ground than you could manually.
- **Tips:**
 - Tame multiple monsters for different tasks.
 - Level up your monsters and increase their friendship to boost their efficiency.

B. Greenhouses

- **Concept:** A specialized farm building that allows you to grow crops year-round, regardless of the outdoor season.
- **Mechanics:**
 - **Construction:** Requires significant materials (often high-tier wood, stone, glass) and gold.
 - **Environmental Control:** The greenhouse maintains its own internal season (usually a season of your choice, like Spring or Summer), bypassing outdoor weather effects.
- **Benefits:**

- **Continuous Income:** Grow high-profit crops continuously, even in Winter.
- **Rare Crop Cultivation:** Grow multi-season crops or specific crops that are hard to get in their native season.
- **Crop Leveling:** Ideal for continuously growing and leveling up specific crops to their maximum.
- **Tips:** Prioritize building a greenhouse as soon as possible, especially before Winter.

C. Other Potential Automation (Game Dependent)

- **Auto-Watering Systems:** Some games might offer sprinkler systems or other devices that automatically water certain areas.
- **Shipping Box Upgrades:** Could increase the capacity or efficiency of your shipping bin.
- **Specialized Monster Farm Equipment:** Unique equipment that assists monster production.

4. Prioritization and Resource Management for Upgrades

- **Early Game:**
 - **Hoe & Watering Can:** Upgrade these first for faster, more efficient basic farming and quicker RP recovery.
 - **Axe & Hammer:** Next, upgrade these to clear more land and access better early-game ores for further upgrades.
- **Mid Game:**
 - **Sickle:** A high-level sickle becomes crucial for maintaining crop levels and soil health.
 - **Fishing Rod:** Upgrade if fishing is a significant source of income/ingredients for you.
 - **Monster Barn:** Start building and upgrading barns to get monster helpers.
- **Late Game/Endgame:**
 - **Greenhouse:** A major investment, but pays off immensely for year-round farming and high-level crop production.
 - **Final Tool Tiers:** Push your tools to their highest levels for maximum efficiency and access to all resources.
- **Resource Hoarding:** Always collect all ores and monster drops, even if you don't immediately need them. They are essential for upgrades.
- **Farm for Gold:** Use your farm profits to fund these expensive upgrades.

By diligently upgrading your tools and strategically investing in automation, you will transform your farm into an efficient, self-sustaining marvel, freeing you to fully embrace your destiny as a Guardian of Azuma.

Greenhouse Mechanics

As you progress deeper into your life as a Guardian of Azuma, you'll inevitably encounter the challenge of seasonal farming. While outdoor plots are beholden to the whims of Spring, Summer, and Autumn, **Greenhouses** offer the ultimate solution:

year-round cultivation regardless of the weather outside. Mastering these crucial structures will elevate your farm to unprecedented levels of productivity and profit.

1. The Purpose of the Greenhouse

The Greenhouse is a cornerstone of advanced farming in *Rune Factory: Guardians of Azuma*, serving several vital purposes:

- **Year-Round Farming:** Its primary function is to allow you to grow any crop in any season, completely bypassing outdoor seasonal restrictions. This is especially critical during the harsh Winter months when outdoor farming becomes impossible.
- **Optimal Growth Conditions:** You can set the internal season of a Greenhouse, ensuring your crops always grow under their most ideal conditions.
- **Consistent Income:** Provides a continuous source of income from high-value crops, even when other farm plots are dormant.
- **Crop Leveling Hub:** Ideal for continuously cultivating and leveling up specific crops to their maximum quality for better selling prices and superior crafting/cooking ingredients.
- **Rare Crop Cultivation:** Necessary for growing certain rare or exotic crops that might have very specific seasonal needs or extended growth times.

2. Acquisition and Construction

Acquiring your first Greenhouse is usually a mid-to-late game objective, requiring significant investment and progression.

- **Unlocking the Blueprint/Option:**
 - **Story Progression:** The option to build a Greenhouse might be unlocked after reaching a certain point in the main story.
 - **Farming Skill Level:** Achieving a high farming skill level (e.g., Farming Level 50+) could be a prerequisite.
 - **Specific Quest:** An NPC might offer a quest to build a Greenhouse, requiring you to gather rare materials.
 - **Carpenter/Builder NPC:** You'll likely need to speak to the town's carpenter or a designated builder NPC to initiate construction.
- **Required Materials:** Greenhouses are substantial structures and will demand a significant amount of high-tier building materials. Expect to gather:
 - **Lumber/Wood:** Large quantities of high-quality wood (e.g., Quality Lumber, Hardwood).
 - **Material Stone/Stone:** Large quantities of high-tier stone (e.g., Shiny Stone, Orichalcum).
 - **Glass/Crystals:** Unique materials like Glass, Crystal Fragments, or even rare Gems might be required for the transparent roofing.
 - **Gold:** A substantial gold fee will also be necessary.
- **Construction Time:** Building a Greenhouse may take a few in-game days,

during which the builder NPC might be unavailable.

3. Internal Mechanics

Once constructed, a Greenhouse functions as its own miniature farming ecosystem.

- **Internal Season Control:**
 - **Setting the Season:** A panel or control interface inside the Greenhouse allows you to select its desired internal season (Spring, Summer, Autumn). You cannot usually set it to Winter, as the purpose is to grow crops *during* Winter.
 - **Changing Seasons:** You can typically change the internal season at any time, but be aware that changing the season while crops are growing might cause them to wither if they are not compatible with the new season.
 - **Benefits:** This allows you to perpetually grow your most profitable crops (e.g., Summer Pineapples) or crops needed for specific recipes, even if it's Winter outdoors.
- **Soil Health:**
 - Greenhouse plots still have soil health and fertility, similar to outdoor plots.
 - You will still need to manage them with **fertilizers** (Basic Fertilizer, Greenifier) and **Withered Grass** to maintain optimal growth and quality.
- **Watering:** Crops within the Greenhouse still require daily watering.
 - **Manual Watering:** You can manually water with your Watering Can.
 - **Automation:** Some Greenhouses might have upgrades or spaces for automated sprinklers (if available in the game) or allow you to assign monster helpers to water.
- **RP Consumption:** Farming actions within the Greenhouse (tilling, planting, watering, harvesting) still consume your RP, just like outdoor farming.
- **Limited Space:** While invaluable, Greenhouses typically have a limited number of plots compared to your expansive outdoor farm. This means you'll need to strategically choose what to grow inside.

4. Benefits of Greenhouse Farming

The advantages of owning a Greenhouse are immense, significantly boosting your late-game economy and capabilities.

- **Continuous Income:** Plant multiple-harvest, high-value crops (like Pineapples or Strawberries) and harvest them non-stop, creating a steady stream of gold regardless of the outdoor season.
- **Leveling Rare Crops:** Ideal for consistently growing high-level versions of valuable crops that might take many seasons to reach maximum level.
- **Year-Round Ingredient Supply:** Ensures you always have a fresh supply of seasonal ingredients for cooking and crafting, even when they're out of season outdoors.

- **Resource Independence:** Less reliance on relying solely on dungeon dives for income during specific seasons.
- **Experimentation:** Provides a safe environment to experiment with new crop types or advanced farming techniques without worrying about seasonal changes.

5. Optimal Usage Strategies

To get the most out of your Greenhouse, consider these strategies:

- **High-Profit, Multi-Harvest Crops:** Dedicate most of your Greenhouse space to crops that yield multiple harvests and sell for high prices (e.g., Pineapples in a "Summer" Greenhouse, Strawberries in a "Spring" Greenhouse).
- **High-Level Crop Production:** Use Greenifiers and potentially 4-Leaf Clovers on dedicated Greenhouse plots to grow crops to Level 10. These sell for astronomical prices and are ideal for crafting the best dishes or gifts.
- **Seed Production:** If you have a Seed Maker, use your Greenhouse to consistently grow high-level crops and convert them into high-level seeds. These seeds can then be sold for profit or used on your outdoor farm in their native season.
- **Rare/Long-Growth Crops:** Plant crops that take a very long time to mature or have unique seasonal requirements here, ensuring they don't wither.

- **Winter Farming Hub:** In Winter, your Greenhouse becomes your primary source of agricultural income and fresh ingredients. Shift your focus indoors for farming during this season.
- **Companion Integration:** If monster helpers can work inside the Greenhouse, assign them to water or harvest, further automating your income.

6. Integration with Overall Farm Management

The Greenhouse doesn't replace your outdoor farm; it complements it.

- **Resource Supply:** Your outdoor farm will still be crucial for initial seed production, lower-tier crops for daily use, and collecting various building materials (wood, stone).
- **RP Management:** While monsters can help, farming in the Greenhouse still consumes your RP. Balance your indoor farming with other activities like adventuring or crafting.
- **Financial Investment:** The initial cost of a Greenhouse is substantial, but the long-term returns make it one of the most worthwhile investments in the game.

By strategically building and utilizing your Greenhouse, you'll ensure continuous prosperity, unparalleled farming efficiency, and the ultimate control over Azuma's rich agricultural bounty, allowing you to freely pursue your destiny as its Guardian.

Chapter 7

FORGE AND FLAME – Crafting and Equipment

Ignite your inner artisan with this ultimate guide to crafting and gear mastery! Learn the intricacies of **weapon and armor crafting** to forge unstoppable equipment, discover the secrets of **accessory creation and powerful buffs**, and pinpoint the best locations for **material farming and rare drops**. Finally, outfit yourself with the **best equipment tailored for each playstyle**, ensuring you're battle-ready for any challenge Azuma throws your way.

Weapon and Armor Crafting

As a Guardian of Azuma, raw strength isn't enough; you need the right tools for the job. Mastering **Weapon and Armor Crafting**, primarily through the **Forging** skill, is paramount to your survival and success. This discipline allows you to create powerful armaments and resilient protection, tailored to your evolving needs and the formidable challenges ahead.

1. The Art of Forging: Your Path to Power

Forging is the process of creating and enhancing weapons (swords, spears, axes, etc.) and armor (shields, headgear, bodywear, footwear) using raw materials.

- **Associated Skill:** Forging.
 - **How to Level Up:** Primarily by successfully crafting items at the forge. You also gain experience even if you fail, albeit less. Crafting higher-level recipes grants more experience.
 - **Benefits of High Forging Skill:** Unlocks more complex recipes, reduces the RP cost of crafting, increases the success rate of crafting attempts, and significantly boosts the hidden bonuses applied to crafted items (see section 5).
- **Importance:**
 - **Direct Power Increase:** Crafting superior gear is often the most significant way to boost your Attack, Defense, and Magic Defense stats.
 - **Elemental Advantage:** Allows you to create weapons and armor with specific elemental properties or resistances.
 - **Status Effect Control:** Infuse gear with status effects (Paralysis, Seal) for combat, or resistances (Poison Resist) for defense.
 - **Cost-Effective:** Crafting is generally much cheaper than buying high-tier equipment from shops, especially once you have a good material supply.

2. Accessing the Forge

You'll utilize specific stations for forging.

- **Blacksmith's Shop (e.g., Goro's Forge):**
 - **Initial Access:** This will be your primary forging location for a significant portion of the game.
 - **Services:** Offers a crafting interface where you can choose

recipes, input materials, and execute the forging process.

- **Personal Forge:**
 - **Acquisition:** After upgrading your house sufficiently, you may be able to purchase or craft a personal forge (or a dedicated "Forge Room" expansion).
 - **Benefits:** Convenience. No need to travel to town, saving time and allowing you to craft late into the night.

3. Basic Forging Mechanics

Understanding the core process is crucial for successful crafting.

- **Required Materials:** Each recipe has a list of specific materials (e.g., "Iron," "Wooly Furball," "Small Crystal") or material categories (e.g., "Any Ore," "Any Claw").
- **RP Consumption:** Every forging attempt consumes your Rune Points (RP). Higher-level or more complex recipes consume more RP. If your RP is insufficient, the craft will consume your HP instead.
- **Forging Skill Requirement:** Each recipe has a recommended Forging skill level. Attempting recipes significantly above your skill level will result in a very low success rate, but still grants experience even on failure.
- **Success Rate:** A percentage displayed before crafting indicates your chance of success. Higher skill, better quality materials, and certain buffs can increase this. Failing a craft usually results in a "Scrap Metal" or "Object X" and consumed RP/HP, but you keep your core materials.
- **Quality of Crafted Item:** The level of the materials used in the recipe (especially the primary ingredients) directly influences the final level of the crafted item. Higher-level materials (e.g., Level 10 Iron) yield higher-level equipment.

4. Learning New Recipes

Your recipe book doesn't fill itself! Actively seek out new recipes.

- **Recipe Bread (Weapon Bread / Armor Bread):**
 - **Source:** Purchase from the General Store, Restaurant, or specific vendors. Dropped rarely by certain monsters or found in dungeon chests.
 - **Usage:** Consume the bread to learn a new recipe within your current skill level range. "Recipe Bread+" is for higher-tier recipes.
 - **Tip:** Save before eating Recipe Bread. If you don't learn a new recipe (because you know them all for your skill level), reload and try again later when your skill is higher or in a new area.
- **Skill Level Up:** Automatically learn basic recipes as your Forging skill increases.
- **Request Board Quests:** Many villager requests reward specific weapon or armor recipes upon completion.
- **Exploring Dungeons:** Some unique recipes are found in treasure chests or dropped by specific bosses.
- **NPC Dialogue/Events:** Certain characters might teach you recipes after specific friendship levels or events.

5. Upgrading and Enhancing Equipment (The Deep Dive!)

This is where crafting truly shines, allowing you to customize and vastly improve your gear. You can upgrade an item a certain number of times (typically up to +9 or +10).

- **Process:**
 - Place the weapon/armor you want to upgrade in the designated slot at the Forge.
 - Place the material you want to upgrade *with* in the material slot.
 - Confirm the upgrade.
 - Each successful upgrade increases the item's level (e.g., a Sword +1, +2, etc.).
- **General Upgrade Materials:** Any item you have can technically be used as an upgrade material, but their effects vary wildly.
 - **Ores:** Primarily increase Attack (weapons) and Defense (armor).
 - **Monster Drops:** Provide stat boosts (e.g., Claws for ATK, Furballs for DEF) and often elemental resistances or status effects.
 - **Gems:** Provide significant stat boosts and sometimes elemental resistances.
 - **Crops/Processed Foods:** Can also provide stat boosts or elemental resistance, especially high-level ones.
- **The Power of Item Level (Hidden Bonus):**
 - **Total Level Used (TLU):** Every item in *Rune Factory* has a hidden level (1-10). When you craft or upgrade an item, the total level of all materials used (up to a certain number of slots/upgrades) contributes to a hidden "Total Level Used" score.
 - **Stat Tiers:** Reaching certain TLU thresholds (e.g., 30 TLU, 60 TLU, 90 TLU) unlocks significant bonus stats (Attack, Magic Attack, Defense, Magic Defense) on the crafted item.
 - **Maximizing TLU:** To achieve the highest bonus tiers, you need to use as many **Level 10 materials** as possible during both the initial crafting and all subsequent upgrades. For example, using 15 Level 10 materials (6 in crafting, 9 in upgrading) can max out the TLU bonus.
- **Rarity Bonus (Hidden Mechanic):**
 - Similar to TLU, materials also have a hidden "rarity value." Using rarer materials during crafting and upgrading contributes to a "Total Rarity Used" score.
 - Reaching specific TRU thresholds provides additional, often exponential, stat bonuses.
 - **Tip:** Don't worry about perfecting this until late-game or post-game. Focus on TLU first.
- **Inheriting Abilities/Stat Overwrites:**
 - **Concept:** This advanced technique allows you to essentially transfer the base stats, appearance,

and/or certain abilities from one weapon/armor/accessory onto another, usually lower-tier, item.
- o **Method:** Typically, you put the desired "source" item (the one whose stats/properties you want to transfer) into an empty slot *after* the main recipe ingredients when crafting a new item.
- o **Use Cases:**
 - **Appearance:** Crafting a basic weapon (e.g., Broadsword) that *looks* like a Broadsword but has the base stats of a much stronger weapon (e.g., Rune Blade).
 - **Specific Abilities:** Carrying over unique passive effects from certain items.
 - **Combining Bonuses:** Creating a "base" item that allows you to then infuse it with max TLU and TRU bonuses.
- o **Light Ore (Crucial for Cross-Category):** This very rare ore allows you to perform inheritance *between different weapon/armor categories* (e.g., putting a Sword's stats onto an Axe). Without Light Ore, inheritance is usually limited to items within the same category.

6. Weapon Crafting Details

- **Primary Stat:** Attack (ATK) is paramount.
- **Magic Weapons:** For Staves, Magic Attack (M.ATK) is crucial.
- **Critical Rate & Crit Damage:** Some weapons inherently have higher crit chances or can gain them through upgrades.
- **Range:** Spears and Long Swords offer better reach.
- **Elemental Infusion:** Crafting weapons with elemental ores (Fire, Water, etc.) or monster drops will imbue them with that element, dealing bonus damage to enemies with that weakness.

7. Armor Crafting Details

- **Primary Stats:** Defense (DEF) and Magic Defense (M.DEF). Aim for a good balance.
- **Elemental Resistances:** Craft armor or accessories that provide resistance to common elemental damage types (Fire, Water, etc.) or specific elements of a challenging boss. Use elemental cores, scales, or certain monster drops.
- **Status Resistances:** Critical for specific dungeons or bosses. Items like "Poison Ring" (crafted) or specific monster drops used in upgrades can grant high resistance or even immunity to status effects.
- **Accessory Creation:** Often falls under "Crafting" skill, but accessories are vital for both offense (ATK/M.ATK buffs) and defense (resistances, HP/RP boosts).

8. Tips for Optimal Forging

- **Hoard Materials:** Never throw away ores, monster drops, or even high-level crops. They are all potential upgrade materials.

- **Level 10 Materials:** Start working towards reliably producing Level 10 crops (e.g., Turnip Seeds) as early as possible with Greenhouses and the Sickle. These are fantastic for boosting TLU.
- **Farm Specific Monster Drops:** Identify which monsters drop desired upgrade materials (e.g., high-quality fur for DEF, powerful claws for ATK).
- **Balance Between Crafting & Upgrading:** Don't just craft new items. Upgrade your current best gear. The bonus stats from upgrades are incredibly significant.
- **Prioritize Weapon Type:** Pick one or two weapon types to specialize in and focus your material gathering and forging skill on those.
- **RP Management:** Forging consumes a lot of RP. Prepare RP-restoring meals or use the Bathhouse before long crafting sessions.
- **Save-Scumming (Optional):** If you're trying to learn a new recipe from Recipe Bread or aiming for a specific rare outcome with upgrade materials, save before trying, then reload if you don't get what you want.

By diligently practicing the art of forging and understanding the intricate layers of material levels, rarity, and inheritance, you'll become a true master smith, capable of outfitting yourself with legendary gear ready to face Azuma's greatest challenges.

Accessory Creation and Buffs

While mighty weapons and sturdy armor form the backbone of your combat prowess, **accessories** are the refined gems that truly polish your hero's capabilities in *Rune Factory: Guardians of Azuma*. Often crafted with the **Crafting** skill (sometimes distinct from Forging, or a sub-category), these subtle adornments provide crucial stat boosts, elemental resistances, status immunities, and unique passive abilities that can turn the tide of any battle or maximize your daily efficiency.

1. The Art of Accessory Creation

Accessory creation is the process of crafting various wearable items (rings, amulets, boots, etc.) that enhance your character.

- **Associated Skill:** Usually a dedicated **Crafting** skill (or "Accessory" skill). This skill levels up by successfully crafting accessories.
 - **Benefits of High Crafting Skill:** Unlocks more complex recipes, reduces RP consumption, increases success rate, and boosts hidden bonuses applied to crafted accessories.
- **Importance:**
 - **Tailored Enhancements:** Fine-tune your stats to overcome specific challenges (e.g., high fire resistance for a volcano dungeon).
 - **Combat Utility:** Boost damage, critical hit rates, or even apply status effects.
 - **Life Skill Support:** Enhance non-combat activities with boosts to luck, movement speed, or RP recovery.
 - **Cost-Effective:** Crafting often provides better value than buying high-tier accessories.

2. Accessing Accessory Crafting

You'll need a specific station to craft accessories.

- **Crafting Table / Workstation:** Often a dedicated table found in your home or at a specific artisan's shop in town. It may be available early on or require a house upgrade to acquire.

3. Basic Accessory Crafting Mechanics

The core principles of accessory creation mirror other crafting disciplines.

- **Required Materials:** Recipes call for a variety of materials, often including gems (Diamonds, Emeralds), rare monster drops (Claws, Fangs, Scales, Liquids), and unique forageable items.
- **RP Consumption:** Each crafting attempt consumes RP. Higher-level recipes use more RP, and insufficient RP will drain HP.
- **Skill Requirement:** Each recipe has a recommended Crafting skill level. Attempting recipes far beyond your level leads to low success rates.
- **Success Rate:** A percentage indicates your chance of success. Failed crafts usually consume RP/HP but return core materials, potentially yielding "Scrap Metal" or "Object X."
- **Quality of Crafted Item:** The level of the materials used directly influences the final level of the crafted accessory, impacting its base stats.

4. Learning New Accessory Recipes

Expand your repertoire of accessory designs by:

- **Recipe Bread (Accessory Bread):**
 - **Source:** Purchase from various shops (General Store, Restaurant, sometimes specialty shops), found in dungeon chests, or rarely dropped by monsters.
 - **Usage:** Consume to learn a new accessory recipe within your current skill level range.
- **Skill Level Up:** Automatically learn basic recipes as your Crafting skill increases.
- **Request Board Quests:** Many villager requests offer specific accessory recipes as rewards.
- **Exploring Dungeons:** Unique recipes can be found in rare chests or dropped by certain bosses.
- **NPC Dialogue/Events:** Specific characters, particularly those focused on fashion, magic, or treasure, might teach you recipes after building a strong friendship or completing events.

5. Types of Accessories and Their General Buffs

Accessories provide a wide array of enhancements, fitting different slots.

- **Rings:**
 - **Common Buffs:** Direct stat boosts (ATK, DEF, M.ATK, M.DEF), elemental resistances (Fire Ring, Water Ring), status effect resistances/immunities (Poison Ring, Paralysis Ring), critical hit rate boosts.
 - **Examples:** Power Ring (ATK), Shield Ring (DEF), Critical Ring (Crit Rate).
- **Amulets/Necklaces:**

- **Common Buffs:** Similar to rings, but often offer larger stat boosts, higher resistances, or more significant passive effects (e.g., increased RP recovery, higher monster taming chance).
- **Examples:** Lucky Charm (Luck), Art of Magic (M.ATK), Heart Pendant (Relationship gain).
- **Boots:**
 - **Common Buffs:** Movement speed increase, evasion boost, sometimes elemental resistances.
 - **Examples:** Strider Boots (Movement Speed), Silent Boots (Evasion).
- **Unique/Special Accessories:**
 - **Common Buffs:** Context-specific effects (e.g., Friendship Scarf for faster relationship gain, a specific farming tool accessory for RP reduction on farm tasks).
 - **Examples:** Focus Earring (RP consumption reduction), Proof of Wisdom (Skill EXP gain).

6. Upgrading and Enhancing Accessories

Accessories, like weapons and armor, can be upgraded a set number of times (e.g., up to +9 or +10) using various materials to significantly boost their power.

- **Process:** At the Crafting Table, select the accessory to upgrade and the material to use.
- **Upgrade Materials:**
 - **Gems:** Provide significant stat boosts and often elemental resistances (e.g., a Diamond for all stats, a Ruby for Fire Resist).
 - **Rare Monster Drops:** Offer diverse buffs, including ATK, DEF, M.ATK, M.DEF, status resistances, or elemental resistances (e.g., a "Dragon Scale" for high DEF and Fire Resist).
 - **Crops/Processed Foods:** High-level crops (especially Level 10) can provide substantial stat boosts when used as upgrade materials.
 - **Other Accessories:** Sometimes using another accessory as an upgrade material can transfer its base stats or unique properties.
- **The Power of Item Level (TLU) & Rarity (TRU):** Just as with weapons and armor, using Level 10 materials (for **Total Level Used**, TLU) and rare materials (for **Total Rarity Used**, TRU) during both crafting and upgrading will unlock massive hidden bonus stats, making your accessories incredibly powerful. This is crucial for endgame optimization.
- **Inheriting Abilities (Advanced):**
 - **Concept:** This advanced technique allows you to essentially transfer the base stats and/or certain abilities from one item (often a high-stat weapon, armor, or another accessory) onto a newly crafted accessory.
 - **Method:** Place the desired "source" item into an empty slot *after* the main recipe ingredients when crafting a new accessory.
 - **Use Cases:** Crafting an accessory that *looks* like a simple Ring, but

carries the DEF of a heavy Shield, or the ATK of a powerful weapon. This requires specific rare materials (like **Light Ore** for cross-category inheritance).

7. Optimal Usage Strategies

- **Situational Swapping:** Don't stick to just one set. Equip accessories that best suit your current activity:
 - **Dungeon Diving:** Prioritize ATK/M.ATK, DEF/M.DEF, critical rate, and elemental/status resistances relevant to the dungeon.
 - **Farming:** Equip accessories that reduce RP consumption, boost movement speed, or increase crop yield/quality.
 - **Socializing:** Wear items that increase friendship point gain.
 - **Resource Gathering:** Equip items that boost Luck or increase drop rates for specific materials.
- **Prioritize Resistances for Bosses:** For major boss battles, identify the boss's primary elemental attacks and status effects. Equip accessories that provide high resistance or immunity to these.
- **Complement Your Playstyle:**
 - **Offensive:** Focus on ATK/M.ATK and Crit Rate.
 - **Defensive:** Focus on DEF/M.DEF and HP/RP boosts.
 - **Support:** Focus on RP recovery and status effect application.

- **Consider Set Bonuses (if applicable):** Some games have "set bonuses" for wearing multiple items from the same themed set.

By dedicating time to accessory creation and understanding their nuanced buffs and upgrade potential, you will fine-tune your hero for peak performance in every facet of your Azuman adventure.

Material Farming and Rare Drops

In *Rune Factory: Guardians of Azuma*, every grand adventure, every culinary masterpiece, and every piece of legendary equipment hinges upon a constant supply of materials. Mastering **Material Farming** – the efficient acquisition of resources – and understanding the nuances of securing **Rare Drops** are fundamental skills that will fuel your progression and empower you to conquer any challenge Azuma throws your way.

Note: As Rune Factory: Guardians of Azuma is scheduled for release on June 5, 2025, specific in-game names for monsters, drops, and precise locations are illustrative, based on common mechanics found across the Rune Factory series. The core strategies remain universal.

1. The Indispensable Role of Materials

Materials are the lifeblood of your Azuman journey:

- **Crafting:** Ores, monster parts, and specific crops are essential for forging weapons, armor, accessories, and brewing potions.
- **Cooking:** Farmed produce, fish, and monster products are crucial ingredients for HP/RP recovery and stat-boosting dishes.

- **Building & Upgrades:** Wood and stone are vital for expanding your home, building monster barns, and constructing village facilities.
- **Requests & Gifts:** Many villager requests demand specific materials, and certain items are perfect gifts to boost relationships.
- **Selling for Profit:** Excess materials, especially high-tier ones, are a significant source of income.

2. Methods of Material Farming

Each type of material has its own optimal gathering method.

A. Mining (Ores & Gems)

- **Tools: Hammer.** Upgrade your Hammer regularly! Higher-tier Hammers consume less RP per swing, break rocks faster, and allow you to break tougher ore veins.
- **Locations:**
 - **Overworld:** Smaller rocks and common ore veins are scattered throughout the outdoor regions (e.g., Iron in Verdant Hills, Silver in forested areas).
 - **Dungeons:** The primary source of higher-tier ores (Gold, Platinum, Orichalcum) and rare gems (Diamonds, Emeralds, Sapphires). Each dungeon typically specializes in certain ore types.
- **Strategy:**
 - **Daily Rounds:** Mining nodes respawn daily or after a few in-game days. Learn the most efficient routes through dungeons or outdoor areas to hit all accessible nodes.
 - **Charged Attacks:** Use charged Hammer attacks for faster breaking and often a higher chance of rare drops or more materials.
 - **Focus on Specific Ores:** If you need a particular ore for an upgrade, target the dungeon or area known for that ore.

B. Woodcutting (Wood & Lumber)

- **Tools: Axe.** Upgrade your Axe to chop faster, reduce RP consumption, and gain access to larger, tougher trees.
- **Locations:**
 - **Overworld:** Trees are abundant in most outdoor regions (e.g., regular trees in Verdant Hills, bamboo in eastern-themed forests).
 - **Specific Biomes:** Different biomes yield different types of wood (e.g., normal Wood, Quality Wood, Hardwood, Sacred Wood).
- **Strategy:**
 - **Clear & Replenish:** Chop down trees in designated areas, but remember that stumps may need to be cleared too to allow respawn.
 - **Stump Clearing:** Higher-tier Axes can clear tough stumps, freeing up more farmable land or allowing new trees to grow.
 - **Daily Rounds:** Like mining nodes, trees respawn regularly. Establish a route for your daily wood run.

C. Foraging (Wild Plants, Herbs, Fruits)

- **Tools:** None (your hands).
- **Locations:**
 - **Everywhere!** Scattered across all outdoor regions and even within some dungeons.
 - **Seasonal Dependence:** Many forageable items are season-specific (e.g., certain berries in Summer, specific mushrooms in Autumn).
- **Strategy:**
 - **Collect Everything:** Always pick up every forageable item you see. Even common items like weeds or basic grasses have uses (fertilizer, low-tier cooking, basic gifts).
 - **Explore Thoroughly:** Check behind rocks, under trees, and along riverbanks. New areas will have new types of forageables.
 - **Time of Day:** Some rare forageables might only appear at specific times (e.g., glowing mushrooms at night).

D. Fishing (Fish & Aquatic Items)

- **Tools: Fishing Rod.** Upgrade your Fishing Rod to increase casting range, make catches easier, and improve your chances of catching rarer, larger, and more valuable fish.
- **Locations:**
 - **Water Bodies:** Rivers, lakes, ponds, and coastal areas. Look for shimmering spots on the water.
 - **Biomes:** Different biomes will have different types of fish (e.g., freshwater fish in forests, saltwater fish at the coast).
- **Strategy:**
 - **Shimmering Spots:** These indicate active fishing spots with a higher chance of getting a bite.
 - **Bait:** Some games allow the use of bait to attract specific fish or increase bite rates.
 - **Season/Weather:** Certain rare fish might only be available during specific seasons or weather conditions (e.g., rare fish during rain).

E. Monster Hunting (Monster Drops)

- **Tools:** Your **Weapon(s)**, ideally with elemental or status-inflicting properties.
- **Locations:**
 - **Dungeons:** The primary source of monster drops. Each dungeon has its own unique set of monsters and their associated drops.
 - **Overworld:** Some outdoor regions have specific monsters.
- **Items:** Fangs, claws, scales, fur, liquids, powders, elemental cores (essential for forging, chemistry, and specific requests).
- **Strategy:**
 - **Targeted Farming:** If you need a specific monster drop, repeatedly hunt the monster that drops it.
 - **Efficient Combat:** Learn monster attack patterns to defeat them quickly and minimize damage taken.
 - **Area Respawn:** Monsters respawn when you exit and re-

enter an area, or after a certain amount of in-game time.
- **Status Effects:** Using weapons that inflict Paralysis or Sleep can make farming easier and safer.

3. Strategies for Securing Rare Drops

Rare materials, whether from mining, fishing, or monster drops, are critical for crafting endgame gear.

- **The Luck Stat:**
 - **Importance:** Your character's Luck stat directly influences the rarity of items found, including rare monster drops, higher-level ores/gems, and rarer forageables.
 - **How to Boost:**
 - **Accessories:** Craft and equip accessories that boost Luck (e.g., Lucky Charm, Happy Ring).
 - **Food Buffs:** Consume cooked dishes that provide a temporary Luck buff.
 - **Specific Items in Upgrades:** Some rare items (e.g., 4-Leaf Clover) can be used as upgrade materials for your weapons or accessories to provide a permanent "rare drop rate up" effect.
- **Item Drop Rate Boosts:**
 - **Weapon Upgrades:** In previous *Rune Factory* titles, certain items like "Rare Cans" or "4-Leaf Clovers" could be used as upgrade materials for weapons to increase item drop rates from enemies hit by that weapon. This effect often applies even if the monster is defeated by a companion.
 - **Accessory Inheritance:** The effects of "Happy Rings" or "Lucky Charms" can often be inherited onto other accessories during crafting, allowing you to stack their benefits without equipping multiple rings.
 - **Companion Equipment:** Equip your human party members and powerful monster companions with weapons/accessories that have drop rate boosting effects. Their effects often stack with yours!
- **Targeted Farming Runs:**
 - Identify the exact monster or node that yields your desired rare drop.
 - Repeatedly clear the area containing that monster/node. Don't be afraid to leave and re-enter the area to force respawns.
- **Higher Difficulties:** While not always guaranteed, playing on higher difficulties *might* subtly increase the chances of certain rare drops or provide more overall loot.
- **Check Monster Info:** Your in-game Monster Book or bestiary will often list potential drops. Sometimes, it also lists weaknesses or conditions that might increase drop chances.
- **Boss Re-Fights:** Bosses often drop incredibly rare and powerful materials. Many *Rune Factory* games allow you to re-

fight bosses in their lairs after the first defeat.

4. Preparation for Farming Expeditions

Maximize your efficiency by preparing before you head out.

- **Clear Inventory:** Start with an empty backpack to pick up as many materials as possible.
- **Equip Tools:** Bring all necessary farming tools (Axe, Hammer, Sickle, Fishing Rod), ideally fully upgraded.
- **Combat Gear:** Equip your best weapon and armor, especially if going into higher-level zones.
- **Recovery Items:** Stock up on HP and RP restoring foods/potions. You'll need them to sustain long gathering sessions.
- **Companions:** Bring human party members or monster companions. They can fight alongside you and even help gather materials.
- **Return Spell/Item:** Always have a way to warp back to your farm or the dungeon entrance if you get overwhelmed or your inventory fills up.

5. Efficiency Tips for Resource Gathering

- **Optimal Routes:** Learn the most efficient routes through each region or dungeon to hit all valuable mining nodes, tree clusters, and monster spawns.
- **Daily Routine:** Integrate resource gathering into your daily routine. Even 30 minutes of focused gathering can yield significant results.
- **Time Management:** Utilize all daylight hours. If your farm work is automated by monsters, dedicate your time to dungeons.
- **Monster Automation:** Assign tamed monsters to farm work (watering, harvesting) to free up your own RP for gathering.
- **Sell Excess:** Don't hoard materials you don't immediately need. Sell them for gold to fund upgrades or buy other necessary items.
- **Check Request Board:** Many requests ask for common materials you can easily gather for quick gold and friendship.

By embracing diligent resource gathering and strategically pursuing rare drops, you'll ensure a thriving economy and a constant supply of materials, empowering you to craft your legend as the ultimate Guardian of Azuma.

Best Equipment for Each Playstyle

In *Rune Factory: Guardians of Azuma*, your equipment is more than just raw stats; it's an extension of your chosen path. While the "best" gear ultimately depends on your immediate goal (dungeon delving, farming, or socializing), optimizing your loadout for your preferred **playstyle** will significantly enhance your efficiency and enjoyment. This guide offers recommendations for the optimal equipment choices tailored to different archetypes, ensuring you're always geared for success.

Note: As Rune Factory: Guardians of Azuma is set to release on June 5, 2025, specific item names are illustrative examples based on common Rune Factory conventions. Focus on

the types of stats and effects recommended for each playstyle.

General Principles for All Playstyles

Regardless of your focus, certain gear principles apply to everyone:

- **Defense (DEF) & Magic Defense (M.DEF):** Always aim for the highest possible defense on your armor. Even if you're a pacifist farmer, accidental monster encounters or boss attacks can be lethal.
- **HP & RP Boosts:** Accessories that increase your maximum HP and RP are universally beneficial, giving you more resilience in combat and more stamina for daily tasks.
- **Movement Speed:** Boots and accessories that boost movement speed are invaluable for saving time, whether traversing dungeons or running around town.
- **Upgrades are King:** Continuously upgrade all your equipment (weapons, armor, accessories) at the Forge/Crafting Table using Level 10 materials (crops, ores, monster drops) to maximize hidden Total Level Used (TLU) and Total Rarity Used (TRU) bonuses. This provides massive stat boosts beyond the item's base stats.
- **Situational Swapping:** The truly optimized player will swap gear as needed. Have a "farming set," a "dungeon set," and perhaps a "social set."

1. The Master Farmer

Goal: Maximize crop yields, automate farm tasks, and extend daily farming time. **Priority Stats:** RP Max, RP Recovery, Luck, Movement Speed, Crop Growth/Quality bonuses.

- **Weapon:**
 - **Type:** Any low-RP consumption weapon (e.g., One-Handed Sword) for quick monster clearing on your farm.
 - **Key Traits:** Infuse with status effects like Sleep or Paralysis to quickly disable farm intruders.
- **Armor:**
 - **Focus:** Moderate DEF/M.DEF. You're mostly safe on your farm.
 - **Example:** Any mid-tier armor.
- **Accessories:**
 - **RP Cost Reduction: Focus Earring** (or similar) to reduce RP consumption for farming actions.
 - **Movement Speed: Strider Boots** or **Dash Shoes** to quickly move around your farm.
 - **Luck: Lucky Charm** or **Happy Ring** to increase chance of finding high-level forageables and crops.
 - **RP Recovery:** Accessories that boost RP recovery rate.
- **Tools (Crucial!):**
 - **Hoe, Watering Can, Axe, Hammer, Sickle:** All upgraded to their highest possible tier (e.g., Platinum Hoe/Watering Can, Legendary Sickle). This is your core investment.
 - **Sickle:** A high-tier Sickle (e.g., Gold Sickle) is *essential* for harvesting crops without destroying their roots, preserving crop level and soil health.

- **Companion:**
 - **Monster Helpers:** Recruit and upgrade monster helpers specifically for watering, harvesting, and tilling. They are your ultimate automation tools.

2. The Dauntless Adventurer

Goal: Dominate dungeons, defeat powerful bosses, and gather rare materials. **Priority Stats:** Attack, Magic Attack, Defense, Magic Defense, Critical Hit Rate, Elemental Resistances, Status Effect Resistances.

- **Weapon:**
 - **Type:** Your preferred weapon type (e.g., Two-Handed Sword for raw damage, Spear for range, Magic Staff for spells).
 - **Key Traits:**
 - **Highest ATK/M.ATK:** Prioritize weapons with the highest base damage.
 - **Elemental Infusion:** Have weapons imbued with different elements (Fire, Water, Earth, Wind, Light, Dark) to exploit enemy weaknesses.
 - **Status Infliction:** Infuse with Paralysis, Seal, or Poison for crowd control or boss debuffs.
- **Armor:**
 - **Head, Body, Shield, Foot:** Maximize DEF and M.DEF.
 - **Elemental Resistances:** Have sets or individual pieces that offer high resistance to specific elements (e.g., Fire Dragon Scale Armor for fire resistance in volcanic dungeons).
 - **Status Resistance:** Gear with high resistance to common dungeon status effects (e.g., Poison, Paralysis).
- **Accessories:**
 - **Offensive: Power Ring** (ATK), **Magic Ring** (M.ATK), **Critical Ring** (Crit Rate).
 - **Defensive: Shield Ring** (DEF), **Talisman** (M.DEF), **Heart Pendant** (HP Max), **Courage Badge** (RP Max).
 - **Situational: Proof of Wisdom** (EXP gain), **Elemental Amulets** (e.g., Fire Charm for Fire Resist).
- **Tools:**
 - **Axe & Hammer:** Upgraded for breaking obstacles and mining rare dungeon materials.
 - **Sickle:** A basic one for cutting weeds/fodder, but combat is the focus.
- **Companions:**
 - **Human Party Members:** Equip them with the best gear available and max their friendship for enhanced combat effectiveness.
 - **Combat Monsters:** Bring strong, high-level monsters that can tank hits, deal damage, or heal.

3. The Master Crafter / Artisan

Goal: Create the most powerful equipment and items, level crafting skills efficiently. **Priority Stats:**

RP Max, RP Recovery, Crafting Skill bonuses, Luck.

- **Weapon:**
 - **Type:** Any. Your weapon is secondary.
 - **Key Traits:** Infuse with items that give passive RP reduction or Luck bonuses.
- **Armor:**
 - **Focus:** Moderate DEF/M.DEF. You're mostly safe in your workshop.
 - **Key Traits:** Armor infused with items that boost RP Max or RP Recovery.
- **Accessories:**
 - **RP Cost Reduction: Focus Earring** (or similar) to reduce RP consumption for crafting.
 - **Skill Boost:** Accessories that specifically boost Forging, Chemistry, or Cooking skill levels.
 - **Luck: Lucky Charm** or **Happy Ring** to increase the chance of successful crafting and better quality items.
 - **RP Recovery:** Accessories that boost RP recovery rate.
- **Tools:**
 - **High-Tier Hoe, Watering Can, Axe, Hammer:** To efficiently gather high-level materials needed for crafting.
 - **Sickle:** A high-level Sickle is critical for obtaining Level 10 crops for TLU/TRU upgrades.
- **Companion:**
 - **Monster Helpers:** Those that provide monster products (Milk, Eggs, Fur) essential for many recipes.

4. The Social Butterfly / Town Charmer

Goal: Maximize friendship, unlock all character events, and pursue romance. **Priority Stats:** Friendship Gain, Movement Speed, Luck, Money-Making (for gifts).

- **Weapon:**
 - **Type:** Any. You rarely need it for social activities.
 - **Key Traits:** Could infuse with a Luck-boosting item.
- **Armor:**
 - **Focus:** Moderate DEF/M.DEF.
 - **Key Traits:** Appearance-focused if you care about character aesthetics.
- **Accessories:**
 - **Friendship Boost: Heart Pendant** or **Friendship Scarf** (or similar) to boost friendship point gains. *Crucial for this playstyle.*
 - **Movement Speed: Strider Boots** or **Dash Shoes** to quickly reach NPCs across town.
 - **Luck: Lucky Charm** or **Happy Ring** to help acquire desired gift items from drops or foraging.
 - **Money Boost:** Accessories that boost gold acquisition from selling.
- **Tools:**
 - **Fishing Rod:** For catching fish, which are universally liked gifts.

- **Hoe/Watering Can:** For growing crops as gift items.
- **Companion:**
 - **Any Companion:** Bringing a companion along can sometimes trigger unique dialogue with NPCs, enhancing your social interactions.

5. The Balanced Guardian

Goal: Excel at all aspects of the game: combat, farming, crafting, and socializing. **Priority Stats:** A well-rounded mix of all the above.

- **Equipment Strategy:** This playstyle thrives on **situational gear swapping**.
 - **Default Set:** A balanced set of high-DEF/M.DEF armor, a versatile weapon (e.g., One-Handed Sword), and accessories that boost HP/RP Max and movement speed.
 - **Dungeon Set:** Swap to your best offensive weapon, high-resistance armor, and combat-focused accessories (ATK, Crit, elemental/status resistance) before heading into a dungeon.
 - **Farming Set:** Swap to your RP-reducing/movement speed/Luck accessories and upgraded farming tools when working on your farm.
 - **Social Set:** Briefly put on friendship-boosting accessories when doing your daily town rounds or attending festivals.
- **Tools:** Invest in upgrading ALL your tools to high tiers.
- **Companions:** Utilize a diverse roster of companions: some for farm work, others for combat.

By strategically equipping your hero based on your activity, you'll be able to conquer every challenge and truly become the versatile, all-encompassing Guardian Azuma needs!

Chapter 8

BONDS BEYOND BATTLE — Taming Monsters and Companions

Forge unbreakable bonds with Azuma's fantastical creatures in this comprehensive guide! Learn **how to befriend and tame monsters**, understanding their unique needs and abilities. Discover effective **companion combat roles and skills** to build an unstoppable adventuring party, master the art of **monster ranching and productivity** for a thriving farm, and identify the **best monsters for both combat and farming** to truly revolutionize your gameplay.

How to Befriend and Tame Monsters

Beyond the familiar faces of Azuma's townsfolk, the wild lands teem with creatures of all shapes and sizes. Many of these aren't just foes to be vanquished; they are potential allies waiting to forge **bonds beyond battle**. Mastering the art of **befriending and taming monsters** is a cornerstone of your adventure in *Rune Factory: Guardians of Azuma*, providing invaluable companions for combat, diligent helpers for your farm, and unique sources of vital resources.

1. Why Tame Monsters? The Benefits

Taming monsters unlocks a powerful new dimension to your gameplay:

- **Combat Companions:** Bring monsters into dungeons to fight alongside you. They can absorb damage, deal extra attacks, and provide tactical support.
- **Farm Helpers:** Assign monsters to perform daily farm chores like watering, harvesting, and tilling, saving your RP and time.
- **Resource Production:** Many tamed monsters produce valuable items (e.g., milk, eggs, fur, honey) daily, providing a consistent source of income and crafting materials.
- **Mounts:** Certain large monsters can be ridden, allowing for faster traversal across the world map.
- **Unique Skills:** Some monsters possess special abilities that can be used in combat or on the farm.
- **Hidden Bonuses:** A higher friendship level with your monsters boosts their effectiveness in all roles.

2. Prerequisites for Taming

Before you can invite monsters into your life, you'll need a few essentials:

- **Monster Barn:** This is absolutely crucial. You must build a **Monster Barn** on your farm to house tamed monsters. You can typically get the blueprint or build it through the town's carpenter/builder NPC (e.g., talking to the General Store owner or a specific construction NPC). As you tame more monsters, you'll need to upgrade and expand your barns.

- **Brush:** The **Brush** is your primary tool for interacting positively with monsters, both wild and tamed. You'll usually obtain it early in the game or be able to purchase it from the General Store.

3. The Taming Process: From Wild to Ally

Taming a monster in *Rune Factory: Guardians of Azuma* is primarily a non-violent process, focusing on generosity and positive interaction.

1. **Identify Tameable Monsters:** Most non-boss monsters are tameable. Bosses are often tameable as well, but usually only after you've defeated them in their normal dungeon context.
2. **Approach the Monster:** Find the monster you wish to tame in a dungeon or on the overworld.
3. **Offer a Gift:** This is the core of taming. Select an item from your inventory and offer it to the monster.
 - **Monster Preferences:** Every monster type has specific items they **Like** (minor boost) and **Love** (major boost). Giving them a **Loved** item significantly increases your chance of success.
 - **Common Liked/Loved Items:**
 - **Farm Products:** Milk, Eggs, Honey, Fodder (for Woolies, Buffamoos, etc.).
 - **Crops:** Specific vegetables or fruits (e.g., Turnips, Carrots, Strawberries).
 - **Monster Drops:** Sometimes a monster likes items dropped by *other* monsters, or even their own drops.
 - **Cooked Dishes:** Generally good for many monsters.
 - **Dislikes/Hates:** Giving a monster an item they dislike or hate will lower your chances of success or make them hostile. **Weeds** are universally hated.
 - **Tip:** Experiment with different items! If you don't know a monster's preferences, try offering common farm produce or generic monster drops first.
4. **Observe the Reaction:** When you offer a gift, pay close attention to the monster's reaction:
 - **Hearts/Music Notes:** Floating hearts or music notes indicate a positive reaction and an increase in taming success chance. More hearts/notes mean a better chance.
 - **Skull/Negative Symbol:** A skull or angry symbol means the monster disliked the gift, reducing your chance or making them hostile.
 - **"No Effect":** Sometimes, a monster will simply ignore the gift. This means it has no preference for that item, or your Taming skill is too low.
5. **Brush the Monster:** After offering a gift, use your **Brush** tool on the monster. Brushing also increases your taming chance and monster friendship. You can typically brush a monster several times per day.
6. **Repeat and Persist:** Continue offering gifts and brushing. The taming process is often cumulative. The monster will display progressively more hearts or positive reactions with each successful gift/brush.
7. **Success Indication:** When you succeed, the monster will display a large heart over its head, emit a positive sound, and typically become passive, no longer attacking you.
8. **Sending to Barn:** Once tamed, the game will prompt you to send the monster to your **Monster Barn**. Confirm to complete the process.

- **Barn Space:** If your Monster Barn is full, you cannot tame any more monsters until you build a new barn or upgrade an existing one.

Factors Influencing Taming Success:

- **Item Preference:** Giving a Loved item offers the highest chance.
- **Player Level vs. Monster Level:** Taming monsters significantly higher level than you is much harder. Level up your character before attempting to tame powerful dungeon monsters.
- **Taming Skill (Passive Skill):** As you successfully tame more monsters, your passive Taming skill will increase, making future attempts easier and consuming less RP.
- **Monster Friendship:** Each gift/brush builds "monster friendship." A higher monster friendship makes subsequent taming attempts easier.
- **RP Consumption:** Taming attempts consume your RP. Having high RP (or consuming RP recovery items) can help.
- **Weakening Monsters (Usually NOT Required for Taming):** Unlike some monster-catching games, *Rune Factory* generally does *not* require you to lower a monster's HP for taming. In fact, attacking them might make them hostile or reduce your taming chance. The focus is on kindness.
- **Specific Items for Taming (Rare):**
 - **Love Potion:** A rare crafted or found item that drastically increases taming success rate.
 - **Friendship-Boosting Accessories:** Some accessories (e.g., a "Friendship Scarf" or "Happy Ring") might passively increase your Taming skill or chance of success.

4. Post-Taming Actions: Welcoming Your New Ally

Once a monster is tamed, your responsibilities shift to care and utilization.

1. **Naming Your Monster:** You'll be prompted to give your new ally a name. Choose wisely!
2. **Monster Barn Care:**
 - **Feed Daily:** Monsters need to be fed daily (typically with Fodder from your silo) to maintain their health and happiness. Unfed monsters might get sick or leave.
 - **Brush Daily:** Continue brushing your monsters daily. This increases their friendship level.
3. **Assigning Roles:**
 - **Farm Work:** From the Monster Barn menu, you can assign monsters to specific farm areas and tasks (watering, tilling, harvesting).
 - **Party Member:** You can invite up to two monsters (plus human companions) to join your adventuring party.

5. Tips for Successful Taming

- **Know Their Likes:** Before venturing into a dungeon, check online wikis or experiment with common items to learn what the monsters in that area like.

- **Bring a Variety of Gifts:** Carry a diverse range of items in your backpack (crops, monster drops, cooked dishes) so you have options for different monsters.
- **Brush Consistently:** Brushing is free and effective. Use it after every gift.
- **Save Before Taming:** If you're trying to tame a rare or high-level monster, save your game nearby. If you fail too many times or run out of gifts, you can reload.
- **Level Up Your Taming Skill:** The more you tame, the easier it gets. Prioritize taming weaker monsters first to build up your skill.
- **Beware of Combat:** If you accidentally hit a monster you're trying to tame, it might become hostile. Try to avoid combat with your target.
- **Don't Overdo Gifts:** There's usually a daily limit to how many gifts a monster will accept or how much friendship they can gain in a single day.
- **Monster Friendship Matters:** Tamed monsters with higher friendship levels are more effective in combat and more diligent on the farm. Keep brushing them!

By diligently applying these strategies, you'll soon have a thriving ranch of loyal monsters, ready to assist you in every aspect of your life as a Guardian of Azuma.

Companion Combat Roles and Skills

You don't have to face the dangers of Azuma alone! In *Rune Factory: Guardians of Azuma*, forging **bonds beyond battle** extends to recruiting powerful allies to fight by your side. Both human villagers and tamed monsters can become invaluable **combat companions**, offering unique roles and skills that dramatically influence your success in dungeons and against formidable bosses. Mastering their capabilities is key to forming an unstoppable adventuring party.

Note: As Rune Factory: Guardians of Azuma is scheduled for release on June 5, 2025, specific companion names and their exact skill sets are illustrative, based on common mechanics found across the Rune Factory series. The core concepts remain universal.

1. Types of Combat Companions

You'll have two primary categories of allies to choose from:

A. Human Companions (Villagers)

- **Who They Are:** These are the various named townsfolk you befriend. Many, especially those with combat-oriented personalities or specific lore, can be invited to join your party.
- **Acquisition:** Typically, you need to reach a certain Friendship Level (e.g., 3-5 hearts) with them before they agree to join you. Some might also require completing a specific side quest.
- **Key Characteristics:**

- **Equippable Gear:** You can equip them with weapons, armor, and accessories, which directly impacts their stats and combat effectiveness. This is crucial for their survival and damage output.
- **Unique Skills:** Each human companion has a distinct set of active and passive combat skills that reflect their personality or profession (e.g., a knight will have defensive skills, a mage will have elemental spells).
- **Dialogue & Personality:** They often have unique dialogue lines in dungeons and react to situations, adding to the immersion.

B. Monster Companions (Tamed Monsters)

- **Who They Are:** Monsters you have successfully tamed through the gift-giving process.
- **Acquisition:** Tamed via gifts and brushing in the wild, then sent to your Monster Barn.
- **Key Characteristics:**
 - **Innate Stats & Roles:** Their stats, elemental resistances, and general combat roles are inherent to their species (e.g., a large beast might be a natural tank, a slithering creature might inflict poison).
 - **Growth:** They level up by participating in combat and gain stats based on their species.
 - **Feeding:** Their effectiveness is tied to being fed regularly at the Monster Barn. Some favorite foods might temporarily boost their stats.
 - **Limited Equipment:** Generally cannot be equipped with weapons or armor by the player, but some may have accessory slots or specific items that boost them.

2. General Companion Mechanics in Combat

- **Inviting Companions:** Talk to the desired companion (human or monster) and select the option to invite them to your party.
- **Party Size:** You typically can have 1-2 companions join you in dungeons. The exact number can vary by game.
- **AI Behavior:** Companions are controlled by AI. They will generally follow you, attack nearby enemies, and use their skills automatically. Their aggression level might be adjustable.
- **Companion HP:** Companions have their own HP bars. If their HP reaches zero, they are "knocked out" and will return to town (human) or your Monster Barn (monster), often requiring recovery time or healing.
- **Healing Companions:** You can use healing spells or items on your companions in combat. This is vital for keeping them in the fight.
- **Friendship/Love Level Influence:**
 - **Damage/Defense:** Higher friendship/love levels often translate directly into increased Attack, Defense, and overall combat effectiveness for both human and monster companions.
 - **Skill Unlocks:** Some companion skills might only unlock once their friendship/love reaches a certain level.

- **Joint Attacks:** Very high friendship/love levels can sometimes unlock powerful "Joint Attacks" where you and a companion perform a combined special move.

3. Companion Combat Roles (Archetypes)

Choosing the right combination of companions can make or break a dungeon run.

A. The Tank (Front-Line Defender)

- **Role:** Draws enemy aggro, absorbs damage, protects you and other party members.
- **Key Stats:** High HP, High Defense, High Magic Defense.
- **Typical Companions:**
 - **Human:** Knights, heavily armored warriors.
 - **Monsters:** Golems, large beasts (e.g., Buffamoo variants, strong wolves), armored monsters.
- **Skills:** Provoke abilities, defensive buffs, self-healing, high damage resistance.
- **Strategy:** Position them to draw attention while you attack from a safer angle or heal.

B. The Damage Dealer (DPS - Damage Per Second)

- **Role:** Focuses on dealing high amounts of damage quickly.
- **Key Stats:** High Attack, High Magic Attack, Critical Hit Rate.
- **Typical Companions:**
 - **Human:** Rogues, skilled swordsmen, powerful mages, archers.
 - **Monsters:** Fast-attacking creatures (e.g., some insect types), elemental monsters, powerful melee attackers.
- **Skills:** High-damage active attacks, elemental spells, passive damage buffs, critical hit bonuses.
- **Strategy:** Let the tank draw aggro, then unleash your strongest attacks.

C. The Support / Healer

- **Role:** Restores HP/RP, cleanses status effects, applies beneficial buffs to the party.
- **Key Stats:** High Magic Attack (for healing potency), RP Max, RP Recovery.
- **Typical Companions:**
 - **Human:** Priests, benevolent mages, compassionate villagers.
 - **Monsters:** Healing-focused monsters (e.g., some fairy types, elemental sprites).
- **Skills:** Healing spells (single-target or AoE), status cleanse, party-wide buffs (Attack Up, Defense Up).
- **Strategy:** Keep an eye on party HP. Prioritize healing over attacking, especially in boss fights.

D. The Utility / Crowd Control

- **Role:** Inflicts status effects on enemies, manages enemy groups, provides unique battlefield advantages.

- **Key Stats:** Focus on status effect potency, speed, elemental damage for specific effects.
- **Typical Companions:**
 - **Human:** Enchanters, tricksters, ranged attackers.
 - **Monsters:** Monsters that naturally inflict poison, paralysis, sleep, or seal.
- **Skills:** Status-inflicting spells/attacks, AoE skills, enemy debuffs (Attack Down, Defense Down).
- **Strategy:** Apply debilitating effects to the most dangerous enemies first. Use AoE to thin out groups.

4. Companion Skills (General Concepts)

Companion skills contribute significantly to their effectiveness.

- **Active Skills:**
 - These are specific attacks or abilities companions will use automatically or when triggered by certain conditions.
 - They often have cooldowns and consume the companion's hidden RP.
 - Examples: "Shield Wall" (tank), "Fireball" (mage), "Heal" (healer), "Poison Spit" (utility monster).
- **Passive Abilities:**
 - Constant effects that boost the companion's stats or provide benefits (e.g., increased critical hit chance, damage reduction, faster movement).
 - Can be tied to their species or specific traits.
- **Friendship/Love Level Unlocks:** Reaching higher friendship/love levels with companions often unlocks stronger versions of their existing skills, new active abilities, or powerful passive buffs.
- **Gear-Dependent Skills (for Human Companions):** Equipping certain weapons or accessories on human companions might grant them access to specific skills or boost existing ones.

5. Optimizing Companions for Combat

- **Party Composition:**
 - **Balanced:** One Tank, one Damage Dealer, or one Support. (e.g., You (DPS) + Tank + Healer).
 - **Aggressive:** You (Tank/DPS) + Two Damage Dealers.
 - **Defensive:** You (DPS) + Two Tanks/Supports.
 - Consider the boss's elemental weaknesses and attack types when choosing your party.
- **Equipping Human Companions:**
 - **Prioritize:** Always give them the best weapons and armor you can spare. Their survivability and damage will increase drastically.
 - **Accessory Focus:** Equip accessories that boost their primary stats (e.g., ATK for DPS, DEF for Tank) or provide crucial elemental/status resistances for the current dungeon.
- **Feeding Monster Companions:**
 - Regularly feed monsters in the Monster Barn to keep them happy and productive.

- Feeding them their favorite foods can sometimes provide temporary stat boosts, which are great before a tough dungeon.
- **Managing Companion HP:**
 - Keep an eye on their health bars. If a companion is low on HP, use a healing spell or potion on them before they are knocked out.
 - Knocked-out companions offer no help and may incur recovery costs.
- **Strategic Use of Abilities:** While AI-controlled, you can sometimes influence companion behavior by drawing enemies, moving to specific positions, or by carefully planning your own attacks to set up combos.

6. Tips for Effective Combat with Companions

- **Player as Leader:** Your role is crucial. You lead the charge, direct the flow of battle, and provide backup.
- **Draw Aggro Strategically:** Use yourself or your tank companion to draw enemy attention away from weaker party members.
- **Watch for Openings:** After a strong enemy attack, both you and your companions can burst damage during the enemy's recovery.
- **Communicate (Implicitly):** Your actions often guide your companions. If you back off, they might too. If you charge, they will follow.
- **Utilize Combination Attacks:** If Azuma has combination attacks, learn how to trigger them for massive damage on bosses.

By carefully selecting, equipping, and managing your companions, you'll transform your dungeon crawls from solo struggles into exhilarating team efforts, ensuring your success against Azuma's most formidable foes.

Monster Ranching and Productivity

Beyond being loyal combat companions, the monsters you tame in *Rune Factory: Guardians of Azuma* are also invaluable assets for your farm. Mastering **Monster Ranching and Productivity** transforms your homestead into a self-sustaining powerhouse, allowing you to automate daily chores, generate consistent income, and acquire essential crafting materials. A well-managed monster ranch is a true testament to a Guardian's ingenuity and efficiency.

***Note:** As Rune Factory: Guardians of Azuma is scheduled for release on June 5, 2025, specific monster names, their exact products, and precise barn upgrade costs are illustrative, based on common mechanics found across the Rune Factory series. The core principles remain universal.*

1. The Core of Monster Ranching: The Monster Barn

Your Monster Barn is the central hub for all your tamed farm monsters.

- **Construction:**
 - **Unlocking:** The blueprint or option to build a Monster Barn is typically unlocked early in the game, often through a tutorial quest from a town NPC (e.g., the General Store owner, carpenter).
 - **Materials & Gold:** Requires basic building materials (Wood, Stone) and a gold fee.
 - **Placement:** You usually build it directly on your farm property.
- **Expansion:**
 - **Increased Capacity:** Each barn has a limited capacity (e.g., 4 monsters). You'll need to upgrade existing barns or build new ones to house more monsters.
 - **Materials & Gold:** Expansions require more building materials and a higher gold fee, escalating with each tier.
 - **Benefits:** Higher-tier barns might offer slight passive stat boosts to monsters housed within them or provide specific facilities.
- **Fodder (Monster Feed):**
 - **Requirement:** Monsters consume one unit of Fodder per day. You must have Fodder stored in your **Silo** (another farm structure) for them to eat.
 - **Acquisition:** Fodder is primarily obtained by cutting down weeds or Fodder Grass with a **Sickle** on your farm. It can also sometimes be purchased from the General Store.
 - **Importance:** Monsters that aren't fed will become unhappy, stop producing products, and may eventually leave your farm.

2. Monster Care: Keeping Your Allies Happy

Happy monsters are productive monsters! Daily care is simple but vital.

- **Daily Feeding:** Ensure your Silo always has enough Fodder for all your monsters. This is automatically consumed each morning.
- **Brushing:** Use your **Brush** tool on each monster once per day. Brushing increases their friendship level and contributes to their overall happiness.
- **Talking:** While less impactful than brushing, talking to your monsters also contributes to their happiness and friendship.
- **Friendship Level:**
 - **Impact:** A monster's friendship level (represented by hearts) is directly tied to its happiness, combat effectiveness, and productivity. Higher friendship means more frequent product drops, better quality products, and increased efficiency in farm work.
 - **How to Increase:** Primarily through daily brushing and feeding. Giving them liked/loved gifts (the same items used for taming) can also boost friendship.
- **Monster Sickness:** Unhappy or unfed monsters might become sick. Use medicines (e.g., "Med. Herb") on them to cure their ailments.

3. Monster Productivity: Resource Generation

Many tamed monsters will produce valuable items daily, which appear near them in the barn for you to collect.

- **Daily Drops:**
 - **Wooly (or similar sheep-like monster):** Provides **Fleece** or **Wooly Furball**. Essential for crafting cloth and clothing.
 - **Buffamoo (or similar cow-like monster):** Provides **Milk**. Used extensively in cooking and for many requests.
 - **Cluckadoodle (or similar chicken-like monster):** Provides **Eggs**. Used in many cooking recipes.
 - **Hornet/Bee Monster:** Provides **Honey**. Useful for cooking and chemistry.
 - **Other Unique Monsters:** Certain monsters might produce unique items like elemental stones, specific monster fluids, or rare grasses.
- **Factors Affecting Productivity:**
 - **Friendship Level:** Higher friendship (e.g., 5+ hearts) increases the frequency of product drops and can improve the product's quality (e.g., Milk L, Milk M, Milk G).
 - **Happiness:** Happy monsters produce more reliably.
 - **Species:** Each monster species produces a specific type of item.
- **Collection:** Simply walk up to the product near the monster and pick it up. Ship it or use it for crafting/cooking.

4. Monster Productivity: Farm Work Automation

This is where monsters truly shine in saving your RP and time.

- **Assigning Tasks:** In your Monster Barn menu, you can view your monsters and assign them to specific farm tasks. You typically choose which plots or areas they should work on.
- **Types of Farm Work:**
 - **Watering:** Monsters will water your planted crops daily.
 - **Tilling:** Monsters will till empty, uncleared land into plantable squares.
 - **Harvesting:** Monsters will harvest fully grown crops.
 - **Clearing:** Some monsters can even clear weeds, rocks, or stumps (though usually less efficiently than player tools).
 - **Planting:** More advanced monster abilities or specific rare monsters might even be able to plant seeds.
- **Efficiency:** A monster's efficiency in farm work depends on:
 - **Friendship Level:** Higher friendship means they work faster and cover a larger area.
 - **Species/Type:** Some monsters are inherently better at specific tasks.
 - **Level:** Higher-level monsters might be more efficient.

- **Setting Task Areas:** You can often set a specific range or set of plots for a monster to work within, preventing them from wandering or tilling areas you don't want.
- **Benefits:**
 - **Save RP:** You conserve your own RP for adventuring or other tasks.
 - **Time Savings:** Farm chores are completed automatically, freeing up your day.
 - **Increased Output:** You can manage larger farm plots than you could manually.

5. Optimizing Your Monster Ranch

- **Balanced Ranch:** Don't just focus on product monsters or farm helpers. Aim for a mix that supports your overall goals.
 - **Early Game:** Focus on Woolies/Buffamoos for basic products and 1-2 reliable waterers.
 - **Mid-Game:** Expand into specialized farm workers and more diverse product monsters.
 - **Late Game:** Recruit monsters for every chore and stock multiple barns with high-friendship product monsters.
- **Prioritize Barn Upgrades:** Expand your barns as soon as you have the materials and gold. More space means more monsters, more productivity.
- **Consistent Care:** Make feeding and brushing a quick daily routine. Happy monsters are essential.
- **Choose Wisely:** When taming, consider a monster's potential farm work ability and its product drops.
- **Monster Pastures (If Applicable):** Some games allow you to release monsters into a "pasture" area on your farm where they roam freely and contribute to the land's health, rather than being confined to a barn.

6. The Benefits of a Productive Monster Ranch

A well-oiled monster ranch provides significant advantages:

- **Financial Stability:** Consistent daily income from monster products.
- **Self-Sufficiency:** A reliable supply of ingredients for cooking (milk, eggs) and crafting (fur, fluids).
- **Time Efficiency:** Automated farm chores free you up for dungeon exploration, quests, or socializing.
- **Reduced RP Drain:** Less personal RP spent on farming means more for combat or crafting.
- **Community Support:** Some villager requests might ask for monster products.

By investing in your monster ranch and nurturing your tamed allies, you'll create a thriving and efficient farm that stands as a testament to your resourcefulness, allowing you to fully embrace your destiny as a Guardian of Azuma.

Best Monsters for Combat and Farming

Your tamed monsters in *Rune Factory: Guardians of Azuma* are more than just adorable companions; they are invaluable allies that can revolutionize both your daily farm life and your perilous dungeon delves. Strategic

monster recruitment means choosing the right creatures for the right job. This guide will help you identify the **best monsters for combat and farming**, turning your ranch into a hub of efficiency and your party into an unstoppable force.

Note: As Rune Factory: Guardians of Azuma is a new title, specific monster names, their exact abilities, and preferred items are illustrative, based on common mechanics and monster archetypes found across the Rune Factory series. The core principles of monster utility remain consistent.

General Principles for Choosing Monsters

Regardless of their role, all monsters benefit from:

- **High Friendship:** The higher a monster's friendship level (increased by daily brushing and feeding), the more effective they are. Higher friendship boosts their stats (HP, Attack, Defense), increases product drop rates, and enhances farm work efficiency.
- **Appropriate Level:** Monsters gain experience when accompanying you in battle. Higher-level monsters have better base stats.
- **Daily Feeding:** Ensure your monsters are fed daily to maintain their happiness and productivity.

1. Best Monsters for Combat

When choosing monsters for your adventuring party, consider their combat role, elemental affinities, and unique abilities. You can typically bring 1-2 monster companions (in addition to human party members) with you.

A. The Tank (Front-Line & Damage Sponge)

- **Role:** Draws enemy aggro, absorbs damage, protects weaker party members (like you or a healer).
- **Key Traits:** High HP, high Physical Defense, often slow but powerful attacks.
- **Archetypes:**
 - **Buffamoo Variants (e.g., Water Buffamoo, Fire Buffamoo):** These cow/buffalo-like monsters are often excellent early-game tanks. They have naturally high HP and DEF, and their elemental variations can provide resistance to specific elemental attacks. (Also produce Milk for farming!)
 - **Golem/Rock Monsters:** Often boast extremely high physical defense and can absorb a lot of hits. Some may have protective skills or ground-based AoE attacks.
 - **Large Beasts (e.g., Armored Bear, Giant Boar):** These monsters typically have a large HP pool and can deal decent physical damage while soaking up hits.
- **What to Look For:** Monsters with "Provoke," "Guard," or high natural elemental resistances (useful for specific dungeons/bosses).

B. The Damage Dealer (DPS - Damage Per Second)

- **Role:** Focuses on dealing high amounts of damage to enemies.
- **Key Traits:** High Attack or Magic Attack, fast attack speed, or powerful AoE (Area of Effect) attacks.
- **Archetypes:**
 - **Wolf/Tiger Variants (e.g., Silver Wolf, Malm Tiger):** Often agile and fast, capable of quick, sustained melee damage. Some can be ridden for mounted combat.
 - **Elemental Fairies/Spirits (e.g., Fire Fairy, Wind Elemental):** These typically excel at ranged elemental magic, dealing high damage to enemies weak to their element. Some may also heal you.
 - **Giant Insects (e.g., Queen Hornet, Hercules Beetle):** Can have strong physical attacks, sometimes with unique status effects (e.g., Hornet's poison sting).
 - **Boss Monsters (e.g., Nine-Tailed Fox, Siren):** Bosses, once tamed, are often among the strongest combat companions due to their naturally high stats and unique attacks. However, they can be challenging to tame.
- **What to Look For:** Monsters with strong active attack skills, elemental damage, or high critical hit rates.

C. The Support / Utility Monster

- **Role:** Heals party members, applies buffs to allies, inflicts debilitating status effects on enemies, or provides unique battlefield control.
- **Key Traits:** Healing spells, status effect infliction (Poison, Paralysis, Sleep, Seal), buff/debuff abilities.
- **Archetypes:**
 - **Fairy Variants (e.g., Green Fairy, Light Spirit):** Often specialize in healing magic (healing you or companions) or applying beneficial buffs.
 - **Mushroom Monsters (e.g., Big Muck, Tricky Muck):** Can inflict poison or sleep status effects with their spore attacks.
 - **Ghost/Spirit Monsters:** May inflict "Seal" (prevents enemy magic use) or "Curse" (reduces stats).
- **What to Look For:** Monsters with healing spells, specific status effects you find useful, or unique passive abilities.

2. Best Monsters for Farming

These monsters are your silent partners, diligently working on your farm and providing valuable resources.

A. Resource Producers (Barn-Focused)

- **Role:** Produce valuable items daily when housed in a Monster Barn.
- **Key Traits:** Consistent daily product drops.
- **Archetypes:**
 - **Wooly (Sheep):** Produces **Fleece** or **Wooly Furball**. Excellent early-game monster, fur is used in many crafting recipes (cloth, clothing, accessories) and sells well at higher levels.

- **Buffamoo (Cow):** Produces **Milk**. Highly valuable for cooking (many recipes require milk) and selling. Milk levels up with the Buffamoo's friendship.
- **Cluckadoodle (Chicken):** Produces **Eggs**. Versatile for cooking and selling. Egg levels up with friendship.
- **Hornet/Bee Monster:** Produces **Honey**. Sells for very high prices, also used in cooking and chemistry.
- **Spider (e.g., Killer Spider):** Produces **Spider's Thread**. Crucial for crafting string-based recipes.
- **Flower Lion (Plant Monster):** Produces **Plant Stems** or **Roots**. Useful for crafting tools and other recipes.
- **Optimization:** Aim for at least one of each primary producer (Wooly, Buffamoo, Cluckadoodle) to ensure a steady supply of basic ingredients and income. Increase their friendship to get higher-level products.

B. Farm Workers (Field-Focused)

- **Role:** Automate daily farm chores, saving your RP and time.
- **Key Traits:** Abilities like Watering, Tilling, Harvesting, or Clearing.
- **Archetypes:**
 - **Watering Monsters (e.g., certain Goblins, elemental sprites):** These monsters can automatically water your crops daily.
 - **Tilling Monsters (e.g., certain Goblins, Orcs):** These monsters will till empty squares on your farm.
 - **Harvesting Monsters (e.g., certain Fairies, small Golems):** These monsters will automatically harvest fully grown crops and place them in the Shipping Bin.
 - **Clearing Monsters (e.g., some Golems, larger monsters):** Can clear weeds, rocks, and stumps from your farm.
- **Optimization:**
 - **Dedicated Roles:** Assign monsters to specific tasks. You might want 2-3 waterers for a large field, and 1-2 harvesters.
 - **Friendship for Efficiency:** Higher friendship levels increase the area a monster can cover and how quickly they complete their tasks.
 - **Targeted Areas:** You can often set specific plots for your monsters to work on.

3. Choosing Your Monster Party: Strategic Synergy

- **Balanced Party:** A good starting point for dungeons is a **Tank** monster (e.g., Buffamoo variant) and a **Damage Dealer** (e.g., Wolf variant or Elemental Fairy). This gives you both offense and defense.
- **Situational Needs:**

- **For a Boss:** Bring monsters that counter the boss's elemental type or inflict status effects it's vulnerable to.
- **For Resource Farming:** Bring monsters that can quickly clear rooms of enemies, or those that might have passive item drop rate boosts (if such effects exist in Azuma).
- **Consider Your Own Playstyle:** If you are a melee fighter, a ranged monster companion provides balance. If you are a mage, a tanky monster can keep enemies off you.

By carefully selecting, nurturing, and strategically deploying your tamed monsters, you'll unlock a wealth of productivity and combat power, making them truly indispensable allies in your quest to become the ultimate Guardian of Azuma.

Chapter 9

HEART OF THE COMMUNITY – Festivals, Quests & Events

Immerse yourself in the vibrant social tapestry of Azuma! This chapter guides you through the full **calendar of festivals and activities**, helping you participate in every joyful celebration. Explore in-depth **romance options and a marriage guide** to find your soulmate, unravel intricate **side quests and their rewarding trees**, and understand how to build crucial **community reputation for exciting unlockables**. Discover how strong bonds are the true heart of your Azuman journey.

Maximizing Skills and Character Builds

Beyond the daily rhythm of farming and the thrill of dungeon delving, lies the intricate art of character progression in *Rune Factory: Guardians of Azuma*. **Maximizing your skills** and strategically planning your **character build** are paramount to overcoming the game's toughest challenges, achieving peak efficiency in all activities, and truly becoming the formidable Guardian Azuma needs. This guide will illuminate the path to optimizing your hero for ultimate power.

Note: As Rune Factory: Guardians of Azuma is scheduled for release on June 5, 2025, specific skill names, precise stat caps, and unique build archetypes are illustrative, based on common mechanics found across the Rune Factory series. The core principles of character optimization remain universal.

1. Understanding Skills: The Engine of Growth

Your character in *Rune Factory* possesses numerous skills, each tied to a specific action. Leveling these skills not only grants passive benefits but also contributes to your overall strength.

A. Active Skills (Combat & Magic)

These skills are directly related to your combat effectiveness.

- **Weapon Proficiencies:**
 - **Examples:** One-Handed Sword Skill, Two-Handed Sword Skill, Spear Skill, Axe Skill, Hammer Skill, Fist Skill.
 - **How to Level:** By successfully hitting enemies with the corresponding weapon type. Using charged attacks or unique weapon arts usually grants more experience.
 - **Benefits:** Increased damage, reduced RP cost for attacks, faster attack speed, unlocks new active skills (e.g., a specific combo, a powerful charged attack).
- **Magic Skills:**
 - **Examples:** Fire Magic, Water Magic, Earth Magic, Wind Magic, Light Magic, Dark Magic, Healing Magic.
 - **How to Level:** By successfully casting spells of that element/type.
 - **Benefits:** Increased spell damage/potency, reduced RP cost

for spells, unlocks new, more powerful spells.
- **Defense Skill:**
 - **How to Level:** By successfully guarding against enemy attacks.
 - **Benefits:** Increases your physical defense, reduces damage taken.
- **Dodge/Run Skill:**
 - **How to Level:** By successfully dodging enemy attacks or sprinting frequently.
 - **Benefits:** Increases your evasion chance, improves your movement speed.

B. Life Skills (Daily Activities)

These skills govern your efficiency in non-combat activities but often provide passive stat boosts.

- **Farming Skill:**
 - **How to Level:** Tilling, planting, watering, harvesting crops.
 - **Benefits:** Reduces RP consumption for farm tools, increases crop yield, improves crop level.
- **Cooking Skill:**
 - **How to Level:** Successfully cooking dishes.
 - **Benefits:** Unlocks new recipes, increases cooked dish quality, reduces RP consumption for cooking.
- **Forging Skill:**
 - **How to Level:** Successfully crafting weapons and armor.
 - **Benefits:** Unlocks new recipes, increases crafting success rate, reduces RP consumption.
- **Chemistry Skill:**
 - **How to Level:** Successfully brewing potions and medicines.
 - **Benefits:** Unlocks new recipes, increases potion potency, reduces RP consumption.
- **Mining Skill:**
 - **How to Level:** Breaking rocks and mining ore nodes.
 - **Benefits:** Reduces RP consumption for Hammer, increases ore yield and rarity.
- **Woodcutting Skill:**
 - **How to Level:** Chopping trees and stumps.
 - **Benefits:** Reduces RP consumption for Axe, increases wood yield and quality.
- **Fishing Skill:**
 - **How to Level:** Successfully catching fish.
 - **Benefits:** Reduces RP consumption for Fishing Rod, makes catching fish easier, increases chance of rare fish.
- **Sleeping Skill, Eating Skill, Bathing Skill, Walking Skill:**
 - **How to Level:** By simply performing these daily actions.
 - **Benefits:** These often provide passive, minor boosts to HP, RP, or core stats (STR, VIT, INT, LCK). They are "free" levels.

2. Character Stats: The Raw Numbers

Your character's core stats directly influence their performance.

- **HP (Health Points):** Your life bar.

- **RP (Rune Points):** Energy for skills, spells, and life activities.
- **STR (Strength):** Primarily boosts Physical Attack (ATK) and physical defense (DEF).
- **VIT (Vitality):** Primarily boosts Physical Defense (DEF) and HP.
- **INT (Intelligence):** Primarily boosts Magic Attack (M.ATK), Magic Defense (M.DEF), and spell damage.
- **LCK (Luck):** Influences critical hit rate, item drop rarity, success chance for farming/crafting, and evasion.
- **ATK (Attack):** Overall physical damage.
- **DEF (Defense):** Overall physical damage reduction.
- **M.ATK (Magic Attack):** Overall magic damage.
- **M.DEF (Magic Defense):** Overall magic damage reduction.

How Stats Increase:

- **Leveling Up:** Gaining EXP from combat or quests increases your overall character level, providing a base increase to all stats.
- **Skill Levels:** Every time you level up any skill (combat or life skill), you gain a small, passive increase to various core stats (e.g., Forging often boosts STR, Cooking often boosts HP/RP).
- **Equipment:** Weapons, armor, and accessories provide direct stat boosts.
- **Food/Potions:** Consuming certain cooked dishes or brewed potions can provide temporary (or sometimes permanent) stat boosts.
- **Relationship Levels:** Higher friendship with NPCs can sometimes provide subtle passive stat boosts.

3. Character Builds: Specializing Your Hero

While *Rune Factory* encourages a balanced approach, focusing your stats and skills can create highly effective specialized builds.

A. Melee DPS (Damage Per Second)

- **Focus:** High physical damage, aggressive combat.
- **Key Stats:** Maximize **STR** and **LCK**. Boost **VIT** for survivability.
- **Primary Skills:** Chosen Weapon Skill (e.g., One-Handed Sword, Two-Handed Sword, Axe, Hammer, Fist), Defense, Dodge.
- **Equipment:**
 - **Weapon:** Highest ATK weapon of choice, upgraded to max TLU/TRU with ATK-boosting materials (e.g., Dragon Fangs, high-level ores).
 - **Armor:** Balanced DEF/M.DEF armor, but prioritize physical defense.
 - **Accessories: Power Ring** (ATK), **Critical Ring** (Crit Rate), accessories boosting STR/LCK.
- **Companions:** Tanks (to draw aggro) or Support (for healing/buffs).

B. Magic DPS (Spellcaster)

- **Focus:** High magic damage, ranged combat, elemental exploitation.
- **Key Stats:** Maximize **INT** and **RP Max/Recovery**. Boost **VIT** for survivability.

- **Primary Skills:** Relevant Magic Skills (e.g., Fire Magic, Dark Magic), Defense, Dodge.
- **Equipment:**
 - **Weapon:** Highest M.ATK staff/wand, upgraded with M.ATK boosting materials (e.g., magic crystals, Int-boosting crops).
 - **Armor:** Balanced DEF/M.DEF armor, but prioritize magic defense.
 - **Accessories: Magic Ring** (M.ATK), **Courage Badge** (RP Max), **Focus Earring** (RP cost reduction), accessories boosting INT.
- **Companions:** Tanks (to keep enemies away) or Utility (for status effects/crowd control).

C. Tank / Defensive

- **Focus:** Absorbing damage, protecting party, high survivability.
- **Key Stats:** Maximize **VIT** and **HP Max**. Boost **STR/INT** for some counter-damage.
- **Primary Skills:** Weapon Skill (often One-Handed Sword with Shield), Defense, Dodge, all Life Skills (for passive HP/RP).
- **Equipment:**
 - **Weapon:** Sturdy One-Handed Sword + highest DEF Shield.
 - **Armor:** Max DEF/M.DEF on all slots, often focusing on elemental resistances.
 - **Accessories: Shield Ring** (DEF), **Talisman** (M.DEF), **Heart Pendant** (HP Max), accessories boosting VIT.
- **Companions:** High-damage DPS companions to make up for your lower personal damage.

D. Hybrid / Balanced

- **Focus:** Competent in both combat and life skills, adaptable to any situation.
- **Key Stats:** Balanced distribution of STR, VIT, INT, LCK.
- **Primary Skills:** At least two weapon skills, a few magic skills, and a strong set of life skills.
- **Equipment:** Versatile weapon (e.g., One-Handed Sword), balanced armor, accessories that provide a mix of offensive, defensive, and utility buffs.
- **Companions:** Mix of Tank, DPS, or Support.

E. Farmer / Crafter / Social-Focused

- **Focus:** Maximizing farm output, crafting ultimate items, building strong relationships. Combat is secondary, for resource gathering.
- **Key Stats:** Maximize **RP Max/Recovery**, **LCK**. Boost **STR/INT** enough for basic combat.
- **Primary Skills:** Farming, Cooking, Forging, Chemistry, Fishing, Woodcutting, Mining, all passive "daily" skills.
- **Equipment:**
 - **Weapon:** Any basic weapon, infused with Luck-boosting items for better drops.

- **Armor:** Comfortable armor with good DEF/M.DEF for safety.
- **Accessories: Focus Earring** (RP cost reduction), **Lucky Charm** (Luck), **Heart Pendant** (Friendship gain), **Strider Boots** (Movement Speed).
- **Tools:** All farming/gathering tools (Hoe, Watering Can, Axe, Hammer, Sickle, Fishing Rod) fully upgraded to their highest tiers.
- **Companions:** Monster helpers for automated farm work.

4. Optimizing Skill Leveling

- **Consistent Use:** The simplest way to level skills is to use them repeatedly.
 - **Combat:** Seek out monster spawners or areas with high monster density for efficient grinding.
 - **Life Skills:** Incorporate them into your daily routine. Cook meals, forge weapons, or brush monsters even if you don't immediately need to.
- **Skill-Boosting Items:**
 - **Food:** Certain cooked dishes can temporarily boost your skill experience gain (e.g., "Skill Bread" or specific gourmet meals).
 - **Accessories:** Rare accessories might provide passive skill EXP boosts (e.g., "Proof of Wisdom" for general EXP, "Expert's Charm" for specific skill types).
- **RP Management:** Life skills consume a lot of RP. Prepare RP-restoring foods or use the Bathhouse for long crafting/farming sessions.
- **Sleeping:** Sleep restores all RP and HP, allowing you to go hard on skill grinding each day.

5. Equipment Synergy

- **Maximize TLU/TRU:** Always use Level 10 materials (crops, ores, rare drops) when crafting and upgrading all your gear (weapons, armor, accessories). This is the single biggest factor for boosting overall stats beyond base values.
- **Elemental Matching:** Tailor your weapon's element to enemy weaknesses and your armor/accessories' resistances to enemy strengths for specific dungeons or bosses.
- **Status Effect Infusion:** Infuse weapons with debilitating status effects (Paralysis, Seal) and armor with resistance/immunity to common debuffs.
- **Accessory Stacking:** Be mindful of whether similar accessory effects stack or overwrite each other.

6. Consumables for Builds

- **Buff Foods:** Cooked dishes that provide temporary boosts to ATK, M.ATK, DEF, M.DEF, Luck, or specific elemental resistances are crucial for boss battles and tough dungeons.
- **Potions:** Brewed potions can offer similar benefits to food and often provide immediate relief from status effects.

7. Companion Synergy

- **Complement Your Build:** Choose companions whose roles complement your own build. If you're a Tank, bring DPS companions. If you're a Mage, bring a Tank.
- **Equip Them Well:** Human companions benefit immensely from high-tier gear you equip them with.
- **Monster Buffs:** Some tamed monsters can provide passive buffs or active abilities that benefit your entire party.

8. Flexibility and Endgame Goals

- **Re-spec (Limited):** *Rune Factory* games typically don't have a formal "re-spec" option. Your skill levels are permanent. However, you can always change your weapon type and focus on leveling a new skill.
- **Endgame Push:** After completing the main story, the "post-game" often offers new challenges (higher difficulty dungeons, super-bosses) that require pushing your character's skills and equipment to their absolute maximum. This is where ultimate optimization truly shines.

By meticulously managing your skill progression, strategically choosing and upgrading your equipment, and adapting your build to the challenges ahead, you'll forge a hero capable of anything Azuma demands.

Calendar of Festivals and Activities

The changing seasons of Azuma bring more than just new crops and varying weather; they usher in a vibrant tapestry of **festivals and activities** that are the very heart of the community. Participating in these events is crucial for building deep relationships, earning unique rewards, and truly immersing yourself in the rich culture of this eastern land. Mastering the **Calendar of Festivals and Activities** ensures you never miss a moment of celebration or opportunity.

Note: As Rune Factory: Guardians of Azuma is a newly released title (May/June 2025), precise festival names, dates, and event details are illustrative, based on common mechanics found across the Rune Factory series and its Japanese-inspired setting. The core principles of festival benefits remain universal.

1. Understanding the Calendar

Your in-game calendar is your most important tool for planning your year.

- **Location:** Typically found in your farmhouse (often beside your bed/diary table), and sometimes a public calendar in a central town building (e.g., General Store, Town Hall).

- **Information Displayed:**

 - Current Day of the Week (e.g., Monday, Tuesday, Holiday).
 - Current Day of the Month (e.g., Spring 1, Summer 15).
 - Upcoming Festivals: Marked with a special icon or text on their respective dates.
 - NPC Birthdays: Often marked with a special symbol (e.g., a cake icon) on the birth date of each villager.

- **Tip:** Make checking the calendar a part of your daily morning routine. This allows you to plan your activities around upcoming events and birthdays.

2. General Festival Mechanics and Benefits

Festivals are more than just pretty spectacles; they offer significant in-game advantages.

- **Automatic Trigger:** Festivals usually start at a specific time (e.g., 9 AM or 10 AM) in a designated location (e.g., Town Square, Beach). Simply show up!
- **Time Progression:** Time typically freezes or slows down significantly during festivals, allowing you to fully enjoy the event without losing precious daylight for farming or adventuring.
- **Relationship Boosts:**
 - **Town-Wide Friendship:** Simply attending and participating in a festival often provides a small friendship boost with *all* attending villagers.
 - **Direct Interaction:** Many festivals involve talking to NPCs, which gives a further daily friendship boost.
 - **Competition Rewards:** Winning festival competitions often grants a significant friendship boost with participating NPCs or the festival organizer.
- **Unique Rewards:**
 - **Gold & Items:** Many festivals offer gold, rare items, recipes, or even special decorative furniture as prizes for winning contests.
 - **Festival-Specific Items:** Some festivals might sell unique, limited-time items or ingredients.
- **Lore & Character Development:** Festivals often feature unique dialogue and mini-events that deepen your understanding of Azuma's culture and its residents.
- **Skill Practice:** Certain festivals (e.g., cooking contest, fishing contest) allow you to test and practice your skills in a fun, competitive environment.

3. Yearly Calendar of Festivals (Illustrative Examples)

Here's a breakdown of common festival types and what to expect in each season, infused with Azuman flair.

Spring: Season of New Beginnings

- **Spring 1: New Year's Festival / Cherry Blossom Viewing**
 - **Description:** A peaceful celebration to welcome the new year. Often involves gathering in a central plaza or a scenic cherry blossom viewing spot.
 - **Activities:** Talking to everyone for daily greetings, simple games, viewing fireworks.
 - **Benefits:** General friendship boost with all villagers. Often a cutscene marking the new year.
- **Spring X: Crop Festival / Turnip Festival**

- **Description:** A competition where villagers bring their best-grown crop of a specific type (e.g., Turnip, Cabbage).
- **Activities:** Submit your highest-level crop to the organizer.
- **Benefits:** Win gold, rare fertilizers, recipes, and significant friendship with the organizer. Essential for showing off your farming prowess.

- **Spring X: Bamboo Shoot Hunt / Wild Harvest Festival**
 - **Description:** A scavenger hunt or competition to find the most or highest quality wild forageables in a designated area.
 - **Activities:** Collect specific wild items within a time limit.
 - **Benefits:** Gold, rare forageable items, friendship.

- **Spring X: Spring Market / Artisan Showcase**
 - **Description:** A town-wide market where vendors set up stalls.
 - **Activities:** Purchase unique seasonal goods, rare recipes, or special decorations. Villagers might showcase their crafts.
 - **Benefits:** Access to exclusive items, increased friendship with vendors.

Summer: Season of Sunlight and Warmth

- **Summer 1: Beach Opening / River Opening**
 - **Description:** Marks the beginning of summer activities. Often takes place near a beach or a large river.
 - **Activities:** General mingling, perhaps swimming or a simple beach game. No major competition.
 - **Benefits:** General friendship boost. Unlocks new fishing spots or swimming areas.

- **Summer X: Fishing Festival / Boat Race**
 - **Description:** A competition to catch the largest, most fish, or rarest fish, or a race across a body of water.
 - **Activities:** Submit your best catch or participate in a boat race (if mounts are involved).
 - **Benefits:** Gold, rare fish, fishing-related items, friendship with fishing enthusiasts.

- **Summer X: Starry Night Festival / Tanabata Festival**
 - **Description:** A romantic festival where villagers gather to watch meteors or lanterns under the stars. Often has an eastern aesthetic.
 - **Activities:** Spend time with villagers, especially marriage candidates. Often a good opportunity for a romantic event.
 - **Benefits:** Significant relationship boost with chosen partner, special dialogue.

- **Summer X: Combat Tournament / Martial Arts Competition**
 - **Description:** A test of strength and combat skill.

- **Activities:** Participate in a single-elimination tournament against villagers and potentially monsters.
- **Benefits:** Gold, rare combat items, powerful weapon/armor recipes, a title, and immense friendship with warrior-type NPCs.

Autumn: Season of Harvest and Reflection

- **Autumn 1: Harvest Festival / Moon Viewing Festival**
 - **Description:** A celebration of the season's bounty. Often involves bringing a dish or crop to a potluck.
 - **Activities:** Submit your best crop or cooked dish for evaluation.
 - **Benefits:** Gold, rare seeds, cooking recipes, and significant friendship.
- **Autumn X: Cooking Contest / Azuman Culinary Showdown**
 - **Description:** A competition to prepare the best dish of a certain category (e.g., soup, dessert).
 - **Activities:** Submit your best cooked dish.
 - **Benefits:** Gold, rare cooking utensils, new recipes, friendship with chefs.
- **Autumn X: Monster Taming Festival / Pet Show**
 - **Description:** Showcase your tamed monsters' charm or combat prowess.
 - **Activities:** Submit a tamed monster for judging based on friendship, level, or appearance, or participate in a monster battle.
 - **Benefits:** Gold, rare monster food, monster-related recipes, friendship with monster lovers.
- **Autumn X: Beauty Pageant / Fashion Contest**
 - **Description:** Villagers (and potentially you) show off their best outfits.
 - **Activities:** Wear your most stylish crafted outfit and submit it for judging.
 - **Benefits:** Unique clothing recipes, rare fabric, friendship with fashion-conscious NPCs.

Winter: Season of Rest and Warmth

- **Winter 1: Snow Festival / Lantern Festival**
 - **Description:** A festive event celebrating the arrival of winter, often with snow sculptures or light displays.
 - **Activities:** General mingling, viewing the scenery.
 - **Benefits:** General friendship boost.
- **Winter X: Winter Solstice / Sacred Night**
 - **Description:** A more intimate, often romantic festival.
 - **Activities:** Spend time with your chosen romantic partner. Often leads to a special dialogue or event.
 - **Benefits:** Large love point increase with your chosen partner.

- **Winter X: New Year's Eve / Year-End Feast**
 - **Description:** A final gathering to bid farewell to the old year.
 - **Activities:** Often involves a grand feast and countdown.
 - **Benefits:** General friendship boost.

4. Maximizing Your Festival Experience

- **Check the Calendar Early:** Plan ahead! Know which festivals are coming up so you can prepare the necessary items (best crops, highest-level fish, specific cooked dishes, etc.).
- **Prepare Your Submissions:** For contests, aim to submit the highest-level, highest-quality item possible. This is where your farming and crafting skills truly shine.
- **Talk to Everyone:** Make it a habit to talk to every single NPC at a festival. It's an easy way to get a lot of friendship points in one go.
- **Give Gifts:** If you have an NPC's loved item, a festival is a great opportunity to give it for a massive friendship boost, especially on their birthday which might coincide with a festival.
- **Save Before Contests:** For high-stakes competitions, save your game before the judging. If you don't win, you can reload and try again (or accept the loss and try harder next year!).
- **Enjoy the Lore:** Don't just focus on the rewards. Read the unique dialogue, observe the animations, and soak in the atmosphere. Festivals are a huge part of Azuma's charm.

By making festivals and activities a core part of your yearly routine, you'll not only reap valuable rewards but also weave yourself deeply into the heart of Azuma's community, building lasting bonds that truly enrich your adventure.

Romance Options and Marriage Guide

Beyond battling monsters and cultivating your farm, the world of Azuma offers another profound journey: building intimate relationships and finding your soulmate. The **Romance Options and Marriage Guide** will illuminate the path to deepening your bonds with charming villagers, navigating the complexities of their hearts, and ultimately, settling down to build a family in *Rune Factory: Guardians of Azuma*.

Note: As Rune Factory: Guardians of Azuma is a newly released title (May/June 2025), specific marriage candidate names and exact event triggers are illustrative, based on common mechanics and character archetypes found across the Rune Factory series. The core principles of romance and marriage remain universal.

1. Understanding Love Points and Friendship Points

Every named NPC in Azuma has a **Friendship Level** (usually 0-10 or 0-15 hearts). For eligible marriage candidates, this system extends to **Love Points** (or "Love Level"), which often starts at 0 and goes up to 10 (or a similar cap) before marriage.

- **Friendship vs. Love:** All villagers gain Friendship Points. Marriage candidates gain both Friendship Points (general

affection) and Love Points (romantic affection). Love Points are usually gained after you've reached a certain Friendship Level (e.g., 3-4 hearts).
- **Tracking Progress:** You can typically view the Friendship and Love levels of all characters in your Main Menu (often under a "Relationships" or "Townsfolk" tab). Love points are often indicated by a different color heart or a separate counter.
- **Gender Lock:** Traditionally, *Rune Factory* games have featured gender-locked romance options (male protagonist can only romance female candidates, and vice-versa). Assume this is the case unless the game explicitly states otherwise.

2. Identifying Marriage Candidates

- **Distinctive Characters:** Marriage candidates are typically a specific subset of villagers who have unique portraits, deeper backstories, and more extensive dialogue.
- **In-Game Clues:** The game might highlight them on your calendar (e.g., with a different icon on their birthday) or by specific dialogue options appearing only when talking to them.
- **Check Your Relationship Tab:** Your relationship menu will often clearly delineate which characters are marriage candidates.

3. Core Methods to Increase Love Points (and Friendship)

Building a relationship is a consistent effort, combining daily interactions with thoughtful gestures.

A. Talking Daily

- **Impact:** A fundamental way to gain both Friendship and Love Points. Just a single conversation each day provides a small, consistent boost.
- **Tip:** Make talking to your chosen candidate(s) a non-negotiable part of your daily routine.

B. Giving Gifts (The Fastest Way)

- **Impact:** The most significant and rapid way to increase both Friendship and Love Points. The effect varies wildly based on whether the gift is liked, loved, disliked, or hated.
- **Likes (Moderate Boost):** Most candidates have several items they "like." These give a good consistent boost.
- **Loves (Massive Boost):** Each candidate has one or two "loved" items. Giving these provides a huge increase in Love Points. They will react very enthusiastically.
- **Dislikes/Hates:** Giving disliked or hated items will decrease Love/Friendship. Avoid these at all costs!
- **Tip:**
 - **Research Preferences:** Pay close attention to dialogue for hints about their favorite foods or items. Check their character profile in the menu for more explicit hints. Online guides will also be invaluable post-release.
 - **Daily Gift:** Aim to give your chosen candidate(s) at least one liked or loved gift every single day.
 - **Birthday Bonus:** Giving a loved gift on their birthday provides an

enormous boost to both Friendship and Love Points, often filling multiple hearts. Mark these dates on your calendar!
- **Cooked Dishes:** Cooked dishes are almost universally liked by all NPCs, making them a safe and effective gift if you don't know specific preferences.

C. Completing Requests

- **Impact:** Completing a request from your chosen candidate provides a significant boost to their Friendship and Love Points, along with item and gold rewards.
- **Tip:** Check the Request Board daily and prioritize any requests from your romantic interest.

D. Dating & Special Events

- **Dating (Confession):**
 - **Trigger:** Typically, once your chosen candidate reaches a certain Love Level (e.g., 7 hearts or higher), you'll have a chance to confess your feelings to them.
 - **Mechanic:** This usually involves a specific dialogue option. Success often depends on their Love Level and potentially a random factor or your current relationship with other NPCs.
 - **Outcome:** If successful, you'll begin dating. If unsuccessful, you can try again later after increasing their Love Level further.
- **Date Events:** Once dating, special "Date Events" or "Love Events" will trigger at specific Love Levels. These are crucial for progressing your relationship towards marriage.
 - **Trigger:** These often trigger automatically when you talk to the candidate, enter a specific location at a certain time, or after completing specific story segments.
 - **Choices:** Some events might involve dialogue choices that can influence the outcome or your Love Points.
 - **Importance:** You *must* complete these events to unlock the marriage proposal.
- **Festivals:** Participating in festivals, especially romantic ones like the Starry Night Festival, can provide significant Love Point boosts if you attend with your chosen partner.

4. Marriage Requirements and Proposal

The path to marriage is the culmination of your romantic efforts.

- **Max Love Level:** Your chosen candidate's Love Level must be at its maximum (e.g., 10 hearts).
- **Complete All Love Events:** You must have triggered and completed all prerequisite "Love Events" with your candidate. These often tell their full story arc.
- **Double Bed:** You typically need to upgrade your house to include a Double Bed. This is often an expensive house upgrade.

- **Engagement Ring:** You must possess an **Engagement Ring**. This is usually a crafted item (requiring a high Forging skill and specific materials like Platinum or Diamonds) or rarely found/bought.
- **Main Story Progression:** In most *Rune Factory* games, you need to have completed the main storyline before you can propose marriage. This ensures you've faced all major threats and proven yourself a true Guardian.
- **Proposal:** Once all conditions are met, talk to your chosen candidate, and a special "Proposal" dialogue option will appear.

5. Life After Marriage

Marriage in *Rune Factory* adds a new layer to your daily life.

- **Spousal Perks:**
 - **Unique Dialogue:** Your spouse will have extensive new dialogue reflecting your married life.
 - **Daily Routines:** They might have new routines, perhaps even helping out on the farm or in your home.
 - **Special Meals/Gifts:** Your spouse might cook for you, give you daily gifts, or have unique requests.
 - **Combat Support:** Your spouse can still join you as a party member, and their effectiveness might be further enhanced.
 - **Love Points Continue:** You can continue to earn "Love Points" even after marriage, further strengthening your bond.
- **Having a Child:**
 - **Trigger:** After marriage, a few weeks or months later, a special event will trigger where you discuss having a child.
 - **Pregnancy:** Your spouse will become pregnant (or you will become pregnant if playing as a female protagonist). This period usually lasts for a specific number of in-game days.
 - **Birth:** A child will be born, often with a choice of gender.
 - **Raising Your Child:** Your child will grow through several stages, offering new interactions, dialogue, and potentially even their own side quests as they grow older. This extends the gameplay experience significantly.

6. Tips for Romance Success

- **Focus on One:** While you can raise friendship with many, concentrate your efforts on one or two candidates if marriage is your goal.
- **Birthday Bomb:** A loved gift on a birthday is gold. Seriously.
- **Daily Conversation + Gift:** Make this your baseline routine.
- **Don't Forget About Dates:** If you're dating, pay attention to the in-game calendar or hints from your partner about triggering specific love events.
- **Save Frequently:** Especially before confessing your feelings or proposing marriage, in case you fail (or change your mind!).

- **Enjoy the Story:** Each candidate has a unique personality and story. Get to know them beyond just their gift preferences. The journey to marriage is as important as the destination.

By investing your time and heart into Azuma's charming villagers, you'll uncover some of the most rewarding and enduring experiences *Rune Factory: Guardians of Azuma* has to offer, culminating in a beautiful life beyond mere battle.

Side Quests and Reward Trees

While the main storyline of *Rune Factory: Guardians of Azuma* guides your epic journey, the vibrant heart of the game truly beats within its myriad **Side Quests**. These engaging mini-narratives, often tied to intricate **Reward Trees**, offer a wealth of opportunities to deepen your connection with Azuma's community, uncover hidden lore, and acquire invaluable resources, recipes, and gold. Mastering the art of managing and prioritizing these quests is key to a truly fulfilling and efficient adventure.

1. The Importance of Side Quests

Side quests in *Rune Factory: Guardians of Azuma* are far more than just filler; they are essential for holistic progression:

- **Relationship Building:** Completing requests is one of the most effective ways to boost Friendship (and Love) Points with villagers.
- **Gold & Item Acquisition:** They are a consistent source of early-to-late game income and often reward rare items, unique materials, or powerful equipment.
- **Recipe Unlocks:** Many crafting and cooking recipes are exclusively obtained through side quests.
- **Lore & World Building:** Side quests provide deeper insights into the lives of villagers, local traditions, historical events, and hidden corners of Azuma.
- **Unlocking Content:** Certain shops, services, areas, or even marriage candidates might only become accessible after completing specific side quest chains.
- **Skill XP:** Some quests provide direct skill experience, or require you to perform actions that naturally level up your skills.

2. Accessing Side Quests: The Request Board

The primary hub for most side quests is the **Request Board**.

- **Location:** Typically found in a central area of your starting town (e.g., in the town square, outside the General Store, or near the Elder's house). New towns you unlock will also have their own Request Boards.
- **How to Accept:** Approach the Request Board and interact with it. A list of available quests will appear. Select a quest to read its details and "Accept" it.
- **Acceptance Limits:** Most games have a limit to how many requests you can have active at once (e.g., one or two). You may need to complete an active request before accepting a new one from the board.
- **Refresh Rate:** New requests typically appear daily or every few days. Check the board consistently!
- **Direct Requests:** While the board is primary, some NPCs might also give you a direct quest if you talk to them repeatedly,

trigger a specific character event, or reach a certain friendship level. These often don't appear on the board.

3. Types of Side Quests

Side quests are diverse, ranging from simple errands to multi-part investigations.

A. Fetch Quests

- **Description:** The most common type. An NPC asks you to acquire a specific item (e.g., "Bring me 3 Turnips," "I need 1 Iron Ore").
- **Completion:** Gather the item(s) and deliver them directly to the quest giver.
- **Difficulty:** Varies. Early ones are easy. Later ones might require venturing into challenging dungeons for rare monster drops or ores.

B. Delivery Quests

- **Description:** An NPC asks you to deliver an item to another NPC.
- **Completion:** Acquire the item (if not given) and deliver it to the designated recipient. Sometimes, a short dialogue exchange will occur.
- **Difficulty:** Simple, often acting as introductions to other villagers or locations.

C. Hunting Quests

- **Description:** An NPC asks you to defeat a certain number or type of monster.
- **Completion:** Go to the specified area (or find the monster type yourself) and defeat the required number. Then report back to the quest giver.
- **Difficulty:** Varies based on monster strength and location. Some might involve mini-bosses.

D. Crafting Quests

- **Description:** An NPC asks you to craft a specific weapon, armor, accessory, cooked dish, or potion.
- **Completion:** Craft the item using your respective skills (Forging, Cooking, Chemistry) and deliver it.
- **Difficulty:** Requires you to have learned the recipe and gathered the necessary materials, often pushing you to level up your crafting skills.

E. Exploration Quests

- **Description:** Less common, but some quests ask you to discover a specific location, find a hidden object in an area, or explore a new part of the map.
- **Completion:** Reach the destination or find the hidden item, then report back.
- **Difficulty:** Requires keen observation and thorough exploration.

F. Character-Specific Story Quests (Hidden/Triggered)

- **Description:** These are multi-part quests that delve deeply into a character's backstory, personality, or a specific problem they're facing. They are often tied to friendship/love levels.
- **Completion:** Involve multiple stages, dialogue choices, and often unique mini-events.

- **Difficulty:** Varies, but the reward is usually significant relationship gain and deeper narrative.
- **Tip:** These are often the "Love Events" for marriage candidates. Prioritize them for your chosen partner.

4. Reward Trees: Unlocking Progression

Many side quests, especially those from the Request Board or specific NPCs, aren't standalone. They are part of **Reward Trees** or **Quest Chains**, where completing one quest unlocks the next, leading to increasingly valuable rewards and content.

- **Concept:** Imagine a tree where completing "Quest A" (e.g., "Bring me 3 Turnips") unlocks "Quest B" (e.g., "Bring me 1 Cabbage"), which then unlocks "Quest C" (e.g., "Bring me 1 Level 2 Cabbage").
- **Escalating Difficulty & Rewards:** As you progress down a quest chain:
 - **Requirements become harder:** From common items to rare monster drops, specific cooked dishes, or high-level crafted gear.
 - **Rewards become better:** More gold, rarer items, unique recipes, permanent stat-boosting food, access to new shops, or permission to enter previously blocked areas.
- **Specific NPC Chains:** Many NPCs have their own unique quest chains that reveal their story and provide rewards tailored to their profession (e.g., the Blacksmith's quests might yield rare forging recipes, the Chef's quests might give cooking recipes).
- **Town Upgrade Quests:** Sometimes, a series of quests from the Mayor or Elder will unlock new facilities in town (e.g., a larger General Store, a new bathhouse, access to a Monster Barn blueprint).

5. Strategy for Managing Side Quests

Navigating the sheer volume of quests can be overwhelming. Here's how to manage them efficiently:

- **Check the Request Board Daily:** Make it a habit. New quests pop up frequently, and you don't want to miss a valuable one.
- **Prioritize Rewards:**
 - **Recipes:** Always prioritize quests that reward new crafting or cooking recipes. These unlock permanent abilities for you.
 - **Gold/Rare Items:** If you need money or a specific rare material, target quests that offer them.
 - **Friendship:** Focus on quests from NPCs you want to befriend quickly, especially marriage candidates.
- **Group Similar Quests:** If multiple requests ask for similar items or involve the same dungeon, accept them all and complete them in one efficient run.
- **Keep a Stockpile:** Maintain a good inventory of common items (ores, monster drops, common crops). This allows you to instantly complete many requests.
- **Don't Over-Accept:** Don't accept too many requests that require extensive grinding if you only have limited active slots. Focus on what you can realistically complete soon.
- **Read Carefully:** Always read the quest details. Some quests have specific

requirements (e.g., "must be Level 3," "deliver after 6 PM") or hidden conditions.
- **Balance with Main Story:** While side quests are vital, ensure you still progress the main story to unlock new areas, powerful resources, and important plot points that can, in turn, facilitate easier side quest completion.
- **Utilize Companions:** Some quests might involve combat. Bring your companions along to make them easier.

By thoughtfully engaging with Azuma's abundant side quests and understanding the valuable reward trees they offer, you'll not only contribute to the well-being of the community but also empower your hero with the skills, resources, and relationships needed to fulfill your destiny.

Made in the USA
Columbia, SC
14 June 2025